CLASSIC
CAFES

For
Sylvia De Marcos

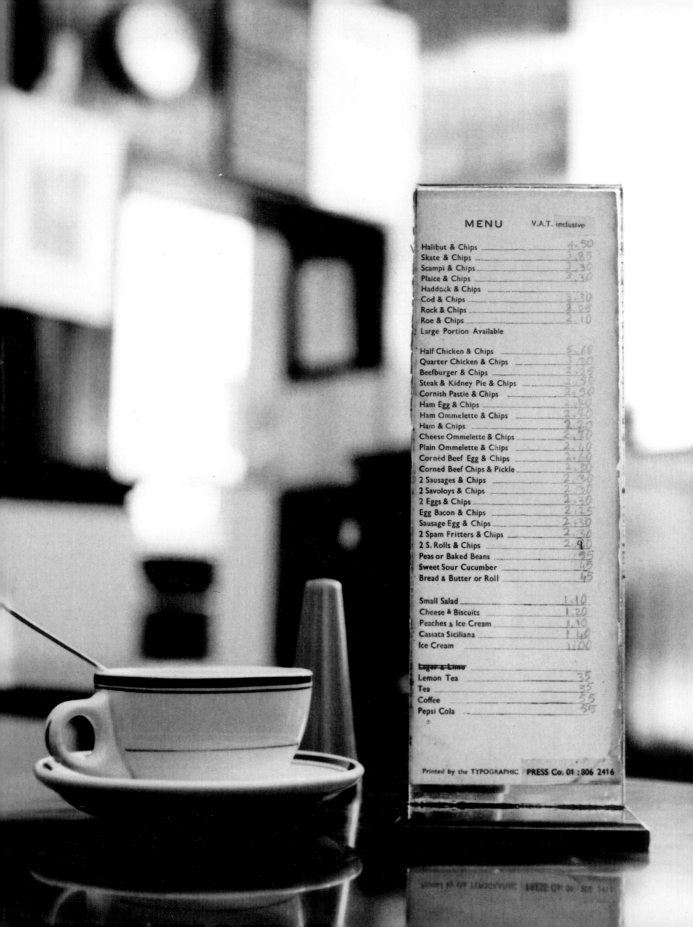

MENU V.A.T. inclusive

Halibut & Chips _____ 4.50
Skate & Chips _____ 3.85
Scampi & Chips _____ 3.30
Plaice & Chips _____ 3.30
Haddock & Chips
Cod & Chips _____ 3.30
Rock & Chips _____ 3.25
Roe & Chips _____ 3.10
Large Portion Available

Half Chicken & Chips _____ 5.60
Quarter Chicken & Chips _____ 3.20
Beefburger & Chips _____ 2.80
Steak & Kidney Pie & Chips ____ 2.50
Cornish Pastie & Chips _____ 2.30
Ham Egg & Chips _____ 2.80
Ham Ommelette & Chips _____ 2.50
Ham & Chips _____ 2.20
Cheese Ommelette & Chips _____ 2.20
Plain Ommelette & Chips _____ 2.40
Corned Beef Egg & Chips _____ 2.60
Corned Beef Chips & Pickle ____ 2.20
2 Sausages & Chips _____ 2.30
2 Savoloys & Chips _____ 2.20
2 Eggs & Chips _____ 2.30
Egg Bacon & Chips _____ 2.15
Sausage Egg & Chips _____ 2.30
2 Spam Fritters & Chips _____ 2.50
2 S. Rolls & Chips _____ 2.90
Peas or Baked Beans _____ 35
Sweet Sour Cucumber _____ 05
Bread & Butter or Roll _____ 45

Small Salad _____ 1.10
Cheese & Biscuits _____ 1.20
Peaches & Ice Cream _____ 1.10
Cassata Siciliana _____ 1.40
Ice Cream _____ 1.00

Lager & Lime _____
Lemon Tea _____ 35
Tea _____ 35
Coffee _____ 55
Pepsi Cola _____ 55

Printed by the TYPOGRAPHIC PRESS Co. 01 : 806 2416

Adrian Maddox

CLASSIC CAFES

Black Dog Publishing Limited

London and New York

Architecture Art Design Fashion History
Photography Theory and Things

Photographs by **Phil Nicholls**

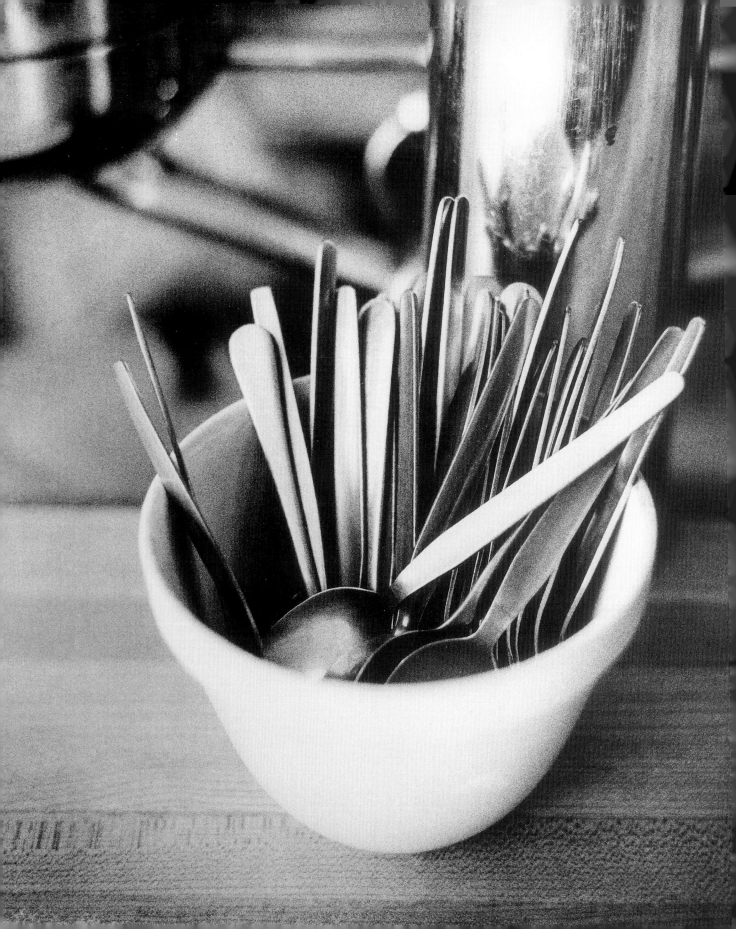

Contents

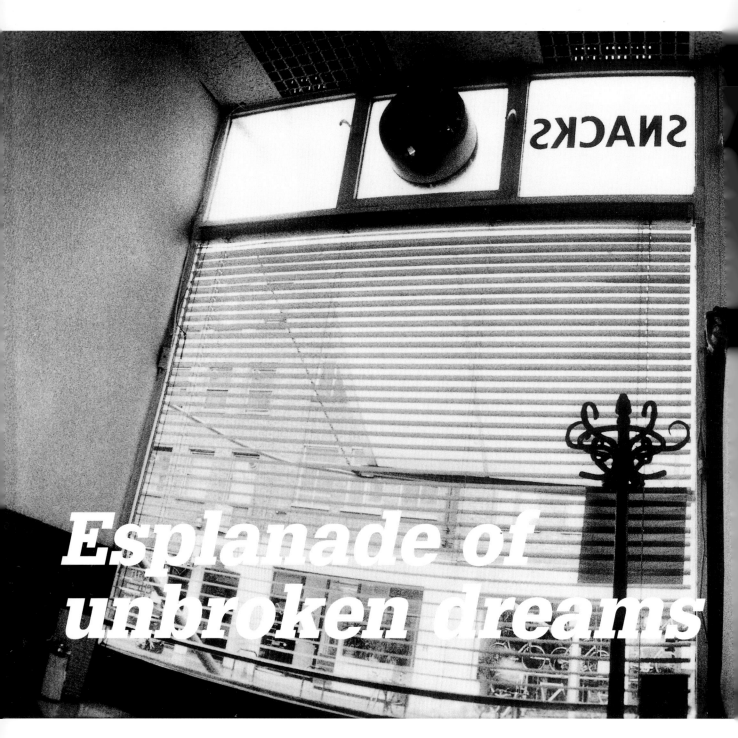

Esplanade of unbroken dreams

You hate food. This is a very dark country. Blame it on the empire. Eighty per cent of you are working class and you think it's fantastic to go into some revolting cafe and eat something disgusting to endorse your working class status.
Raymond Blanc, *The Sunday Times*, 2002

I am never so relaxed as when sitting in a greasy spoon. The joy lies in the atmosphere of speckled lino, fly spattered blinds, sunlight filtered through smeared windows to hit a cloud of steam, and an eternal war between bleach and grease... it's like a day-care centre for artists, window cleaners and escapees from rehabilitation centres....

Joanne Briscoe, *The Independent*, **1997**

Think back. A Post War British high street. 50s Festival Britain with a streak of 60s sanguine. Incidental music everywhere plays melody on the move, the sound of the garden suburbs. Light orchestral themes and period easy listening shimmer just out of range.

Britain in repose: new towns and nylons, wool shops and slingbacks. A white-collar Shangri-La of gents outfitters, parks and gardens, chalet lodges, pavilions, bowling greens, banqueting halls, lidos and Lubetkin marine architecture.

And at the centre of this cavalcade of contentment, the new espresso cafe – the very model of Mid-Century Modernism. Bringing a continental elan to colourless British town centres everywhere; a melee of mosaics, menus, laminates and leatherette. The feel is Ease for England: the lost innocence of Terence Stamp and Julie Christie bowling down a mint municipal concourse.

An esplanade of unbroken dreams....

I started collecting classic cafes – the vintage British 1950s working-man's Formica variety – after a first visit to Barcelona in the mid-1980s. My hotel, the Pension Dali off Las Ramblas, the grand boulevard linking the waterfront to the heart of the city, had no breakfast room so the early part of the day was spent on gumshoe sorties looking for suitable cheap eateries in the old town.

The sheer range of places available was beguiling. Las Ramblas was lined with old-timer cafes, many retaining their aged, gleaming aluminium frontages, Mid-Century Modern signs and period table/chair combinations. With dozens of these little joints strung out around the area, the pulsing delta of alleyways off Las Ramblas was one of the best sectors for *badar* (the Catalan verb meaning "to walk around awe-struck, eyes wide open, mouth agape"). Here, you could pause for endless coffees and 'bikinis' (toasted sandwiches) or linger under the wrought-iron canopies of the Boqueria market, packed full with 1950s Googie-shaped trader's kiosks. Whole areas looked as though that fabled province Dan Farson's *Soho In The Fifties* had been shipped in brick by brick. Time had not withered them. And, unlike the London I'd recently moved to, where real life Soho was fast fading in the grip of yet another British recession, the locals seemed content for it to remain that way.

Many years before this trip, I'd been led around the markets of provincial northern towns as a child on shopping excursions with my grandmother. These excursions usually ended up in 'classic' style Italian family cafes where, basking in the familial atmosphere (and plied with hefty slabs of buttered toast) my grandmother would tell me about her run-ins with Little Richard, Keith 'n' Mick and The Beatles at the local ballroom where she headed up the catering operations.

The cafes we ended up in seemed to connect with these tales of back-stage glamour: they all looked racily of-the-moment with colours and fittings unlike anything else on the high street. The banquettes alone, in their lush ranges of Technicolor reds and greens, appeared immensely sumptuous. The free-standing chairs and tables, exotic wall coverings and snazzy light fittings seemed deliberately designed to be attractive. It was all utterly un-British.

The visit to Barcelona rekindled many of these memories. Returning to London after the holiday, I'd re-live the nostalgic charge with breakfasts out at a tiny cafe sitting opposite a main gate on Brixton's Brockwell Park (near the then disused 1930s open-air Lido.) The place was perfect: the cafe's powder-blue Formica interior, quaint counter set-up, front parlour layout and generally neglected mien was exactly what I was looking for. It was run by two battling sisters in their 60s and radiated all the slighted charm of a Little England to be found uniquely among the minutiae of smudged walls, scraped vinyl-topped tables and steaming Gaggia machines. Often the room would be empty in the mornings, but the interior awoke such happy memories of Barcelona that I kept visiting for over a decade until it closed, without warning, one afternoon in 1996.

After this discovery, cafes started to come to me. I couldn't walk down a main road or back street without them beckoning from round corners. I could spot the pulse-racing visual cues at 50 feet: old Univers letterfaces, sun-bleached window menus, scurvy curtains, shabby door frames, lolloping hatstands… all clues that further visits might be in order. I started rounding up these strays; gathering material for cod newsletters, never-to-be-made documentaries and, eventually, a website.

To make the grade, there had to be a sustained whiff of the 1950s and 1960s. A waft of early 1970s was acceptable, but only if based on the look of the smart older-style Wimpys. Any places that had fallen prey to KFC or McDonalds-style refits were ruled out automatically. A key indicator: the dread arrangement of red or yellow-orange plastic-moulded seating bolted to floors. An immediate passion-killer.

After dozens of previously invisible locales made themselves known, I came to think of these places as 'classic' in the sense that they retained some or most of their old fittings; evoking a time when the country had seemed somehow to be in better shape, in better spirits. Then I noticed just how much people actively despised them. Once, approaching The Alpino cafe in Chapel Market N1 for a meeting, one acquaintance complained that since much of his poverty-stricken Liverpool childhood had revolved around such spots, he was reluctant to relive the trauma. Others also refused trips out to new discoveries; the decor, food and clientele – the sheer scale of abjuration – making them anxious and depressed.

Yet, increasingly, these were the very qualities I was looking for. The really good cafes seemed doomed by their own isolation; you could sense the melancholy condensing on the windows, as customers watched the world outside, things happening elsewhere. They piqued a lifelong personal fixation with Pinter-esque ambiences of all kinds; triggers I'd previously experienced only in glimpses of bright 1950s architecture in GPO public information films… the start of Sidney Lumet's *The Pawnbroker* as the main Quincy Jones theme ushers Rod Steiger's descent into Harlem… bursts of noodling modernistic background music in episodes of *The Prisoner*…. Now, 1960s lite-jazz motifs welled up every time another foundling site came into view.

For me, the food being served was immaterial. With substandard grub such a long-standing British tradition, you could complain interminably about any amount of food at any number of eateries. The bad food would remain for generations; the cafes themselves – with their cherished fixtures and fittings and their eternal, aching emptiness – were vanishing by the month.

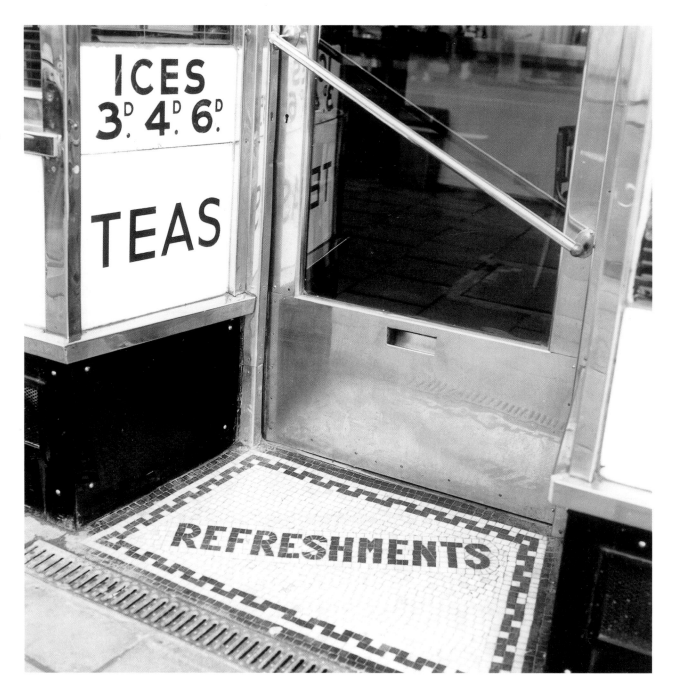

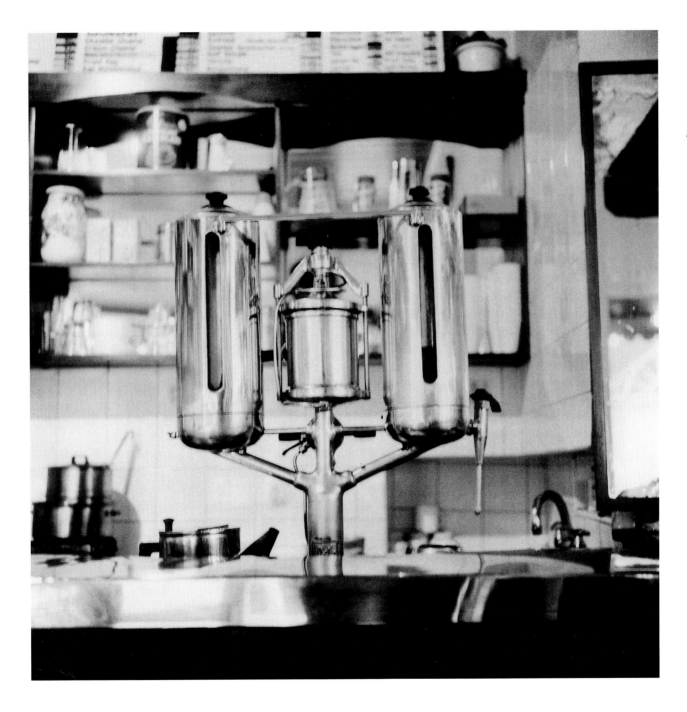

Somehow, the massing of all these signs of abandonment suggested a bigger picture. Like blocks of half-glimpsed Mayan temples subsumed by writhing jungle, these battered old outposts implied some greater context, an altogether different type of civilisation. A cutting back of the cultural undergrowth indicated a direct line from the very first coffee shops of the Restoration through to an almost exact reconstruction exactly three centuries later with the first wave of modern coffee bars in 1953.

And the story of the classic cafe we know today is very much a fable of this reconstruction. A fable seen at its most magically potent in the birthing of British rock 'n' roll: impresario Larry Parnes sharking through a tiro Soho coffee bar scene, cherry-picking baby-boomers like Marty Wilde, Billy Fury and Dicky Proud... Parnes' charm-school grooming feeding directly into the pioneering new medium of TV and the pop show *Oh, Boy* under the aegis of Jack Good. A generation gap forged in the neoteric inferno of popular music, television and the cafes.

Later, I discovered how the Contemporary look in European design had engulfed England after 1951, keying into this Teen Age. It was evident that the cafes were the leftovers of a 1950s Britain that had tried to break away from the mores of Empire England. Here was a Britain keying up to rejoin the modern world after the War. The all too swift failure of the attempt had left a legacy of these cafes – incidental places full of incidental people subject to an incidental music looping slowly through their lives. Suddenly I saw something, beckoning again, just around a corner....

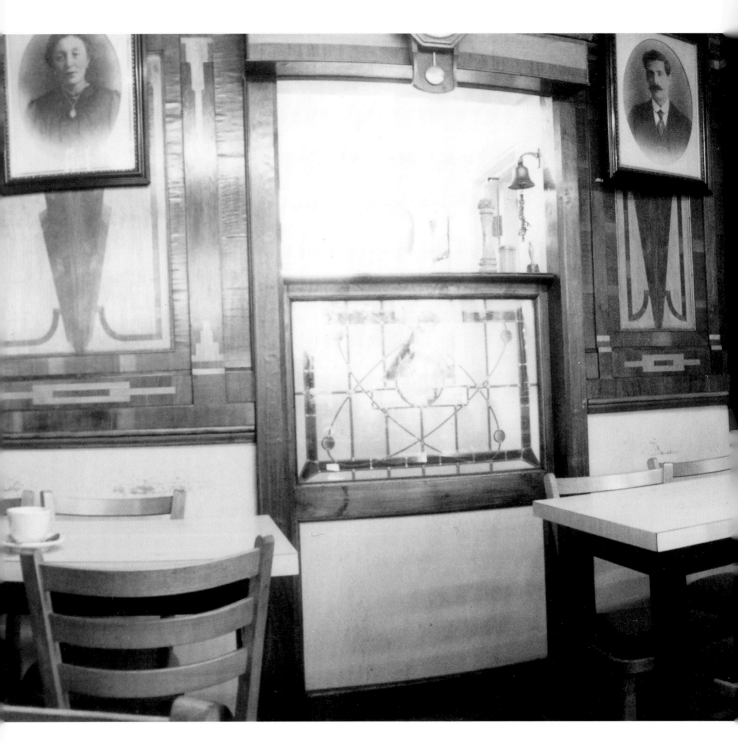

… wherever you look in Soho you will see a restaurant, Trattoria or Coffee House… and bacon and egg cafes… the decor is loud, shiny and tasteless… they are cheap in every sense of the word. The frightening thought about all this is that these are the places of the future….
Frank Norman, *Soho Night & Day*, 1966

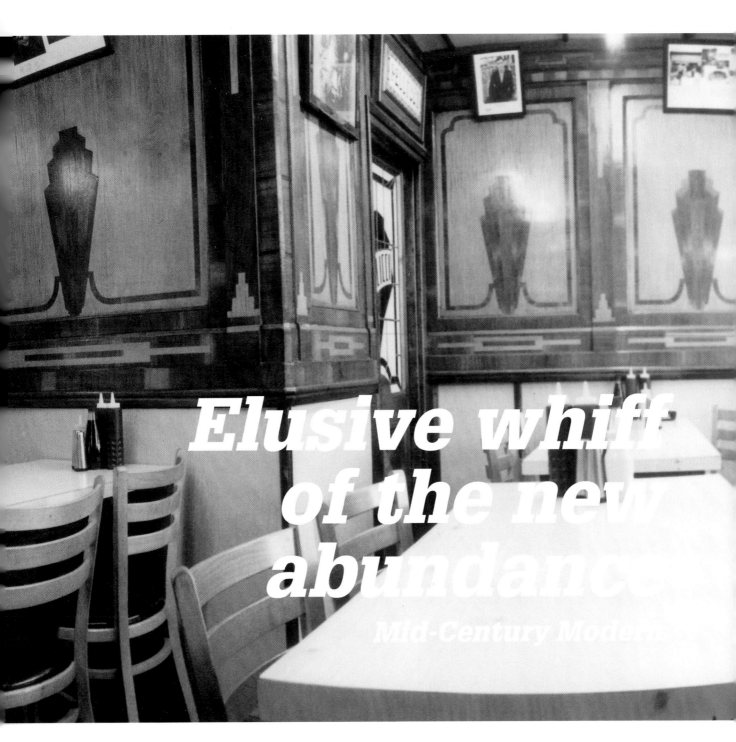

Elusive whiff of the new abundance

Mid-Century Modern

… the young for once, built their world — and the young acclaimed it. When 1950 ended Britain had stood poised between the old world and the new. The Festival of 1951 gave her a playful push, over the threshold, into the Future… a throwing off of the stifling weight of Victorian grandeur… the faded Edwardian red plush….

Harry Hopkins, *The New Look*, **1964**

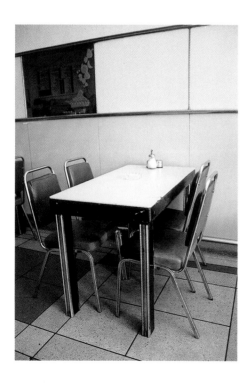

Cultural advance guard

The French café and American diner have both received substantial attention and acclaim, building architectural reputations across books, fanzines and the internet. However, their British equivalents, the classic Italian-run Formica cafes of the 1950s, were never given their due despite their manifest contribution to the (sub)cultural life of Post War Britain.

In his study of Swinging London *Ready, Steady, Go!*, Shawn Levy argues that from 1963-1967 London effectively dictated youth culture to the rest of the world.[1] But this ascendancy can be traced back directly to the activities in the cafes of the 1950s. Within a decade of the first Soho espresso bar, The Moka at 29 Frith Street, being opened in 1953 (a model for classic Formica cafes to come) London became the world's hippest city: a ferment of music, fashion, film, photography, scandal and avant-gardism. The cafes were the creative enclaves where this new order was forged. For a country that had emerged from World War Two economically crippled and, as it seemed, facing the complete collapse of long-held social and political certainties, they became forcing houses for the cultural advance guard coursing through London at the time. Fundamentally un-British environments, they acted as safe-houses where more open European and Americanised lines of debate could spark and flare.

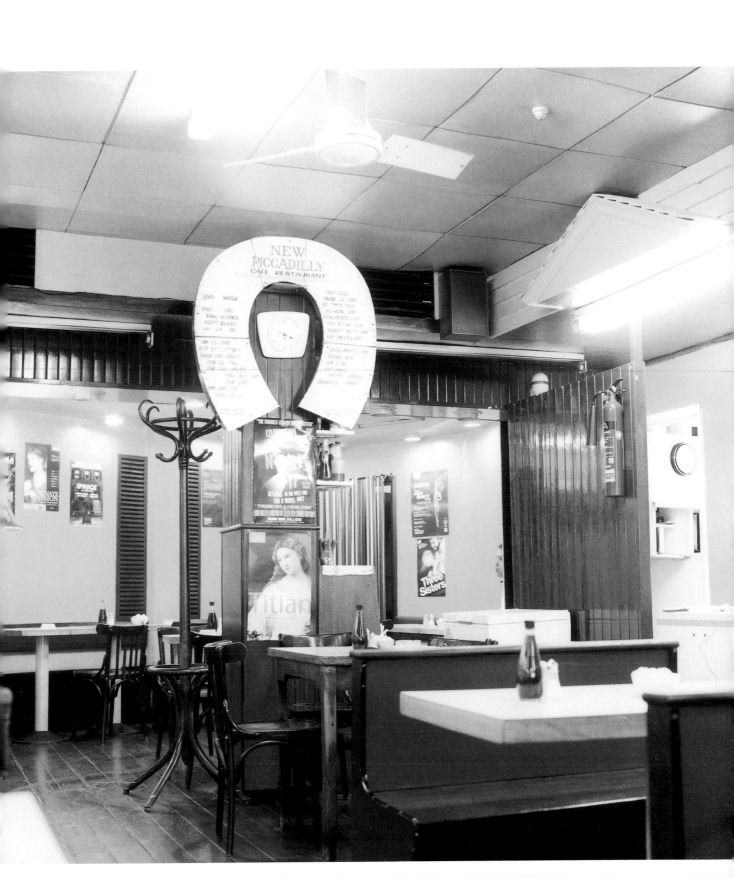

Britain can't have it

Despite its tumult, the six-year stretch of the war years fostered a tremendous sense of optimism; a determination that the evident need to rebuild Britain might also be an opportunity to establish a new nation. As part of this overhaul, the Council of Industrial Design (COID) was established in 1944 to stimulate the regeneration of British industry. With the home market suffering intense competition from American goods, the 1946 *Britain Can Make It Happen* exhibition at The Victoria & Albert museum was set up: "to stage a prestige advertisement before the world of British industry".[2] Over 3,000 manufacturers submitted in excess of 15,000 items for the show. It was dubbed "Britain Can't Have It" by the press: most of the products were for export only.

Undaunted, British enthusiasm for a new era was further stimulated with the 1951 Festival of Britain, a brave attempt to lift Post War spirits, consolidate National identity and "one of the first concerted attempts at modern architecture in Britain this century, a brilliant microcosm in which every single object had

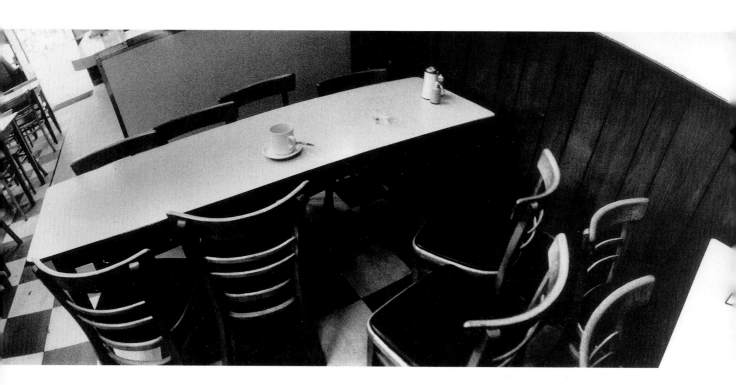

been designed for its job".[3] Amidst the rubble and exhaustion of Post War Britain, the Festival represented a surge of populist hope. Twelve million pounds – at a time of national steel and wood shortages – was spent on the build and eight and a half million visitors came to its pavilions on the South Bank between May and September 1951.

The COID was responsible for the selection of every manufactured product in the exhibition – a total of some 10,000 designs. The Home of the Future exhibit drew the biggest crowds with its clean lines, new electrical appliances and colourful Formica finishes. (The opening of the British Formica factory, also in 1951, saw old wood and oil-cloth covered work-tops throughout the country being replaced with a tide of boomerang-patterned laminates.) Young designers like Terence Conran, only 19 at the time, were able to work without commercial pressure on manufacturing a vision of what the future could be. Referring to the overly "designer" look of the Festival, one wag described it as "all Heal's let loose".

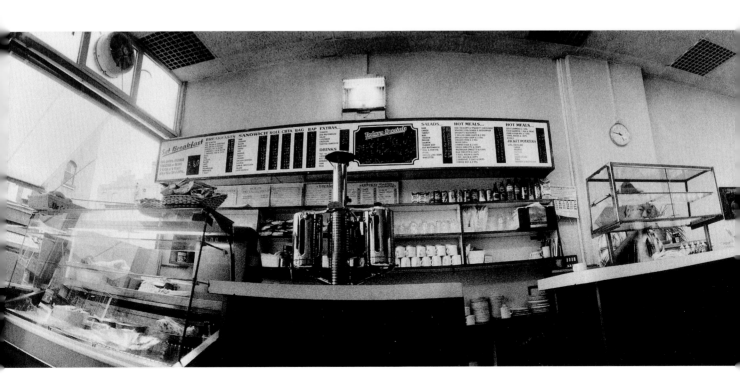

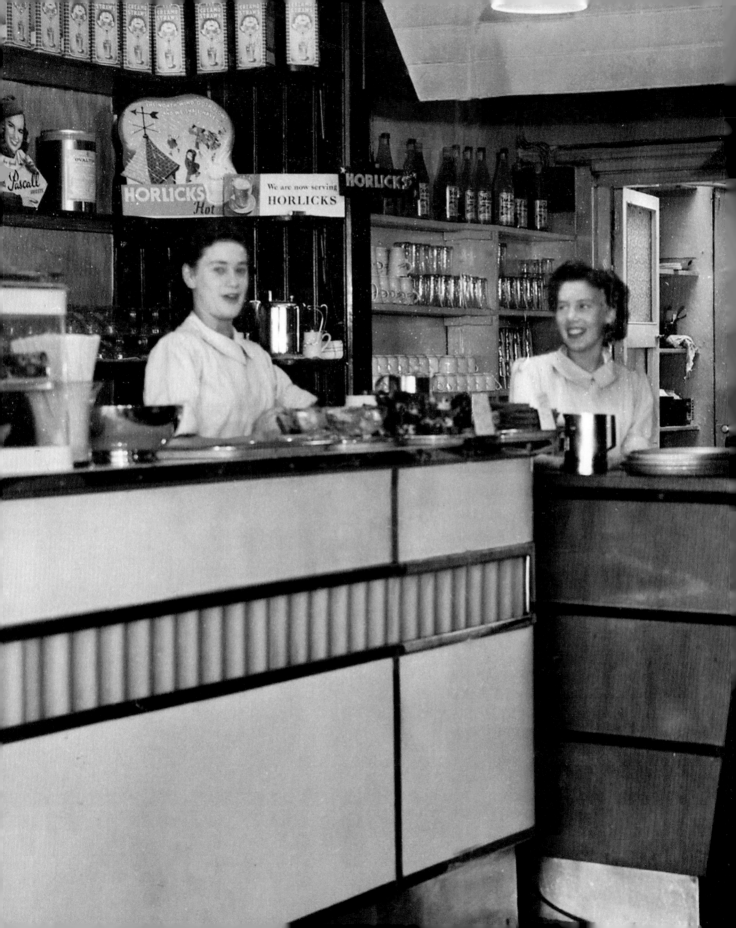

Mid-Century Modern

The privations of the Post War period had meant that factories could produce furnishings and materials of a dismally low standard; customers had little choice but to buy whatever limited ranges were foisted on them. But The Festival of Britain upped the ante. With its proliferation of stark plastic panels, bright walls of glass, precision machined alloys and of-the-moment furnishings, a 'new' architectural idiom, Contemporary, was established.

During the 1930s, British Modernists had battled to convince the authorities, and the general public, that their building theories could resolve Britain's social problems. (Only in 1935 would the ninth Earl De La Warr introduce Modern architecture to a wider public with the building of Serge Chermayeff's Bexhill-on-Sea pavilion.) However, as Post War town planning quickly began to necessitate the provision of large numbers of new functional buildings, a creative door was opened for the British Modernists – by the mid-1950s, 2,500 new schools had been built, and ten entirely new towns were under construction.

Where Le Corbusier and Walter Gropius had been determined to present architecture as a new way of living (Bauhaus functionalists lauded Modernist car and ocean liner design as examples of the vital force that technology could play in people's lives), Contemporary design accented a stripped-down, primary, decorative art. The all-white uniformity of 1930s Moderne styling was displaced by softer-edged shapes and textures. New ranges of fabric, furnishings and building materials deliberately encouraged visual stimulation. Inspiration was taken from the texture and patterning of Scandinavian furniture, stylish Italian light-fittings and melamine tableware. Even linoleum and PVC flooring were set-off by abstract, linear, stylised designs.

An important element of the Festival was the collaboration of architects and designers. The new look they favoured would become especially evident in kitchen interiors and functional commercial spaces, like cafes, as flush finishes, vibrant laminated surfaces and colourful table ceramics became fashionable. Often, colour schemes seemed to be based on the frosted pastel hues common in the old 1930s milk bars – ice cream sundae colours that signified rebellion against the dull palette of the War years. Ironically, seemingly overnight, the high street dominance of these milk bars (and Lyons Corner Houses) was breached as the Post War Italian family cafes moved *en masse* into British high streets. For many, these Mid-Century Modern coffee bars exemplified the zest of the age, appealing to a generation keen to put the priggish strictures of the Edwardian era behind them. In the words of Theo Crosby (Technical Editor of *Architectural Design* magazine) praising the work of 1950s Social Realist photographer Roger Mayne, they: "caught the elusive whiff of the new abundance".

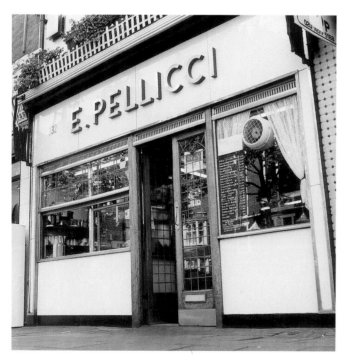

Melancholy and anonymity

The cafe glory years of the 1950s faded as the post-coital cultural tristesse of the late 1960s took hold. From the 1970s onwards, old coffee bars were viewed as unsightly, depressing symbols of a Festival Britain whose internationalist dreams had turned rancid. Eventually, the blanket term "cafe" came to absorb all the different milk bar, espresso bar, proto-Wimpy variants as they whittled down operations to become the basic scuffed restaurants we know today. Those still standing can sometimes happily be found lurking untouched – and often untroubled by custom – off the highways and byways of Britain. Many retain a marooned quality which either dismays or delights punters to the present. But with a little imagination, an inkling of the distinctiveness of their old form and function can still be sensed.

One such orphan architectural outpost, the Tea Rooms in London's Museum Street, is notable for its refraction of two previous centuries of cafe activity: a hint of nineteenth century worker's snack bar; a dash of twentieth century Lyons dining hall. A kind of evanescent EveryCafe, the Tea Rooms hangs on like some skid-row staging post in the 1960s documentary *The London Nobody Knows* (*Mondo Cane* for Cockneys fronted by James Mason: "the gritty historic fabric that was London in the sixties… facets of London life long since forgotten: street markets and their entertainers, residential slums…the toughness of what it was to be homeless… ").[4]

Outside, the Tea Rooms' yellowing exterior signage is offset by a large jolly green Deco typeface hailing from another century. Inside, this magically washed-up parlour-style cafe is decked with wall-to-wall carmine mosaic Formica. Fry ups are prepared on an old war-horse cooker called " The London". A scene that precisely recalls the greasy immanence of William Ratcliffe's 1914 painting *The Coffee House*, which "despite its colourful interior, conveys a characteristic melancholy and anonymity".[5]

The Pinter-esque setting is underscored as the owners – Rina and Eugenio Corsini – attend to their flock from a tiny serving area that steams and spits with chip fat, spilt teas and sauce splatter: he quietly makes over the bread slices; she brightly parries notes and queries from the customers. The regulars rehearse an eternal recurrence of phatic tics: a ponytailed old Beatnik rehashes tabloid scares… two old soldiers keep warm over chunky white mugs and sallies about the weather… streams of postal workers perch on the tiny tannin-proofed benches and glower out of the windows.

Through the thick-rimmed fug of inertia, the reek of a raw kitchen-sink existence, the rankle of lives solidified into defeat, is palpable. The ragged glory of the Tea Rooms is that it so superbly distils decades of British managed decline; the blanching of life from a nation forever making do, always on the mend. A place where the Mid-Century Modern aspirations of Post War Britain wilted; where the lost fervour of an age now stands mouldering, brutally Starbuck-ed by packs of surrounding designer coffee joints.

Despised, dishonoured, antediluvian

Today places like the Tea Rooms are usually dismissed as "greasy spoons" – despised, dishonoured, antediluvian. But these last remaining cafes, with their languishing Mid-Century Modern utility aesthetic (and refreshingly food-indifferent ethos) are actually little gems of British vernacular high street commercial architecture. In an era of inert 'theme' brasseries and fast-breeder American coffee-chains, they preserve a lost poignant quality in British life – a quintessential drabness poised somewhere between the ill-starred aspirations of Billy Liar and the enduring dejection of Tony Hancock. Most are now vanishing in a welter of redevelopment and refits. But once, their of-the-moment design and mass youth appeal galvanised Post War British cultural life and incubated a whole generation of writers, artists, musicians and sexual interlopers.

From 1953, when the espresso invasion of Soho began, these yearning spaces became Britain's crucibles of change leading a social shift away from the crushed 1940s. Cafes nurtured Colin Wilson's new existentialism, the hugely influential skiffle scene, Cliff Richard's teen rock, John Bratby's Kitchen Sink realism, John Deakin's raw photo street-reportage, Colin McInnes' teenage rampages, Gilbert and George's urban iconography…. They also figured large in the personal sexual penetralia broached by Christine Keeler and Quentin Crisp.

The cafes of the 1950s added an impassioned, unaccustomed colour to Britain's Post War social, artistic and commercial scene. Acting as hothouses set apart from pre-War strictures, they were "the first sign that London was emerging from an ice age that had seen little change in its social habits since the end of the First World War. Once the ice began to crack, everything was suddenly up for grabs… "[6] And without them, the unleashing influence of the 1960s might never have been so seismic.

I believe coffee once a week is necessary, and you know very well
that coffee makes us severe, and grave, and philosophical.
Jonathan Swift, letter to Esther (Vanessa) Vanhomrigh, 1722

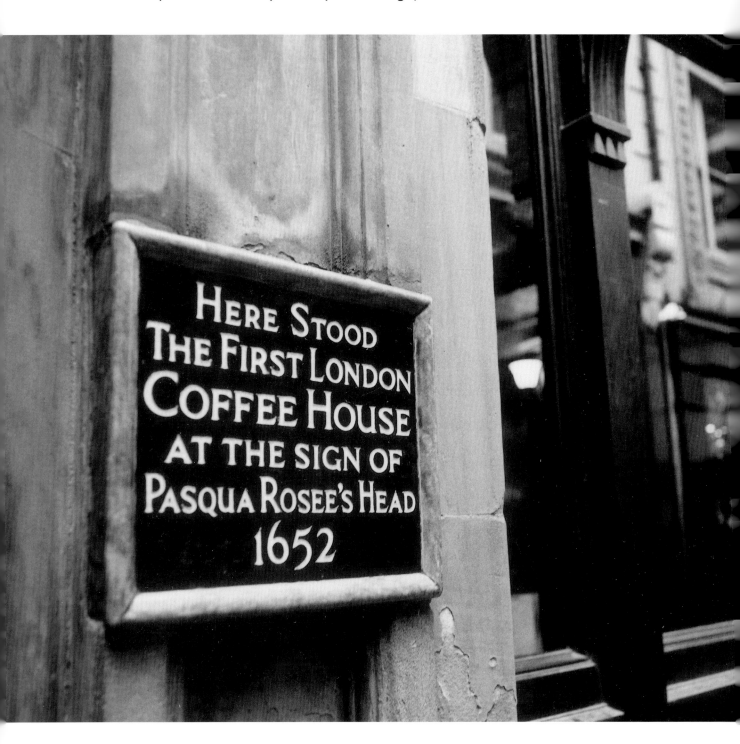

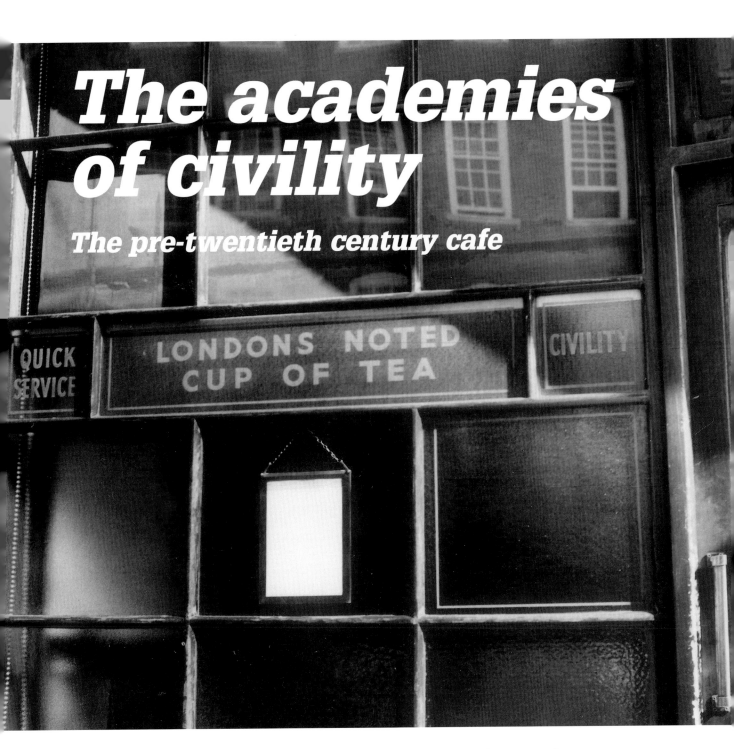

The academies of civility

The pre-twentieth century cafe

QUICK SERVICE

LONDONS NOTED CUP OF TEA

CIVILITY

The room is twisted and narrow so that you must have a care, as you walk, for other people's coffee cups upon small round tables.... Dark hair, dark eyes, sallow-skinned faces everywhere....
Arthur Ransome, *Bohemia in London,* **1907**

The academies of civility

Some three centuries after the first coffee houses appeared in Britain, Aytoun Ellis observed in 1952: "it is interesting to speculate on the increasing popularity of the new Espresso 'coffee houses'… and the possibility that they may in some measure, revive at least one or two of the traditions that characterised the great democratic institutions of the seventeenth and early eighteenth centuries".[1] Ellis was right. The cafes of the 1950s would indeed revive these traditions – and offer up many others.

The precursors to the original coffee houses were the monasteries and inns that had offered hospitality to travellers since the twelfth century. The influx of people into cities to learn trades during the fourteenth century prompted British towns to provide a range of inns to service them and the further expansion of these urban populations during the fifteenth century led to a profusion of 'cook shops' – notably around London's Bread Street and East Cheap – where meal prices were controlled and the public could bring their own pies. The 'ordinaries' – variations on these original cook shops serving meat, poultry, game and pastry – evolved throughout the sixteenth century but with a novel twist: they priced food according to the facilities offered by individual premises. Thus establishing the model for the British taverns that would come to prominence in the nineteenth century.

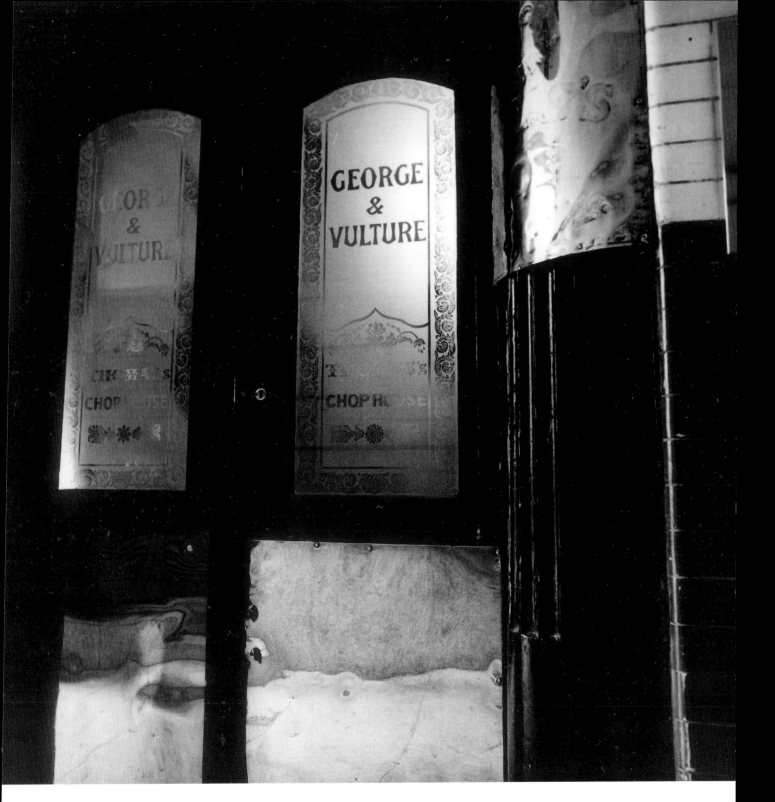

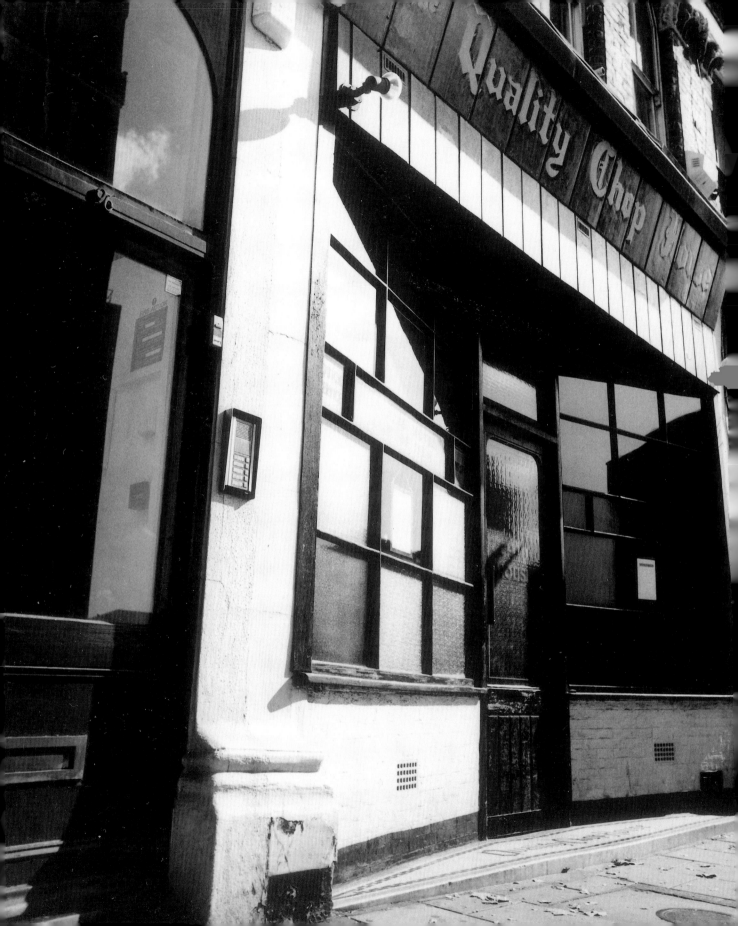

The nursery of temperance

With the prospering of the Mediterranean trade routes, coffee-drinking moved out beyond its Moorish base and into Europe with coffee from the ports of Alexandria and Smyrna first appearing in Venice around 1570. The Arabs used so much coffee that the Christian church denounced it as "the hellish black brew". But Pope Clement VIII baptised it and made it a Christian beverage petitioning: "coffee is so delicious it would be a pity to let the infidels have exclusive use of it". Subsequently, the "first coffee house in Christendom" was established in Oxford in 1650 by a Jew called Jacob at the Angel in the parish of St Peter in the East.[2] Two years later, a Greek servant named Pasqua Rosee began running a coffee shop in St Michael's Alley, Cornhill in the City of London. (The Jamaica Wine House now stands on the site with a commemorative plaque to Rosee.)

A native of western Turkey, Rosee had been brought to London by a merchant named Daniel Edwards. His expertise preparing coffee inspired Edwards to allow him to open London's first coffee house. Rosee's success, coupled with the growth of a leisured middle class and a boom in urban dwelling, saw coffee houses and coffee drinking spread swiftly throughout the city. By 1670 London was teeming with them and by the end of the 1690s there were over 2,000 – all of them brimming with insurance, stock and commodity brokers, hacks, doctors, actors and agents. Baron Carl Ludwig von Pollnitz, visiting London in 1728, believed they had become: "a Sort of Rule with the English… (they) go once a day at least (to coffee houses) where they talk of Business and News, read the Papers, and often look at one another".

Coffee fired debate, and fired the spirit of a Restoration London at the centre of the gentry's

battles against an older, feudal England. Bereft of a monarchy, mid-seventeenth century Britain was rife with previously unthinkable notions like republicanism, democracy and suffrage. Amidst this tumult, coffee houses acted as creative and economic hubs for a merchant class more extensive than that in any other Western country. A class that would oversee the consolidation of commerce with far-flung territories. A class that would build an empire.

Coffee houses became such popular forums that they were dubbed "penny universities" – a penny being the charge for a cup of coffee. Augmented by the developing press, libraries and post offices, they helped establish London's virtual monopoly over news (*The Evening Post* launched in 1706, *The London Journal* in 1723, *The Times* in 1785). *The Coffee House Gazette* commented: "They are the sanctuary of health, the nursery of temperance, the delight of frugality, the academy of civility and the free school of ingenuity." Key players in this social foment included: Will's at Great Russell Street, the best known coffee house of its day, noted for its wits and critics; Garraway's and Child's, located in Change Alley and St Paul's Churchyard, centres for the medical profession, their walls hung round with announcements of "popular pills, drops, lozenges, and dentifrices"; The Grecian, near Will's on Devereux Street, home to philosophers and scholars who went there to discuss the latest meetings of the Royal Society; and the Widow's Coffee House in Islington, overseen by Nell Gwynne, where: "The pint coffee-pots were always ready by the antique and well-filled grate and the famed Islington cakes were arraigned in astonishing numbers along the shelves." Most famous of all, Edward Lloyd's coffee house (opened in 1668 and frequented by merchants and maritime insurance agents) became Lloyd's of London, the best-known insurance company in the world. Other great markets born of the coffee houses, the Stock Exchange and the Baltic, remain in the City of London. (A remnant of Baxter's coffee rooms from 66 Brick Lane – a piece of Delft tiling itself depicting a Restoration coffee house – lies in the collections of The Guildhall from where the City is still administered.)

For essayists of the period like Sir Richard Steele, the accessibility of the coffee house to a wide range of urbanites was vital to the reform of public culture. Today, modern social theorists like Jurgen Habermas, Peter Stallybrass and Richard Sennett, argue that coffee houses structurally transformed the public sphere; creating a nexus of critical gossip, markets and comment. As Isaac D'Israeli noted "The history of Coffee-houses… was that of the manners, the morals, and the politics of a people."[3]

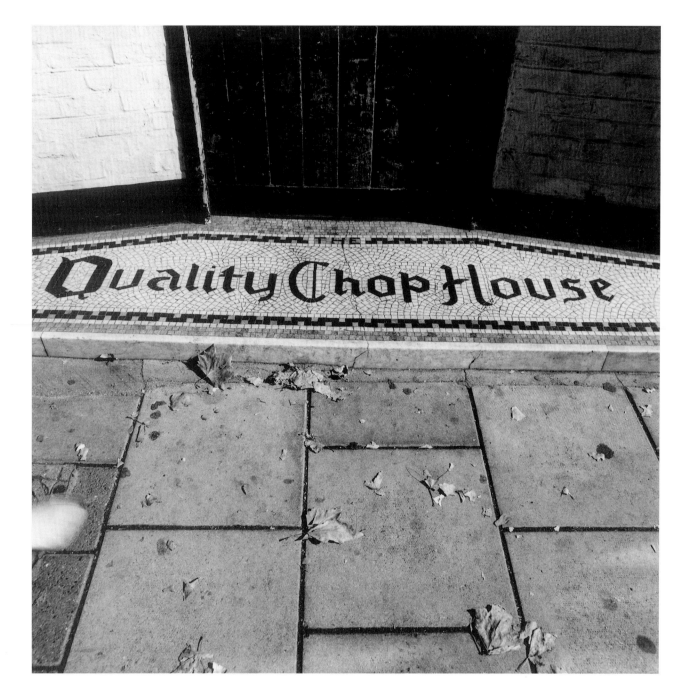

The restorative

From 1652 to 1780, the coffee house was pivotal to London society. Yet by the 1790s they had all but vanished. The rise of the British East India Company had turned the domestic market to tea consumption, and the successes of the Dutch navy in the Pacific had made tea drinking fashionable in the Dutch capital. The first samples reached England between 1652 and 1654 and, as in Holland, the approval of a tea-drinking nobility ensured tea-mania spread rapidly through the nation. But vitally, a newly prolific press, coupled with functioning postal and transport systems, also meant the coffee houses were no longer indispensable meeting places for political and literary debate.

The continental cafés, however, continued to prosper. The art of coffee-making, its processing and blending, became an Italian tradition, an art evident in the splendour of its regal old coffee shops like Caffe Greco in Rome, Pedrocchi in Padua, Michelangelo in Florence and Baratti in Turin. And this traditional base would become important when the vogue for coffee again impacted on the British national consciousness centuries later in the 1950s.

Throughout the late seventeenth century, public attention turned from drink to food. Eateries, now termed "best rooms" and "publick rooms", expanded into central London's Lincoln's Inn Fields, Covent Garden and Haymarket, serving more expensive dishes than the old cook shops. By 1688, over 800 empty and newly built houses in London's Soho district were filled with immigrant French Huguenots who transformed the ground floors into French-style shops and eateries. In his monumental study *London: The Biography*, Peter Ackroyd notes the enduring "atmosphere of freedom and unfamiliarity first created by the Huguenots liberated from the cruelty of

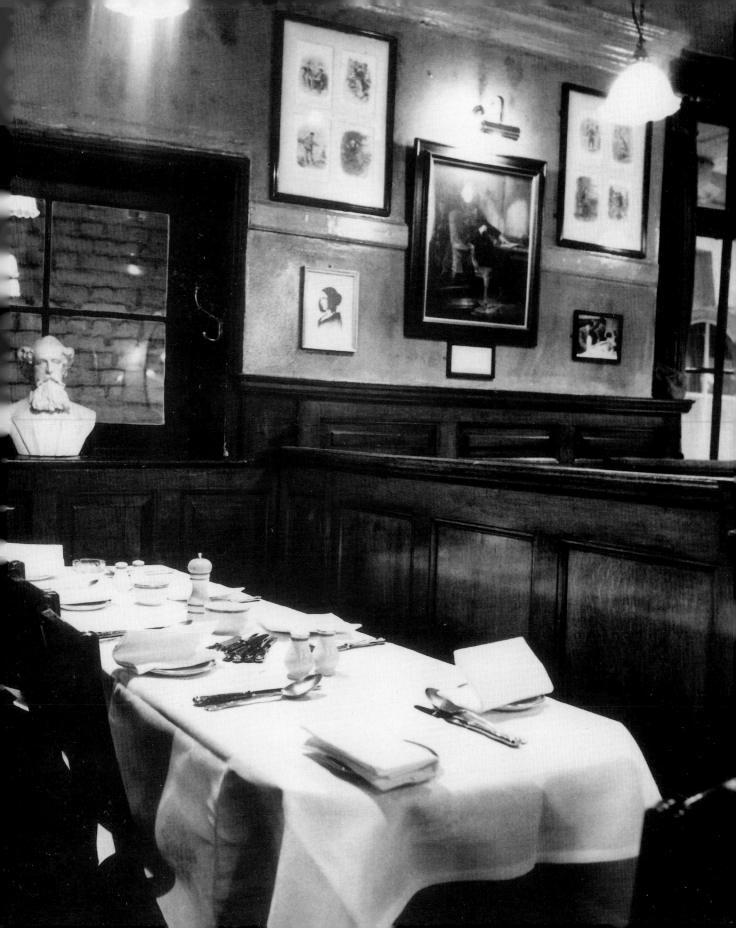

their compatriots". The country would experience a similar sense of liberation with the influx of London's first Italian immigrants some 250 years later.

The coffee houses that had "fought and won the battle for individual freedom… and had given us a standard of prose writing and literary criticism unequalled before or since" had also established a national habit of drinking coffee outside the home.[4] But it was the taverns which introduced the custom of dining out. By the 1790s the British coffee houses had almost disappeared as the tavern-keepers, jealous of their new rivals, rounded on them. Like the inns, taverns provided general lodging and refreshment but also private rooms for drinking, eating, gambling and socialising. In the 1760s, Samuel Johnson and James Boswell regularly dined in Fleet Street's Mitre Tavern with Johnson declaring "… there is nothing which has yet been contrived by man, by which so much happiness is produced as by a good tavern or inn".

Over the course of the eighteenth century, ordinaries, best rooms, publick rooms and coffee houses started to convert to beef houses, chop houses and taverns, offering plain fare at agreeable prices and aiming themselves squarely at the merchant and upper classes. Boswell frequented Clifton's chop house, near the Temple, and Dolly's steak house in Paternoster Row "… a warm, comfortable, large room, where a number of people are sitting at table. You take whatever place you find empty; call for what you like, which you get well and cleverly dressed. You may either chat or not as you like. Nobody minds you, and you pay very reasonably."

Several buildings from this time can still be visited in London. The Quality Chop House on Farringdon Road EC1 was established in the late 1800s as a "progressive working class caterer". Now an upscale restaurant, it retains many original fittings: the restored pews still prompt complaints about "bum-numbing booths" and the beautifully etched windows still bear the legend "London's noted cup of tea". The George and Vulture, the world's oldest tavern (also once home to Charles Dickens and gatherings of the Hellfire Club), survives in a part-seventeenth century building at Castle Court EC3 built on the site of a medieval coaching inn. Chops and steaks are still cooked on an impressive early nineteenth century range in the dining room. The Jerusalem Tavern at Britton Street EC1 dates back to the fourteenth century. Originally a workshop for watch and clock craftsmen, the current frontage was added around 1810. The tavern had links with Samuel Johnson, William Hogarth, Oliver Goldsmith, David Garrick and Handel. Simpsons at Ball Court EC3 is another surviving eighteenth century tavern (now a restaurant), though the interior is a modern reproduction.

As comforting as beer

Uniquely for the times, the taverns concentrated on the quality of food being served. Impressed French visitors were keen to launch taverns in their own country but it was only after the strict culinary guild system was broken in France in 1765 (over a case involving the selling of 'unauthorised ragouts') that this became possible. And so the English tavern started a culinary revolution. Initially, in the mid-1700s, French establishments known as *bouillons* sold a thin soup of meat and vegetables called "restaurants" (from the French *restaurer* – "restorative", "restore to a former state"). Eventually, this soup became so well known that taverns serving the dish themselves came to be called restaurants. By 1886, the English-type taverns which had been popular in Paris died out and this new generation of restaurants – the word had by then come generally to mean an "eating house" – took hold.[5]

Throughout the nineteenth century most taverns gradually turned into restaurants but in 1802 another term was coined: "café". Originating from the French "café" and the Italian "caffe" ("coffee" or "coffee-house") it was first used to describe a basic restaurant serving coffee. (By 1839 "cafeteria" was also coined from Mexican-Spanish to indicate a coffee-store.) Despite these culinary advances in Europe, the English working classes remained largely ensconced in public houses. In an attempt to divert them from alcohol, the temperance movement of the 1880s revived the old coffee houses. "Coffee taverns", one pamphlet stated, "must show there are beverages as comforting as beer, that there are beverages to be bought as cheap as beer." Working men were encouraged to bring their own food to be cooked free of charge in the tavern's kitchen and customers were encouraged to remain as long as they wanted.

As so often through the centuries, the institution would reinvent itself many times over. Some coffee houses survived into the nineteenth century as "workers' cafes" serving basic meals of chops, kidneys, tea and eggs to labourers and porters. Others, "early breakfast houses", sold mostly coffee and bacon. Philanthropist Charles Booth, founder of the Salvation Army, described one of these rough coffee houses in the East End, as being full of "loaves of bread, flitches of bacon, a quantity of butter, two tea-urns… three beer pumps… and a glass jar filled with pickled onions".

In turn, these workers' cafes were largely supplanted by the new dining halls, restaurants and Tea Rooms – some of which survived into the mid-1960s: The Leadenhall Tea Room & Billiards Salon in Lime Street, a "vast subterranean arena which hasn't changed one iota since 1880… one of the weirdest sights in England"; the Cafe Bar, Frith Street (as immortalised in George Scott Moncrieff's eponymous novel of 1932), "one of the most out-of-this-world places in town… an old wooden horseshoe bar with stools… served by very old foreign-speaking men in white aprons. Curious Pete and Dud conversations take place among the older customers… "; the St Gothard Cafe Fulham Road: "the only Victorian cafe in Chelsea which has survived in its original state… gas brackets, low glass-panelled partitions around the marble tables, Art Nouveau vases and cruets… " and The Imperial Russell Square, "a sort of nouveau art Cathedral… very old people indeed are to be seen here, some of them staring at each other across the vast expanse of room through powerful binoculars".[6]

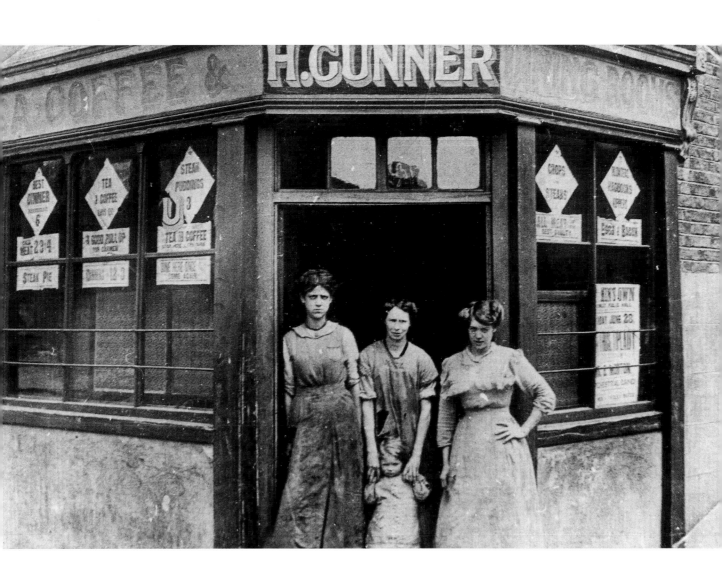

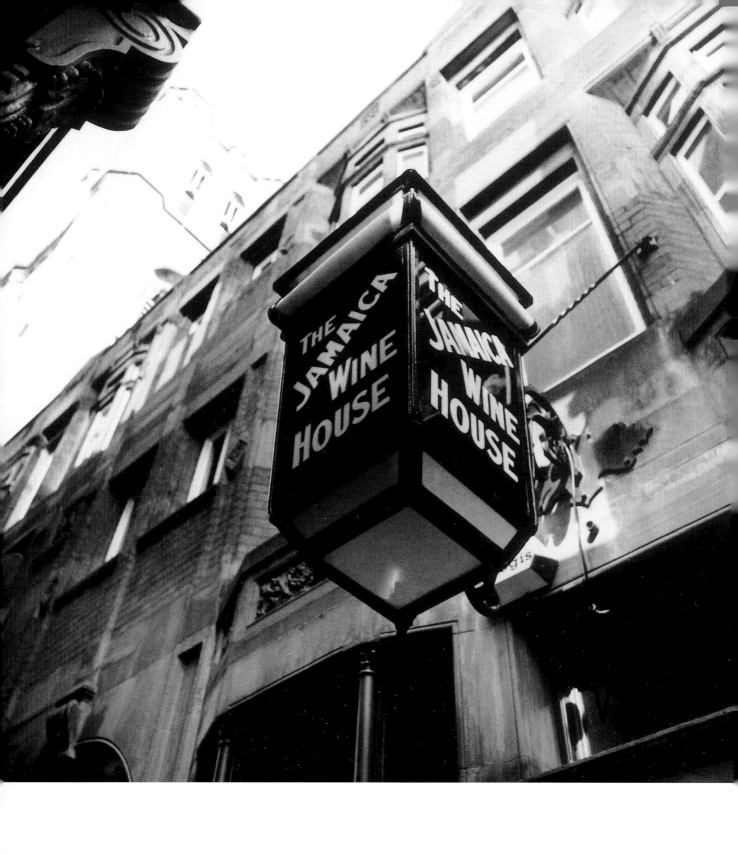

Peculiarly un-English

From the seventeenth century on, Soho had become London's 'cosmopolis' as Greek refugees fleeing from Ottoman rule, French Huguenots escaping persecution and Jews emigrating from Eastern Europe all sank roots in the area. Here, some of the old workers' cafes managed to stand their ground, run mainly by Arabs, Turks, Greeks and Sicilians. Cultivating a slightly wayward clientele, they became linked in the public imagination with 'foreigners', stray 'bohemians' and the late nineteenth century art crowd. In the opening chapter of his memoir *Bohemia in London*, written in 1907, Arthur Ransome presents a cast of these low-lifers flitting between artists' studios in Chelsea, Fleet Street taverns and Soho coffee houses. A typical concern, The Moorish Café, is described as: "a small green painted shop with a window full of coffee cups and pots and strainers…. The room is twisted and narrow so that you must have a care, as you walk, for other people's coffee cups upon small round tables…. Dark hair, dark eyes, sallow-skinned faces everywhere… ".[7]

As these 'bohemian cafes' became popular, their decor began to change. The benches and heavy oblong tables of the older Victorian establishments were replaced by small round tables and dark polished walnut bentwood chairs. Based on Michael Thonet's 1859 Vienna Café chair No. 14 (a staple of Vienna's vibrant café society) it would later enter the modern design pantheon when it was included in Le Corbusier's L'Esprit Nouveau exhibit at the Paris Esposition Internationale des Arts Decoratifs et Industriels Modernes of 1925 (the birthplace of what would later become known as Art Deco). The exhibit presented the modern home as a stark centre of efficiency with metal filing cabinets, industrial equipment and commercial furniture. It greatly influenced the modern movement and by 1930 more than 50 million Vienna Café chairs had been produced. Today, they continue to sell in their thousands throughout Europe and remain an enduring feature of classic cafes all over Britain.

Alongside the modernist seating, Soho's bohemian cafes also began to lay on more elaborate facilities to draw the punters. Mahogany-coloured horseshoe, or lemon-shaped bars where coffee, tea and sandwiches would be served became popular. By the 1920s, there were so many of these places that Alec Waugh noted "Soho is the city's foreign quarter, and there is a quality peculiarly un-English in the life that seethes and shudders about this dozen acres or so of streets."[8]

The new age of the classic cafe was about to begin.

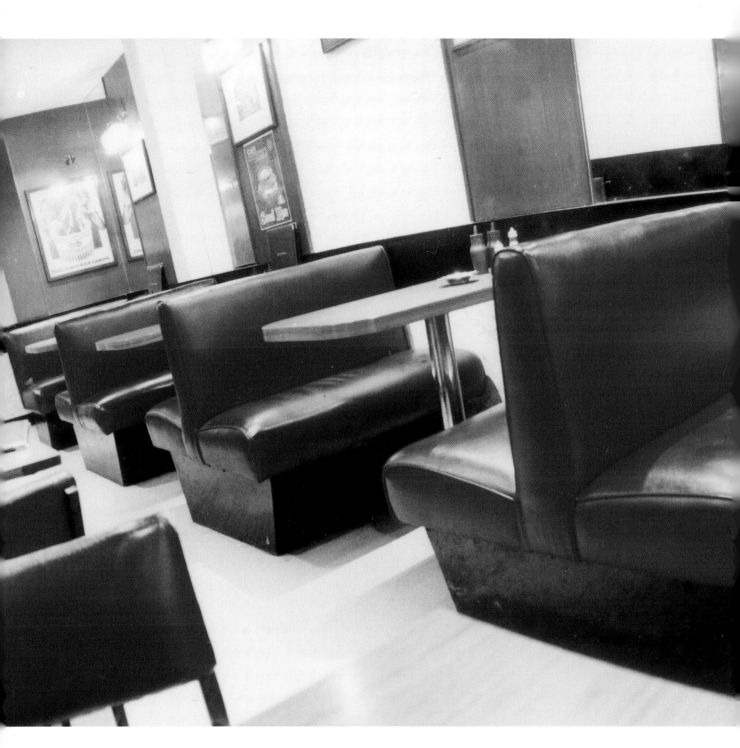

There is a very good Greek Cypriot place… up the Liverpool Road…. Georgiou's place has a steep flight of wooden steps down to it from the street, covered by an awning, and the outside walls have a vitrilite crazy mosaic all over them, shiny pastel colours and black…. And we talk, talk, talk, talk, talk. As though it could make some difference.

B S Johnson, *Albert Angelo*, 1964

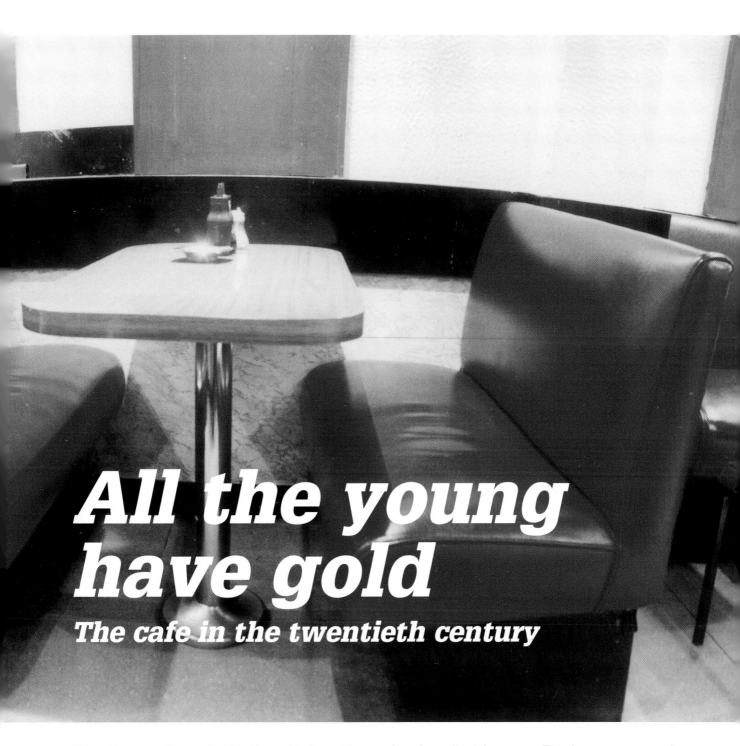

All the young have gold

The cafe in the twentieth century

The café was small, a workers' café, used by lorry drivers and road-mending labourers…. The place was warm and it was cosy with the smells of cooking and the feeling that the place was so often full of humanity…. The huge chromium tea-container rose gleaming from the counter…. Outside the main road hummed and roared with traffic….
John Bratby, *Breakdown*, 1960

Packeted provision

The coffee houses of the mid-seventeenth century played a key role in the development of an ambitious empire-building class. Their efforts would make Britain the dominant industrialised nation of the eighteenth century and, by the nineteenth century, a global power overseeing an empire with an extensive trading base in tea, sugar and coffee. A century later, new kinds of coffee houses (and a similarly ambitious, culturally active class) would also assert themselves; reforging England as the world's hippest nation via the surging creative industries of television, advertising, photography, music, theatre, art, literature and music.

In the late 1950s, one of these players, an upcoming young British actor called Terence Stamp, was taken to supper in London's West End. The experience overwhelmed him: "the Seven Stars Restaurant on the first floor of the Lyons Corner House in Coventry Street… was the most splendid place I'd ever been to and it gave me my first glimpse into that night world where I imagined movie stars shone after dark…. I understood how those English must have felt when spices first arrived from the East".[1]

A remarkably durable institution for much of the century, the Lyons Corner Houses had grown out of the fashionable tea and cake trade of 1870s. With a subsequent upsurge in the trade, the first Lyons Tea Shop was established at 213 Piccadilly in 1894 and by 1900 there were 250 across the country. Building on this success, the first Lyons Corner House was launched in 1909 in Coventry Street London. These Corner Houses, often seating up to 3,000 customers, were cafes built on a grand scale with vast regal interiors. Plugging into the growth of cinemas after the First World War, Lyons aimed to set up branches to attract movie audiences in every town centre, providing hygienic, congenial and affordable places of rest accessible to the mass of working people.

The Lyons Corner Houses and the British milk bars of the 1930s defined the look of cafes for decades to come. Designed along the lines of their Antipodean and American counterparts, milk bars were often fitted into redeveloped Victorian or Edwardian buildings with intimate individual booths and a bar running the length of the room. The first one in the UK was set up in 1935 in Fleet Street by an Australian, Hugh D McIntosh. Within a year there were 420 throughout Britain with this number trebling into the 1940s.

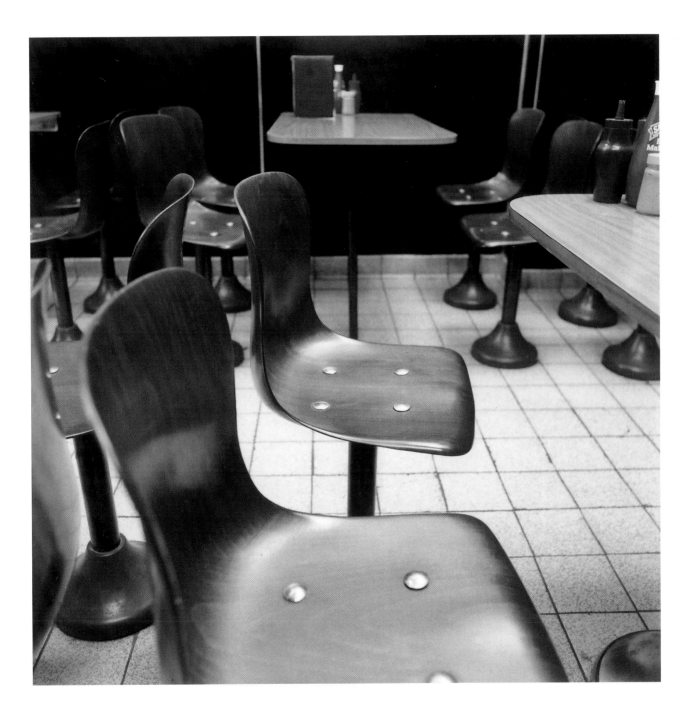

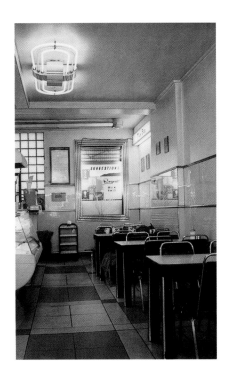

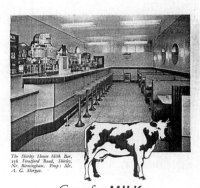

The Shirley House Milk Bar,
156 Stratford Road, Shirley,
Nr. Birmingham, Prop: Mr.
A. G. Morgan.

Cows for **MILK**
Gaskell & Chambers for **BARS**

G. & C. are at your service for a single dispenser or a complete milk bar,
including all furnishings and equipment.
The illustration shows a typical G. & C. installation with counter top and front
in Formica relieved by Australian Walnut—backfitting with Formica-faced top,
peach tinted mirrors—stainless steel footrail and tubular stools—alcove seating
in walnut upholstered with leathercloth and Formica-topped tables—wall
surface to dado faced in Formica and capped in walnut to match counter.
Milk bar service equipment includes cafe set, refrigerated milk storage and
ice cream conservators, stainless steel milk pump. Non-Drip Syrup and
Squash Dispensers.

BRITAIN'S BIGGEST BAR FITTERS **Gaskell Chambers**

*Head Office: Dalex Works, Coleshill Street, Birmingham, 4. Non-Drip Measure Company
Ltd., Ellison Works, Danbrook Road, Streatham, London, S.W.16.*

Streamlined Moderne styling figured large in these commercial interiors. A period ad mat for The Shirley House Milk Bar near Birmingham (built by Gaskell and Chambers "Britain's biggest bar fitters") boasts a range of finishes: "counter top and front in Formica relieved by Australian Walnut – backfitting with Formica-faced top, peach tinted mirrors… stainless steel footrail and tubular stools… alcove seating in walnut upholstered with leathercloth…. Milk bar service equipment includes cafe set, refrigerated milk storage and ice cream conservators, stainless steel milk pump. Non-Drip Syrup and Squash Dispenser".

As resins, metal alloys and laminates entered the design vocabulary for the first time, a popular new material called "Vitrolite" became *de rigeur* for fitting out milk bars. Often used to modernise older buildings, this coloured glass could be easily moulded, laminated and illuminated. It was particularly well suited to covering walls that needed regular cleaning and expensive-to-replace marble counter tops. Large panels of coloured Vitrolite often decorated milk bars, but the glossy style drew fire from an older generation concerned with the new mass culture of "canned entertainment" and "packeted provision" was providing little more than an unvaried diet of sensation: "the milk bars indicate at once, in the nastiness of their modernistic knick-knacks, their glaring showiness, an aesthetic breakdown… "[2]

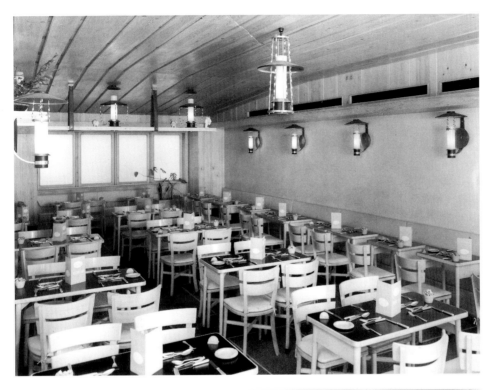

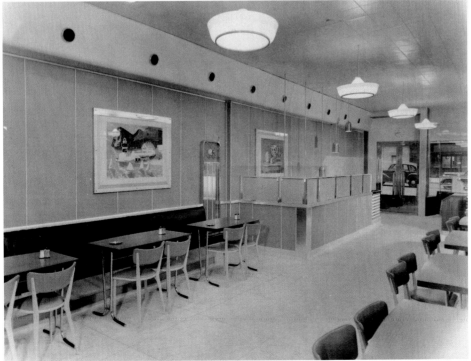

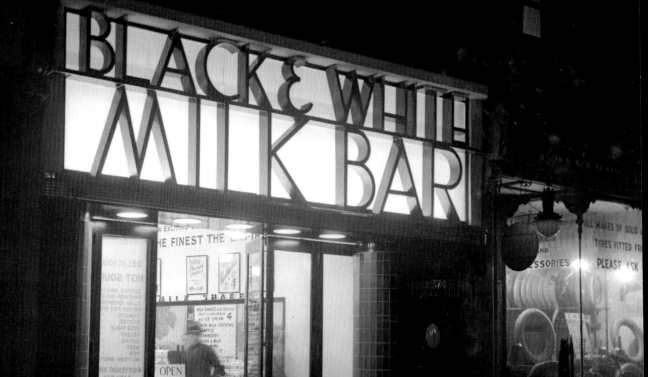

The Black & White

The most famous of London's Vitrolite milk bars were the Black & White chain. (Harold Pinter's *The Black and White* stage monologue of 1954 later immortalised the cafes.) The Pentonville Road N1 outpost designed by Sir John Brown and A E Henson in the late 1930s was handsomely "faced with black tiles with a surface of matt glaze. The main lettering is of wood faced with chromium plate and stands out in silhouette against a background of ribbed opal glass which is lighted from behind. The floor is of black and white tiles, and the ceiling enamelled…."[3] Follow-on models of the 1940s, like the celebrated Moo Cow in Victoria SW1, Richard Levin, upped the ante: "Walls, counters and tables throughout are surfaced with Warerite laminated plastics…. Three gay murals by Eleanor Esmonde White, depicting perambulatory scenes in the Royal Parks occupy the left-hand wall…. original water colours incorporated during the manufacturing process as a permanent part of the plastics panel… ".[4] (Miraculously, the much loved Regent Milk Bar on London's Edgware Road W2 with its jaunty mint-green Vitrolite interior, survived intact right to the summer of 2002.)

Later, the Kardomah cafe chains would profitably build on the milk bars' custom and – to some extent – their styling. Starting out as simple tea and cake operations in Paris in the early 1900s, by the 1950s, Kardomah branches like those in Birmingham's Colmore Row, London's Knightsbridge and Manchester's Market Street (all designed by architects Misha Black and Walter Landauer) boasted luxury ocean-liner panelling, swish modernist signage, designer door handles and massive external illuminated signs. A look characterised by "… gun-metal mirrored glass and flashed opal backed letters… solid teak… Honduras mahogany… red leather… buff tiles… ".[5]

The Kardomahs borrowed liberally from sophisticated New York retail design of the 1930s: shops like Mangel's, Adam Hats and Ray's Dresses. A branch in Swansea, Wales became immortalised when Dylan Thomas left school to work for the South Wales Daily Post but spent most of his time loafing round the cafe with various friends instead. London virtuoso Geoffrey Fletcher particularly revered one splendid example in London's Eastcheap where: "The stairs themselves had dark brown verticals of wood – a design by Vosey – filled in with lozenge glass of red, yellow, and green. From it, one could survey the mosaic-lined cafe, an interior that was completely art nouveau… above the shelf-like dado, at intervals along the frieze, were huge surprising bosses of burnished copper… a vintage production pierced with heart shaped holes."[6] This blatant stage-setting – all deep entrances, display case windows, sweeping curved walls and open plan floors (as can be seen in the Kardomah scenes in David Lean's *Brief Encounter*) – was a trait that would impact on the next generation of cafes as the 1950s unfolded.

Monkey parades

The early twentieth century light-refreshment trade was largely shared between the milk bars, the Lyons Houses, the Kardomahs and the ABCs (the Aereated Bread Company, started in 1864 at London Bridge.) But all these tea-oriented institutions lost ground when the espresso bars flooded the country's high streets after the Second World War.

Though Lyons Corner Houses and Fullers Tea Rooms were among the only places serving teas or pre-cappuccino powder coffees, the affluent youth market found them impossibly old fashioned and unattractive. A young Alberto Pagano newly arrived from Rome at the time to run his mother in law's trattoria in Soho, remembers: "The Lyons House in Piccadilly was huge but it wasn't pretty. It was worse than a canteen: Formica tables, simple lamps with lamp shades, vinyl floors. No service. You just got a cup of tea or instant coffee. It was more of a place for the coach visitors who came to see London shows."[7]

By way of a reaction against the fustiness of Lyons and Fullers, highly distinctive coffee bars started opening all over London between 1953 and 1956. They actively encouraged teens to hang around talking and drinking and signalled a clear break with the established cafe trade. The Lyons Corner Houses (by this time huge buildings often housing a variety of themed restaurants) hit back, opening 11 specialised outlets offering cheaper priced food in more individual surroundings; cafes like the Grill and Cheese and the Bacon & Egg. But the most successful of all the Lyons teen-market ventures were the Wimpy Bar franchises hired from Eddie Gold in Chicago. The first Wimpy opened in 1954 and were introduced into special sections of the Corner Houses. By 1969 there were 460 Wimpy cafes in the UK and eight in Oxford Street alone. Wimpy Managing

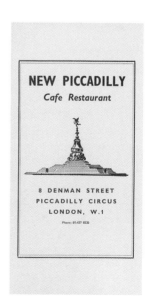

NEW PICCADILLY
Cafe Restaurant

8 DENMAN STREET
PICCADILLY CIRCUS
LONDON, W.1

Phone: 01-437 8530

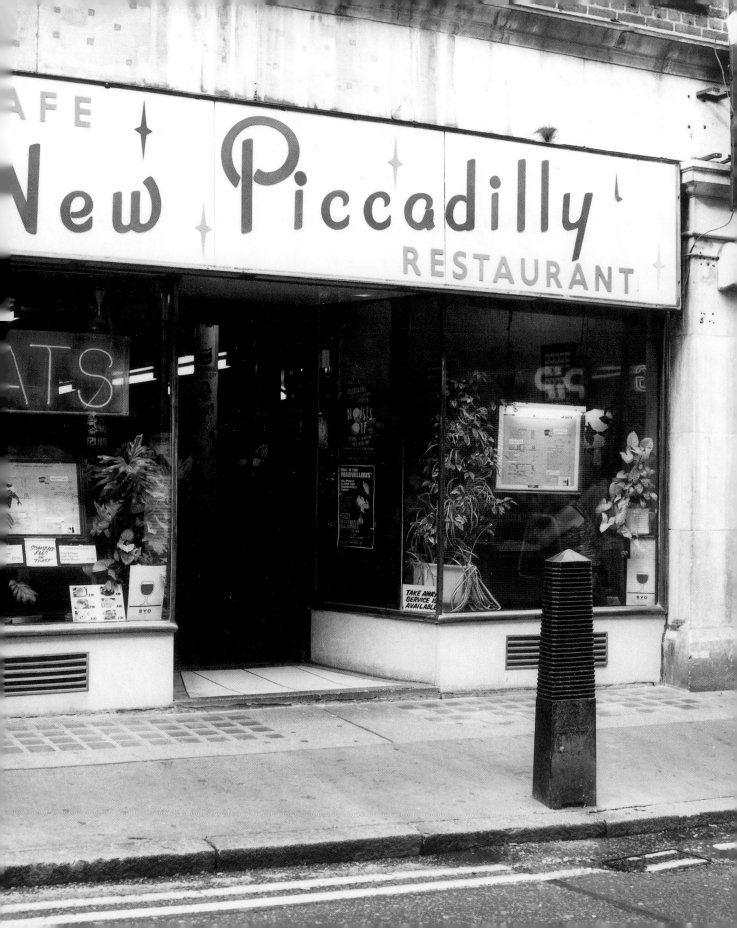

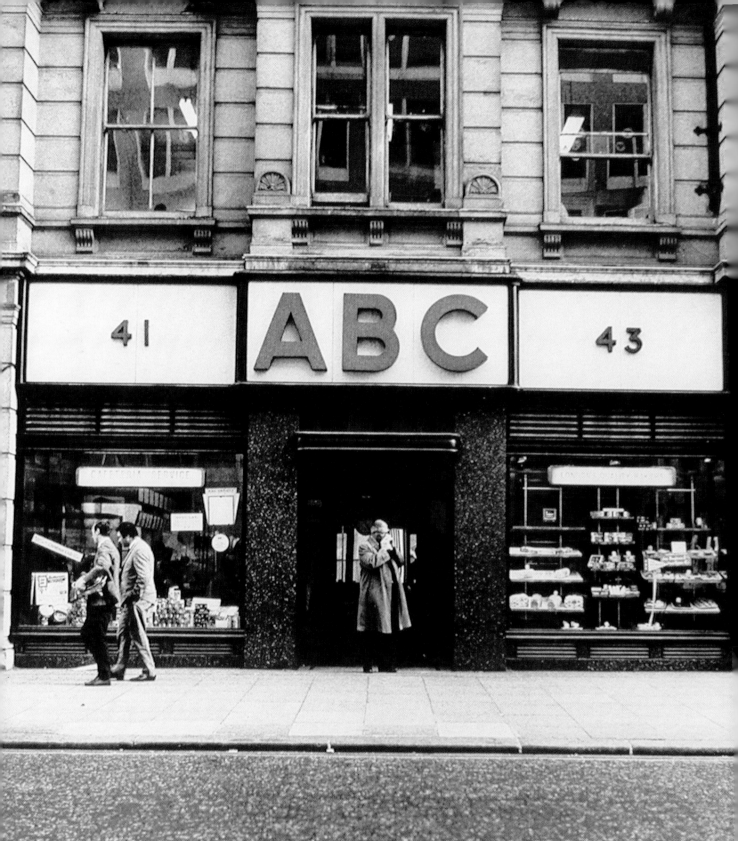

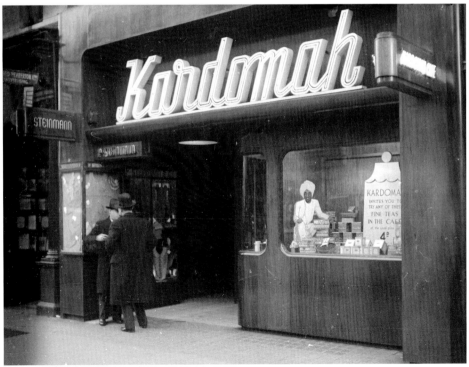

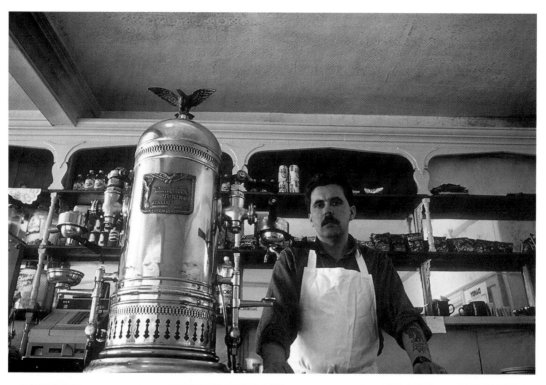

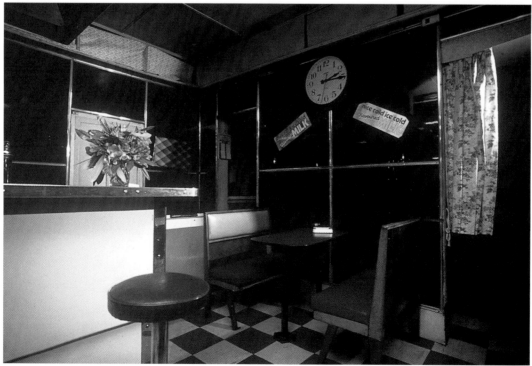

Director David Acheson put their immediate success down to: "people who weren't used to eating out… [Wimpy was] a social meeting place… it was cheerful… and plastic… a lot more fun than sitting at home with the parents in front of black and white TV".[8]

One group of parents and children, however, were inured to this emergent generation gap and were in fact able to exploit it: the close knit Italian immigrant families mostly hailing from the Italian valleys of Taro and Ceno who first settled in South Wales and then London's Hatton Garden and Saffron Hill areas.

Impoverished Italian communities had established themselves in Britain throughout the nineteenth century and by 1871 some 240 had settled in Wales alone. (The owner of Dante's cafe in Duke Street W1 remembered a relative walking across Europe to get to Wales, financing his voyage by playing a small accordion.)

When the Bracchi family opened, arguably, the first Welsh-Italian cafe in Newport in the 1880s they laid the foundation for an Italian cafe trade that would flourish throughout the country over the next half century. As news of the boom in the Welsh coal fields of the time (particularly the Taf, Cynon, Rhymni and Rhondda valleys) filtered back to Italy from the first settlers, so hundreds more Italians came over from Bardi to set up cafes and ice cream parlours:

> the Italian has a strong built-in urge to be his own master…. Soon the cafes were proliferating. In the nineteen twenties there was scarcely a village in the valleys of South Wales which did not have its own Italian cafe… three, four or even five, sometimes in one street, and the numbers continued to grow until the Second World War.[9]

These businesses often thrived in the mining communities because of the hostility of the Welsh temperance movement to the local pubs. Playing to this, cafes labelled themselves "temperance bars" and subsequently became popular with teenagers keen to socialise away from the chapels they'd been schooled in. Cafes like The Express in Abertillery often attracted queues of kids – referred to locally as "monkey parades" – who would wait to grab the best backroom tables for dates. Each year, a coach party from South Wales still travels to Bardi in Italy's Chino valley full of the relatives of the Welsh-Italian families who set up these establishments.

Layabouts and lotus petals

By 1911 the number of Italian immigrants in London had reached some 12,000.[10] Those Italians moving to Little Italy before the First World War had established their own organ-building, mosaic-laying, ice cream-making and goldfish-importing trades. After having built up their own networks of cafes, restaurants and clubs there, a mass exodus from the area began as more and more residential accommodation was demolished to make way for warehouses. With this drift westward, Soho effectively became London's new Italian quarter. And gradually the Italians started to take over from the French population as Soho's main denizens.

Italy had been Britain's ally in First World War, but by the 1940s Italians were being interned in Britain. Lorenzo Marioni, whose late father, Pietro, founded The New Piccadilly cafe in 1951 remembers the Soho of his youth: "The whole place was a mixture of Italians, Greeks, Jews, Maltese and Irish…. Those Irish boys beat the crap out of me… only a few years previously, we were the enemy. We were the Eyeties, and all of us Italian kids were getting hammered."[11]

With their homeland wracked by poverty after the War, many Italians worked on British farms then migrated into the towns. With their background in catering, these new families were able to key into the boom in fast-food and informal eating-out sparked by the opening of the first sandwich bar, Sandy's, in Oxendon Street in 1933. Eventually, the Italians came to dominate the cafe trade. Coffee bars and cafes run by Italians mushroomed, often patronised by the twentieth century counterparts of Arthur Ransome's nineteenth century bohemians. One of these, Quentin Crisp, recalling a meeting in one of his favourite haunts the As-You-Like-It Coffee Bar in Monmouth Street, termed them

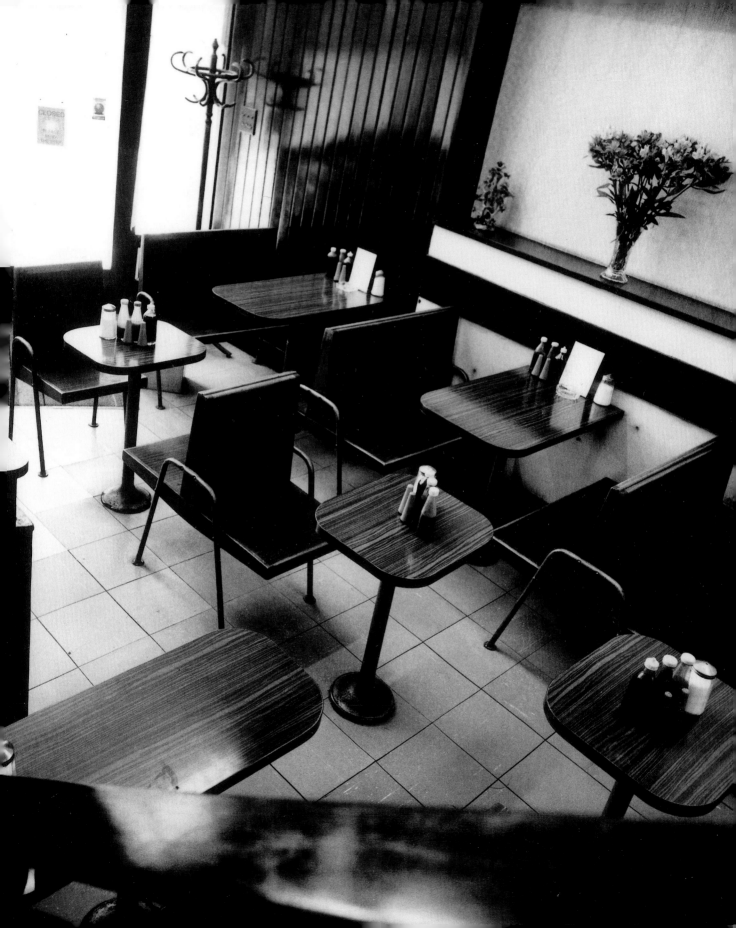

"layabout cafes": "those marvellous places where you could sit through lunch and tea and supper without ordering anything more than one cup of coffee… establishment[s] where several times a week, either accompanied or alone, I sat for hours eating lotus petals".[12]

The seeding of the high street with the first generation of classic cafes had begun, all of them following a common build: little Formica tables, lino flooring, Pyrex cups, juke boxes, a central area for dancing and, crucial to the whole enterprise, espresso machines. These had been invented when Luigi Bezzera acquired a 1906 patent for a machine that forced boiling water and steam through coffee into cups. By 1927 the first La Pavoni espresso machine (designed by master Italian architect Gio Ponti) had been installed in the USA, just as American prohibition had sent coffee sales rocketing. Gaggia altered the basic build in 1945, creating a high-pressure extraction with a thick layer of crema and by 1946 the term "cappuccino" had been coined in deference to the colour of the robes of the Capuchin monks. The unique selling point of the classic cafe was born. (Cafe owner Rick Valoti remembers his father Vic's Sorrento cafe in Soho being one of the first places in London to import an espresso machine, the Universal, a four-handled machine costing nearly 1,000 pounds: a huge sum for the time.)

As late as 1942, restaurant meals in Britain were restricted to one main course with a maximum charge of five shillings. But with the importation of Gaggia espresso machines to Britain in 1952 and the ending of wartime rationing in 1954 (the last restriction to go being the limit of 1s 2d per person per week on meat) a new world opened up.

The first Post War coffee house launched in London's Northumberland Street in July 1952. By 1953 espresso bars sprang up all over Soho where there was already a captive foreign population ready to appreciate the new beverage (Catherine Uttley lists 200 Espresso Bars in 1957's *Where To Eat In London*). The phenomenon owed little to the existing catering trade. Owners tended to be outsiders – architects, antique dealers, wine merchants, interior decorators, sculptors, dentists and film stars – intent on creating a new type of modern cafe with good coffee, cheap food and attractive decor.[13] Adults had pubs and Lyons Corner Houses, but there was nowhere that the newly-identified 'teenager' could feel particularly comfortable; despite four million of them taking home a record-breaking wage of around eight pounds per week by 1958. Britain's coffee bars stepped into this vast gap in the catering market, and the pay-off was substantial: "all the young have gold. Earning good wages, and living for little… the kids have more 'spending money' than any other age group of the population… armed with strength and booty, against all 'squares'".[14]

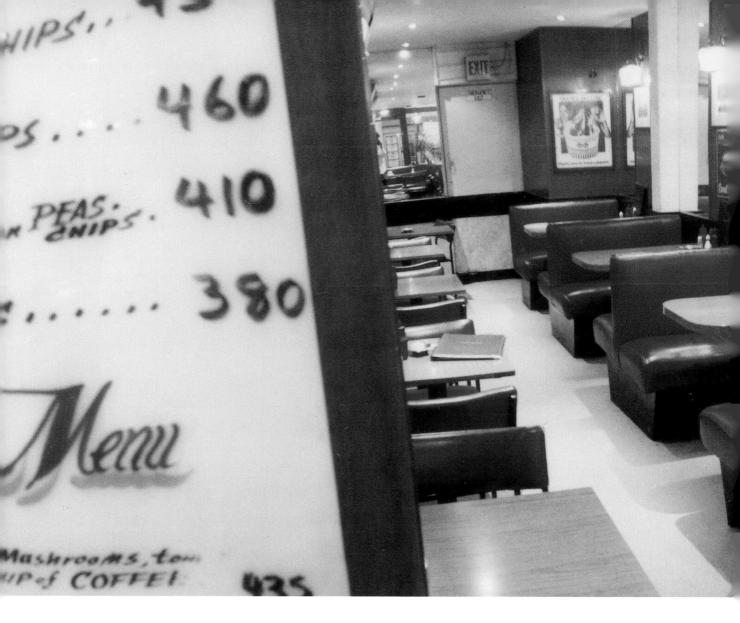

Shoe shop modern

After the travails of the Post War economy, the coffee bars' striking Mid-Century Modern look signalled a cultural revolution. Terence Conran maintained that coffee was to the 1950s what cannabis became for the 1960s and from 1957 to 1960 the number of coffee bars doubled from 1,000 to 2,000 in Britain, with 500 in Greater London alone.[15] Customers were carefully considered before laying out each premises. With their reputation for eye-popping design and a youthful clientele, the coffee bars drew on Festival of Britain design to actively attract youngsters with angular chairs, Formica tables, artful lighting, multi-coloured ceilings and bold door signs.

Some dismissed the form as simple 'shoe shop modern' – in homage to Morris Lapidus'

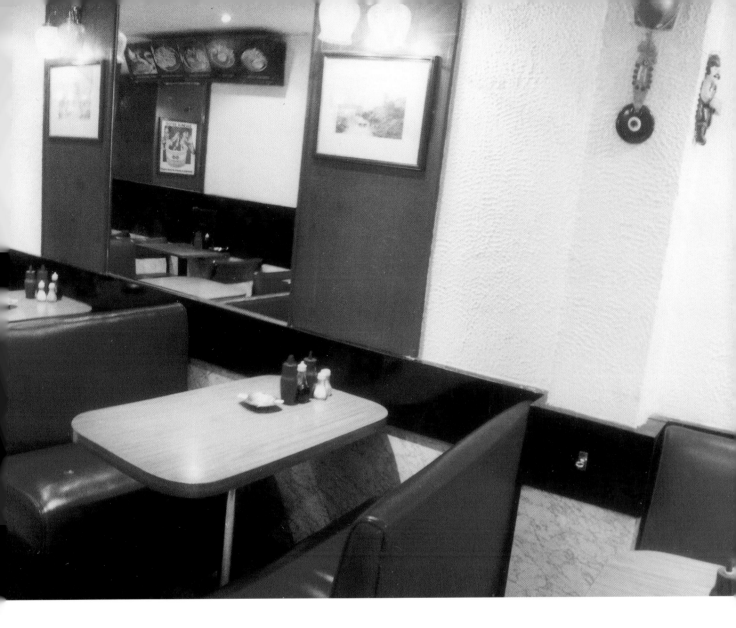

revolutionary New York stores like London Character Shoes, 1931, and National Shoes, 1946.[16] Certainly Lapidus' lavish retail-scapes of plane glass, serried lights, smart fascias and slatted timbers reveal a similar penchant for clarity, sharpness and linearity that would often percolate into cafe design.[17] But places like ``The Bamboo, Moka-Ris, Gondola, Arabica, Mocambo and La Ronde with their singular

"romantic, tropical, titillating… slightly raffish" interiors launched their own new look on the high streets throughout Britain.[18] A look so seductive that one concerned observer in 1954 fretted: "Their slinky, snaky continentalism is sliding into the British way of life… encountering head-on the bluff, plain Englishry of our Red Lions and White Harts…."[19]

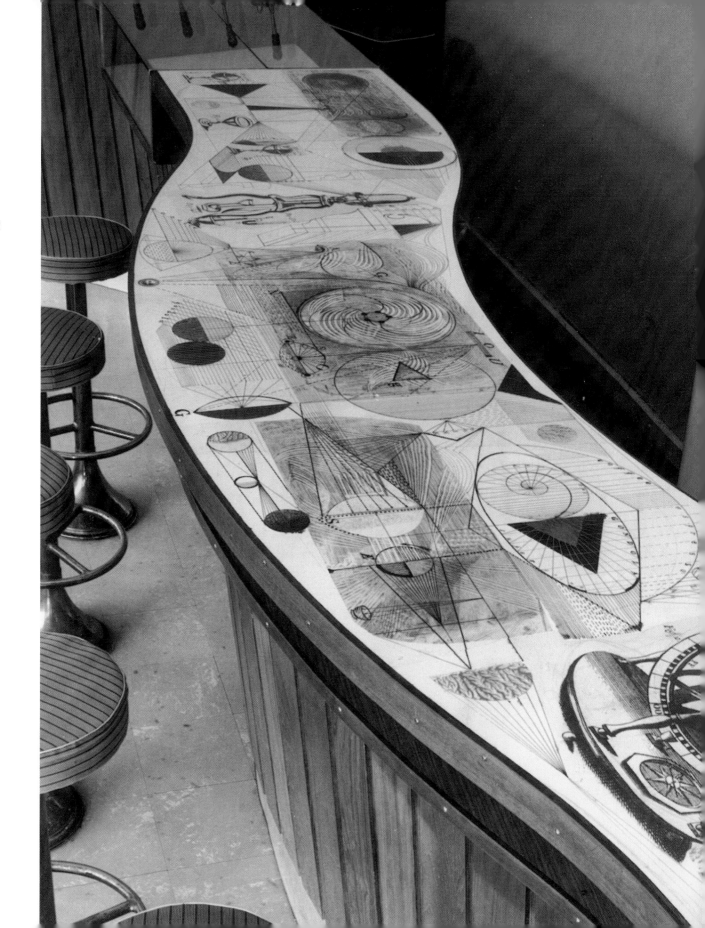

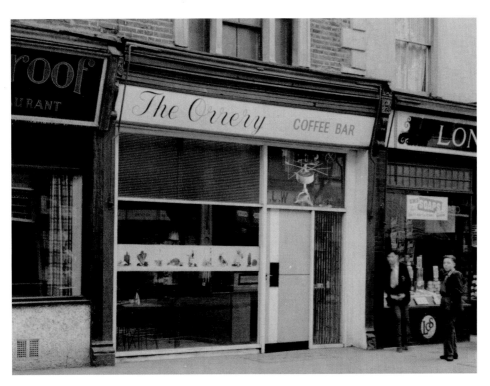

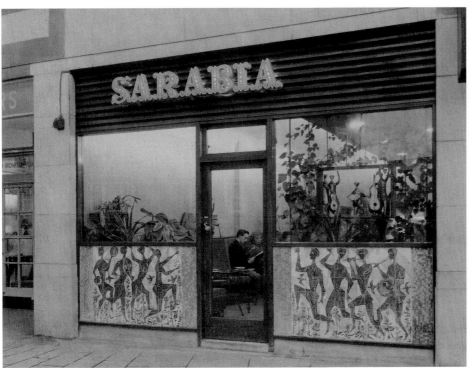

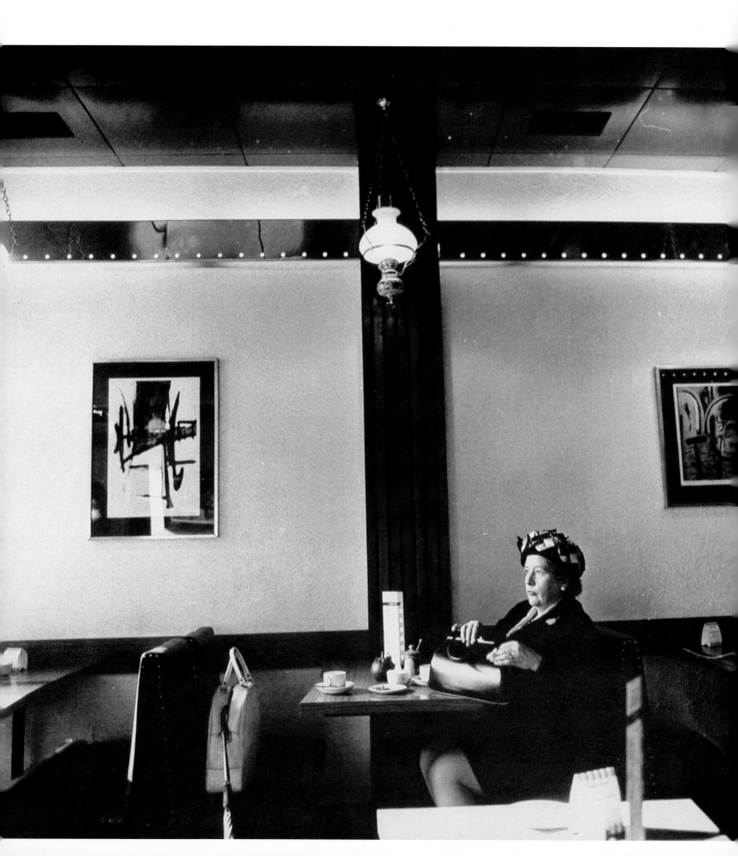

Hidebound by class and etiquette

In 1953, bluff plain Englishry came up against the full force of the American beefburger anschluss when the first Wimpy ("the square meal in the round bun") was served at Wimbledon. A burger-abetted generation developed apace, as London's birthrate accelerated and the first wave of Teds and Mods culturally conspired to escape the dolour of Post War London. Buoyed by the recovery of the country and a rampant hunger for Americana across the board, the coffee bars and Wimpys seen in almost every town centre in the country became a base for a younger generation trying to break with the class restrictions and pub-based social life of their parents. These cafes attracted all forms of jazzers, nouveau existentialists, nascent rock 'n' rollers, beatnik baby boomers, 'Piccadilly exquisites', CND activists and a whole new Post War set of On-The-Roaders: "Serving Italian-style espresso coffee, and providing a juke box and regular live music... these coffee bars, many of which stayed open virtually all night, acquired a powerful mystique as oases of alternative culture in London."[20]

Teenagers now made up ten per cent of the population and 25 per cent of all consumer expenditure. Newspaper cartoons ran pictures of British beatniks lolling round coffee bars as the youthquake of the Absolute Beginners generation rumbled round Britain. There was a pervasive "sense of London as a successful and enthusiastic community, miraculously reassembled after the war... (and) an ill-defined unease, especially among the younger population."[21]

The scene was set for a creative renaissance as diverse art, literary, musical, and sexual subcultures thrived in the burgeoning cafe communities. A decade later, London would be transformed by the activities of this coffee bar generation into the world centre of fashion, design, music, photography, publishing, modelling and advertising. These cultural industries reforged the city and gave the nation as a whole a new sense of identity. The faded glories of the old British Empire had been laid firmly to rest. In the words of Nottingham coffee bar regular author and journalist Ray Gosling: "when we were out on our own, drinking coffee, we could do what we wanted... we wanted a new world, where you weren't hidebound by class and etiquette....
We wanted to kick the old world of afternoon tea and school dinners... into touch. And we did."[22]

El Cubano Brompton Road, Kensington… cosmopolitan staffing… modern decor… two glamorous girls sitting at a counter…. "Imagination is the keynote" states the narrator as he points out a hole in the wall which is part of the modern design… a new type of cafe society is growing up in Britain.

Pathé Newsreel, *Coffee House*, **1955**

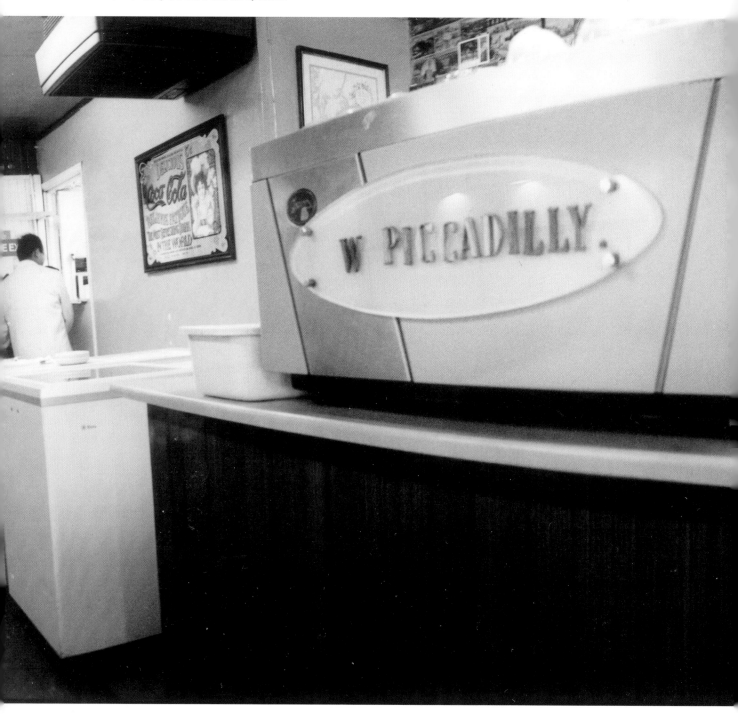

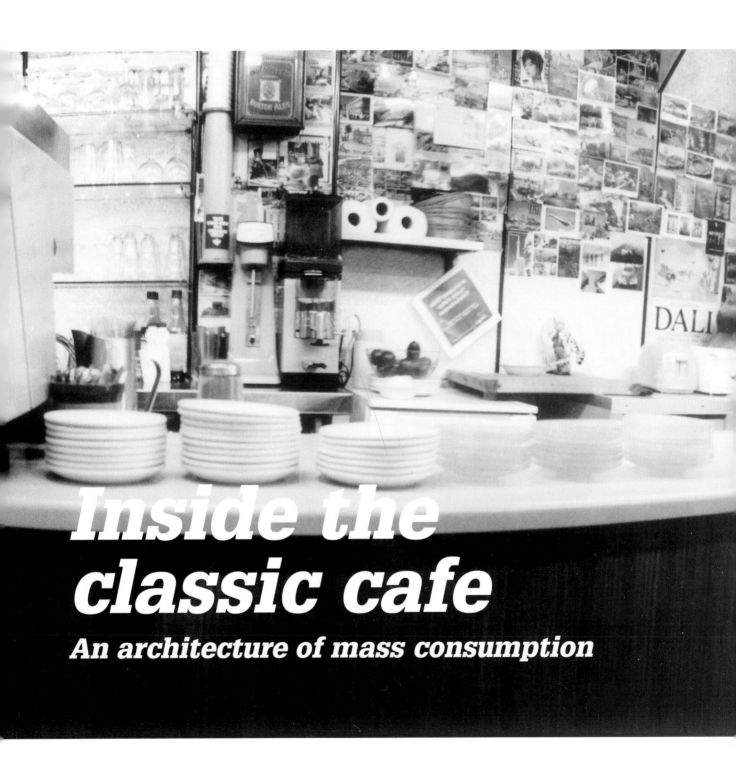

Inside the classic cafe

An architecture of mass consumption

… the most calculated and astonishingly successful exercise in the new 'un-
Englishness' was the espresso bar… which arrived from Italy in the mid-Fifties…
and put a high polish on the contemporary veneer of international sophistication….
Harry Hopkins, *The New Look*, **1964**

A visual and nutritional desert

Although often criticised as "one of the dimmest decades in our architectural history", the 1950s Festival of Britain had marked the end of a modernism characterised by functionalism and monumentality and the beginning of "a period of lighter-spirited, more variegated architecture and design".[1] The advent of the 1950s saw the rebuilding of London, and Festival-style, thriving alongside the emergent Post War consumer culture, spread through the country influencing shop and exhibition design, lighting, lettering, airports, pubs and… coffee bars.

For a previous generation, the Lyons Corner Houses (with their uniformed 'Nippy' waitresses) had symbolised the glory years of the 1930s. But come the end of the Second World War, designers regarded them as: "a kind of visual and nutritional desert somewhere between the works canteen and the Ritz".[2]

With their dazzling Gaggia machines, the design and ambience of the coffee bars, (like that of the milk bars before them) was bracingly innovative – and a rebuke to the Lyons empire. The early ones, characterised by a quirkiness and humour that appealed to a young audience, owed little to the existing catering outlets. By the winter of 1957 there were over 1,000 of them – all sporting the cardinal Contemporary Scandinavian elements of open-plan furniture and curvilinear fittings: "Before long the plywood and laminates of the benches, chairs and bars had been fused to a film of coloured plastic to create Formica. Leatherette in Mondrian primary colours added to the vibrancy of the style."[3] Author Howard Jacobson remembers the energy they brought to the high streets: "growing up in 50s Britain, poised between war and peace, between poverty and prosperity… We were undernourished…. Small, ill-fed, ill-formed, ill-favoured… when the first Italians opened up a coffee bar on Oxford Road in the centre of Manchester circa 1958… it changed our lives… a superabundance of physical vitality and colour…. "[4]

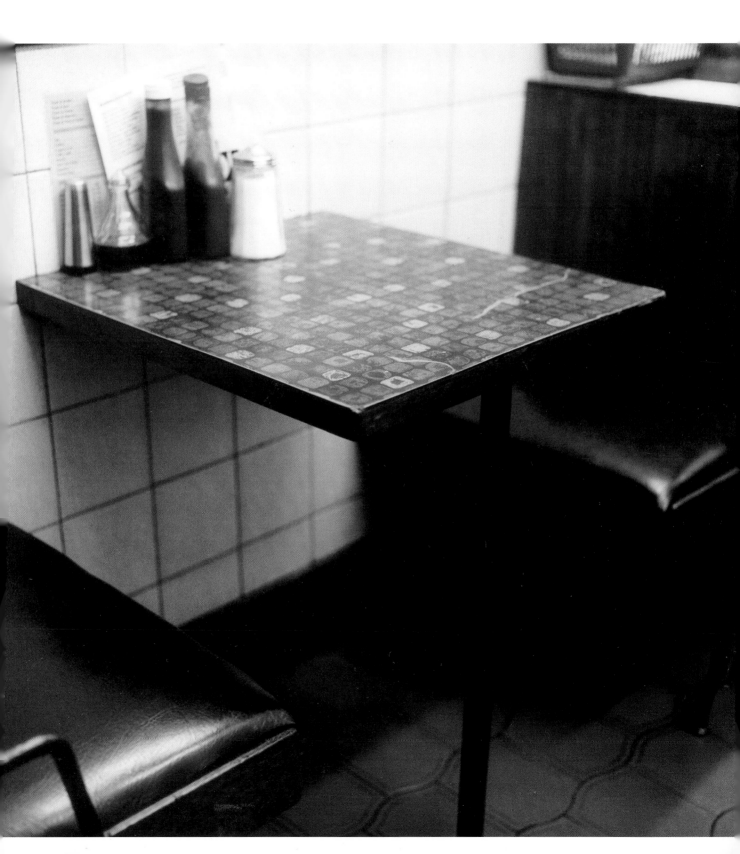

80

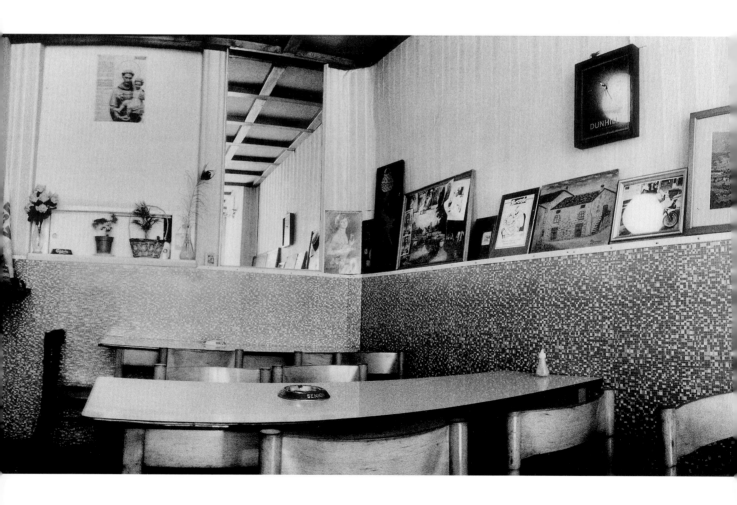

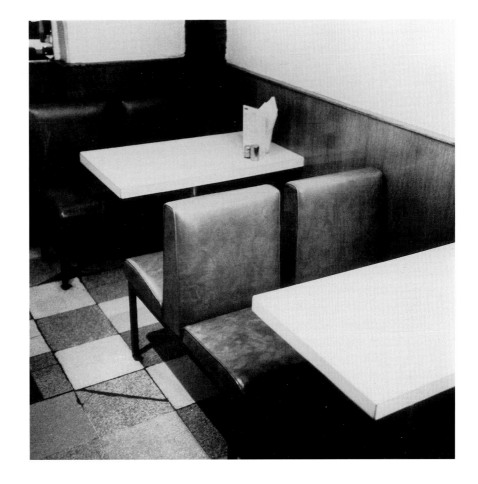

The whole modish gamut

Most coffee bar premises were initially built for other purposes, necessitating much masking of original features and clever exploitation of awkward spaces. Refits often required that ceilings be lowered, cornices be hidden or staircases be screened. Following the Festival of Britain's lead, coffee bar designers took wood, plastics, glass and fabrics and creatively combined them so that everything from litter baskets and signboards through to conical metal lampshades seemed new. Sudden contrasts of colour and texture became *de rigeur*: walls were stripped to the brickwork; papers simulated stone walls; polished surfaces were matched against rough.

Captions accompanying fashionable cafe magazine spreads of the day caught the mood of breathless welcome: "You can find the whole modish gamut of contemporary seating in London's coffee bars…. Laminated plastics for the counter-tops… anything goes from padded leather to handpainted tiles. Note, too, the varied shapes of the counters from straight to staggered to serpentine…. "[5] Reviews of new premises pored over ranges of fixtures and fittings: Cafe Konditorei boasted: "Sapele Alufloor wood mosaic flooring provided by Jos Ebner Ltd… rubber cushions covered with a white and red wool woven material by Tybor. The chairs are from Heals, the curtains from Liberty."[6] The Wayang flaunted wall-to-wall Javanese exotica: "with a contrasting lemon yellow and black textured fabric facing to the front of the bar and a working-top and bag shelf of Warerite Mahogany Wood print edged with hardwood lipping… tiles Pastaweld by J Manger and Son Ltd."[7]

Other influential designs of the time included: The Coffee House "pink Formica table-tops with stars and abstract patterns. Seats; wax polished deal with black legs";

La Reve "painted tapestries of woven rayon and cotton by Michael O'Connor. Seats are lion hide fabric, blockboard framed"; El Cubano "false ceiling of fine-meshed straw-matting with walls of slit bamboo and rough cast plaster"; Moka-Ris "padded leather with brass studs… mahogany framed facade with Parana pine base" and Pinnochio "… staircases with lacquered copper rods."[8]

The Troubadour on London's Old Brompton Road remains an important, authentic cafe from this time. Earl's Court had been the wild western frontier of bohemian Chelsea and was once rampant with coffee houses. Founded in 1954, The Troubadour's dark wood walls and ceilings are still hung with a vast array of exotica from the last century. One of the key centres of London intellectual and artistic life during the period, satirical magazine *Private Eye* was first produced and distributed here and early Ban the Bomb meetings were held in the cafe. The Troubadour was also where Bob Dylan first performed in London and where Ken Russell befriended Oliver Reed.

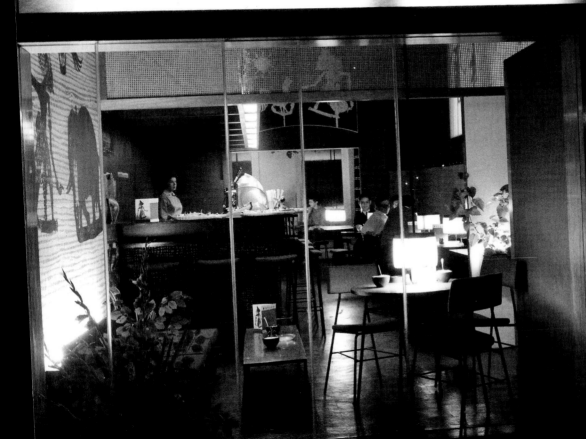

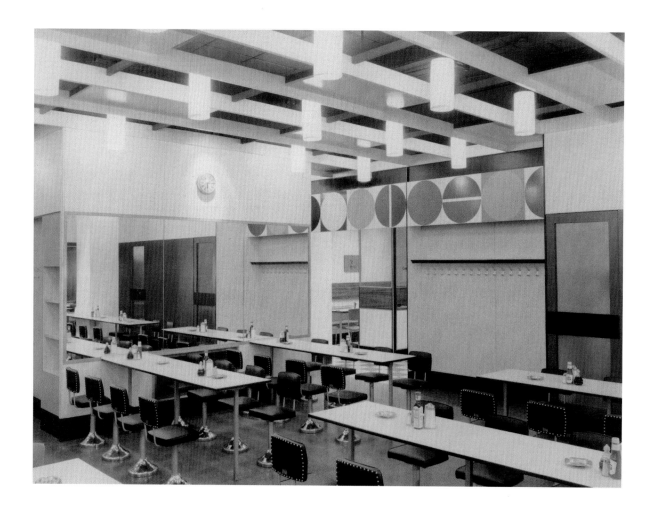

Bizarre, sinister, ravishing

As the number of coffee bars escalated, several strains emerged: Italian Original a la the Moka in Soho, "flashy, neon lit, streamlined"; Authentic English as per Terence Conran's Orrery at Chelsea's World's End, "architect designed, severe, sensible, tasteful" and Theatrical like the Mocambo of Knightsbridge "fake modern, fake Eastern, fake Indian, fake night-club, the whole box of tricks… a bizarre, sinister, ravishing, bedroomy set-up".[9]

However, it would be the Formica-clad interiors of the coffee bars that would come to be popularly associated with the classic cafe style for decades to come. Invented in Cincinnati in 1913 by Herbert Faber and Daniel O'Conor, Formica had been intended as a replacement for Mica in electrical insulators (hence the name "For Mica"). When, in 1927, the company began lithographing images onto sheets of laminate and offering a range of colours at low cost, artists and architects began

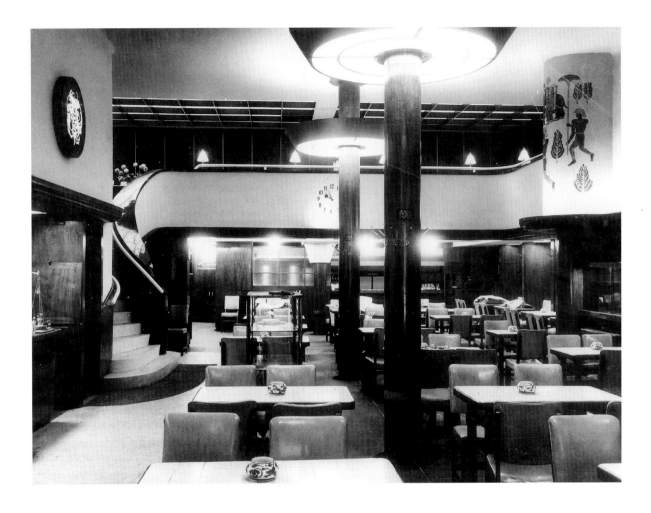

specifying the material for Modernist and Art Deco interiors. Initially, Formica was used to deck out American bars, diners (and even the Queen Mary ocean liner) as a cheap replacement for lacquer during the Moderne vogue for shiny black surfaces. By the time of its arrival in Britain (around 1947) it exemplified everything chic and easy about the wipe-down domestic-luxury lifestyle of America.

With its bright colours and wood grain effects, Formica became a mainstay of the UK's make-do-and-mend culture for the duration of the Post War building boom. Certain pattern lines like dingbats, starbursts, sputniks, sparklers and boomerangs became especially popular. Significantly, all of them seemed to depict "energy caught in the act of explosive release, like a coruscating diamond".[10]

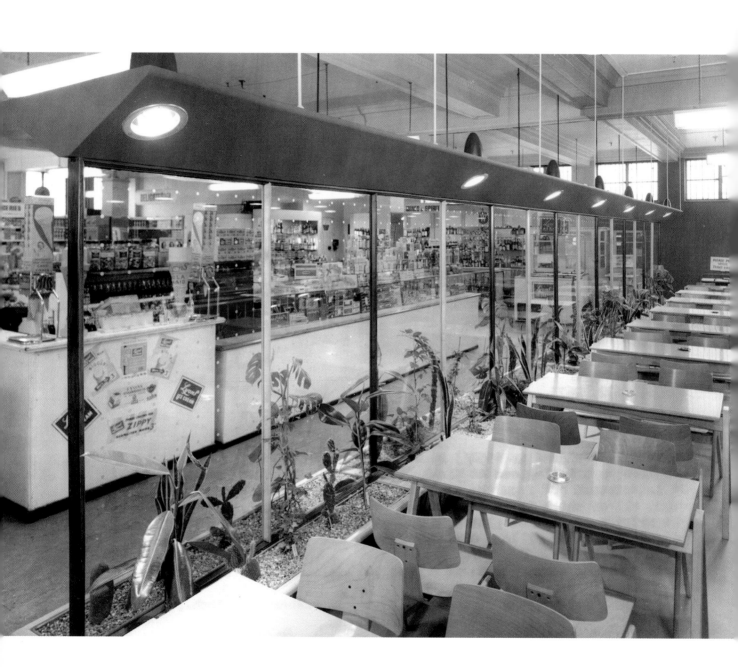

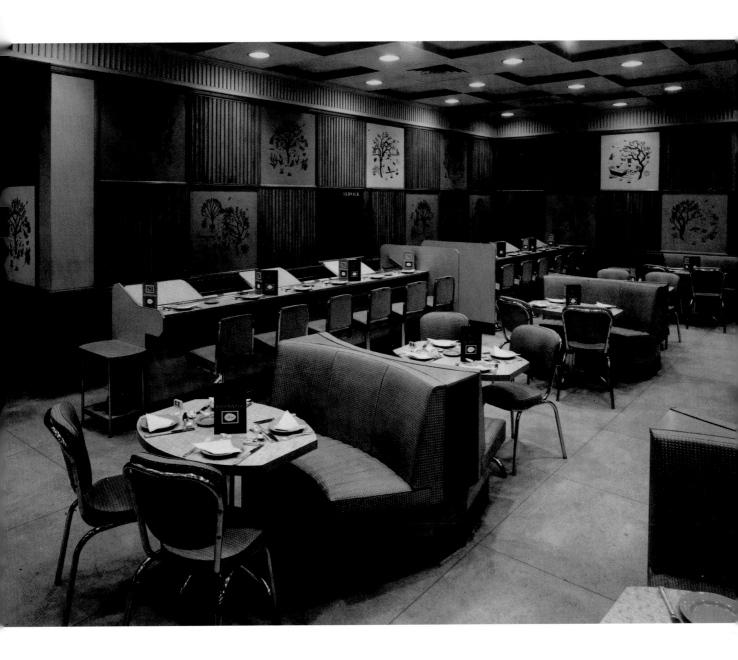

Teenage ambrosia

In London, the most successful caterer of the mid-1950s, Charles Forte, would incorporate the all-conquering new look into his refreshment empire: a kaleidoscopic range of establishments (milk bars, Italian restaurants, coffee houses) all decked out in Mid-Century mode. The once mighty Lyons Corner Houses – "that had preserved a little of the 'muffins under a silver cover' coziness of the Victorian era" – were left in limbo.[11]

With the Forte imprimatur, the consolidation of the cafe-look would be complete. Yet although it had broad public and commercial acceptance, many designers were disappointed with the temperate Swedish Modernism they believed characterised the Festival look. Some deplored the watering-down of pre-War avant-garde design. Others cited a process of Contemporary debasement; a plagiarism even of the Milan Fair of 1948. Others seemed more irked that, as Misha Black architect of the Festival's popular Regatta Restaurant pointed out: "the private pleasure of a few cognoscenti suddenly virtually overnight achieved enthusiastic public acclaim".[12]

In 1985, a parody teen-speak primer for the film *Absolute Beginners* defined the term "caff" for oldsters: "It seems to be the centre of a crucial teen-ritual, something to do with 'abstract expressoism'… a slimy black liquid or cotton woolly milky goo… those in the know regard the stuff as teenage ambrosia… ".[13] This dismissive tone is clearly evident in pronouncements of the time from cultural arbiters like Stephen Gardiner who cavilled: "on the whole, one accepts the espresso style; it means well… even if the result does amount to, as it so often does, no more than a very chi-chi pastiche".[14] The Council of Industrial Design, then the establishment face of good taste in

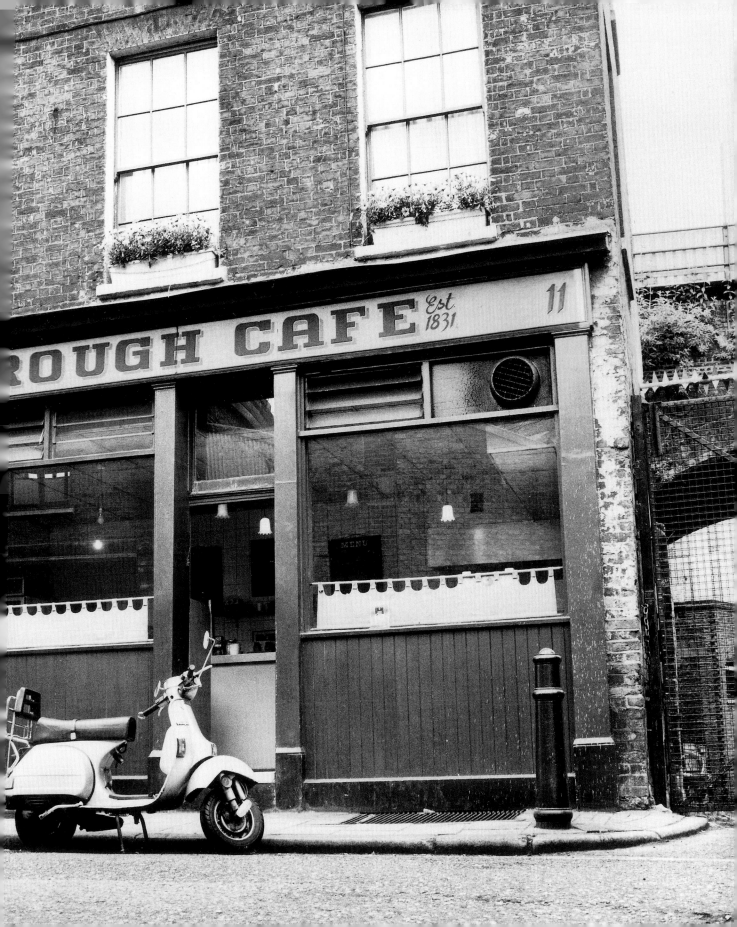

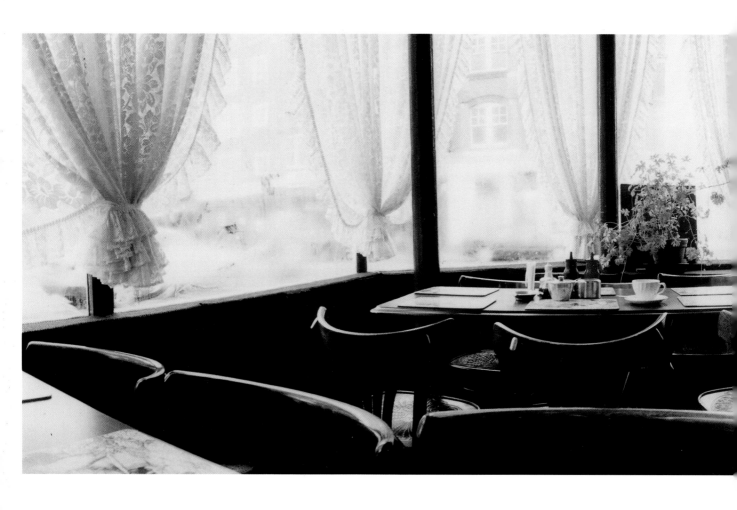

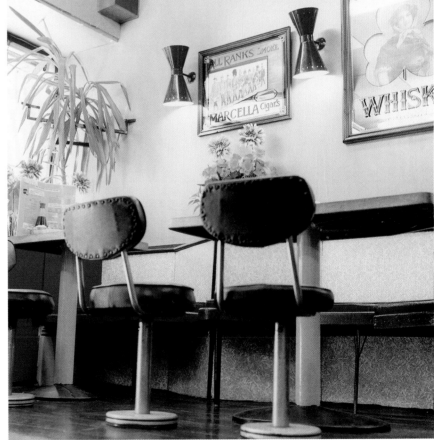

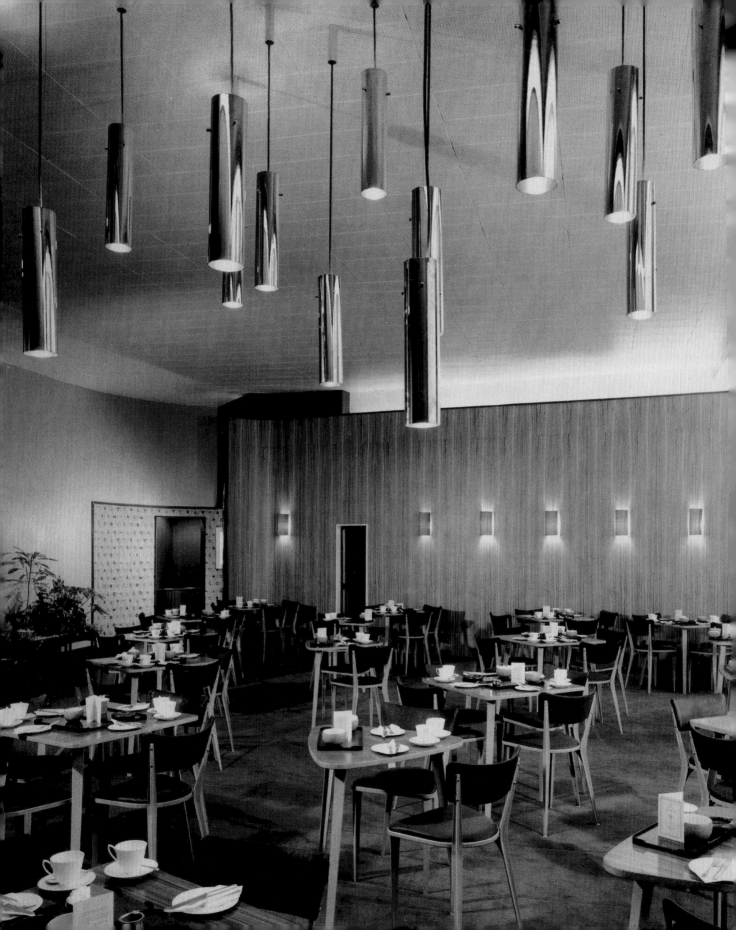

design at the time, was also ill-disposed. COID member Paul Reilly regarded fast-paced coffee bar decor as vulgar commercial populism, full of "brittle mannerisms".[15] Novelist and social historian Marghanita Laski complained of a veritable arsenal of Contemporary traits: "Here are the wooden vertical slats…. There are those same little taper-leg wicker-seated backless stools… the thick glass coffee cups… the rectangular Something hanging from the ceiling."[16] More damningly still, cultural critic Richard Hoggart detected a graver spiritual malaise behind the Formica, lambasting espresso bars as ghettos "full of corrupt brightness, of improper appeals and moral evasions… a sort of spiritual dry-rot amid the odour of boiled milk".[17]

Despite these mandarin qualms, The Festival of Britain did concentrate the Contemporary look in the eyes of the media and the public. When, in 1957, architectural critic Nikolaus Pevsner complained "to this day the City has hardly a major building which is in the style for the (twentieth century)" the coffee bars were among the first buildings to meet the charge head on.[18] They became ubiquitous high street symbols of national regeneration at a time when "having won a war and been schooled in the legacy of the British Empire, (people) were then plunged into a period where they could not have milk without signing for it and were very poor, with incredibly dull lives".[19]

For sure, the designs were quickly copied – and progressively became clichés – but "in England at this juncture the ability of superficial change to stimulate deeper change, as a pebble starts an avalanche, could be considerable… ".[20]

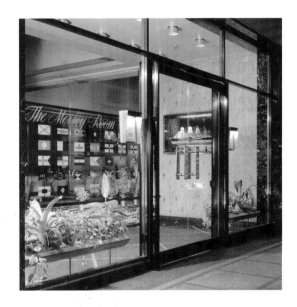

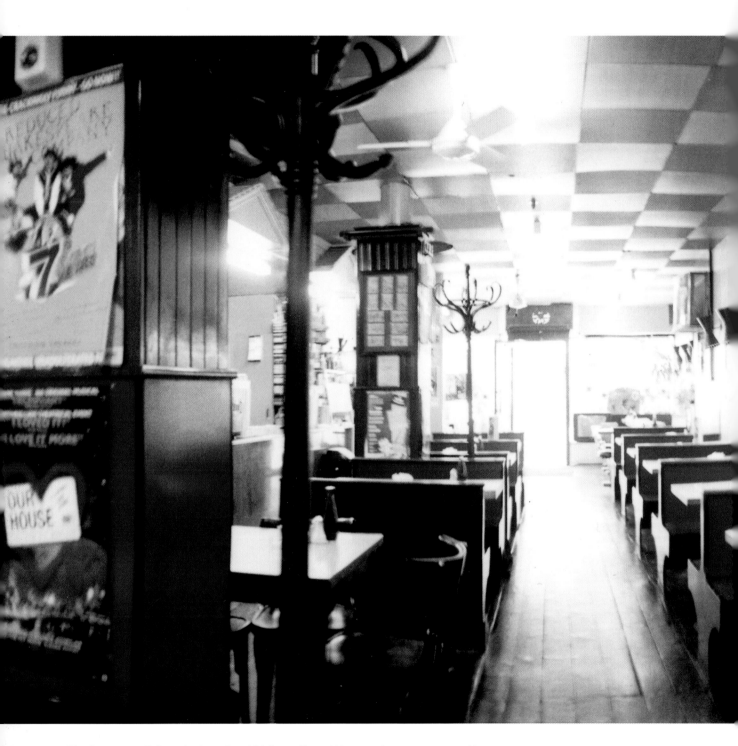

The hot egg spilt into the bread as I bit hungrily.... We were in a transport café on an arterial road. A gang of boys came in with eagles on their backs and TRIUMPH painted beneath in luminous white letters. One of them wore a shirt spotted with blood....
Nell Dunn, *Out with the Boys*, 1966

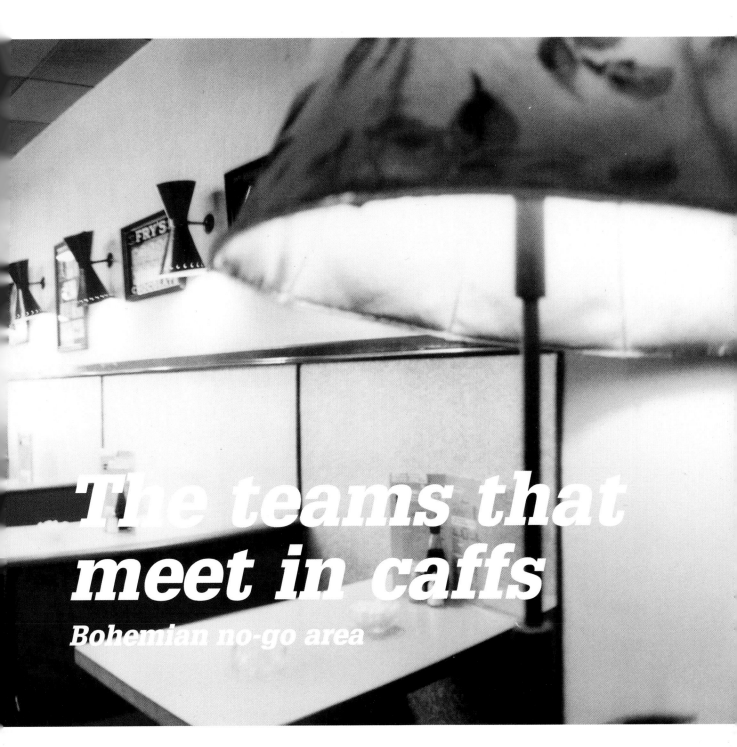

The teams that meet in caffs

Bohemian no-go area

The base of operation I chose was Soho…. It was instant magic to me, a sort of Disneyland for low-lifers. There was a café they used that was full of artists, poets, amateurs and professional philosophers…. It was heaven.
Jeffrey Bernard, *Low Life*, **1986**

Signs, storms, sensations

When the Arts Council called for contributions to its *60 Paintings for '51* exhibition for the Festival of Britain, the catalogue cover art was produced by neo-romantic abstract expressionist, Gerald Wilde. Though influential critics like David Sylvester and John Berger regarded him as an unsung genius, Wilde's work was regularly sidelined and this "prescient painter of urban dreams" was, as ever, omitted from the exhibition itself.[1] In fact, Wilde so, "relished his anonymity, passing unnoticed through bustling crowded London streets" that in 1970 a case of mistaken identity led to his death being announced in the press.[2]

A similar disregard would befall the British cafes – also inexplicably consigned to the historical margins despite their influence on the cultural life of Post War Britain. Odd, because if the mid-1950s were indeed: "a period of upheaval… moulded by a trail of signs, storms, and sensations… the rise of the Angry Young Men… the coming of the rock n' roll craze… the beginnings of a crime wave" then Soho's espresso bars were at the centre of the storm.[3] Their function: to channel the disaffected creativity, romance and bohemianism of a generation in much the way that the seventeenth century coffee houses had transformed the economic and literary landscape of their time.

For those too young for pubs (the licensing laws restricted access to over 21s in the 1950s) the coffee bars were social centres and an intrinsic part of the teenage lifestyle of 1950s Britain. They also cultivated the rudimentary social-commingling that would evolve into the Labour Party's 'classless society' line of the 1960s. As ex-teen Ted Mim Scala recalled after falling in with the Chelsea art set: "the Sar Ta Torga, the Picasso, the Gilded Cage. The King's Road was happening. The coolest place to hang was the Cozy Cafe…. We could eat a good lunch at one of their trestle tables for one and sixpence, in the company of workmen, debutantes, gamblers, models, painters and hustlers."[4]

Feeding off this rich social mix, the coffee bars often polarised around the musical tastes of their clientele: the left-wing Partisan Coffee House maintained a tradition of acoustic folk and protest music; the 2i's was steeped in early American rock 'n' roll…. And the focal point of the coffee bar was usually a juke box with an attendant DIY music culture. Ian Samwell, writer of the Cliff Richard breakthrough smash "Move It" (cited by John Lennon as the first British rock record to matter) recalls stumbling onto a whole ready-made teen habitat:

> I don't remember exactly what it was that first lured me into Soho… I do remember going to Cy Laurie's Jazz Club, Russell Quaye's Skiffle Cellar and the Top Ten Club…. And then of course, at 59 Old Compton Street, there was the one and only, home of the stars and birthplace of British rock 'n' roll, the world famous 2i's![5]

Before Cliff Richard, Tommy Steele, and later, The Beatles hit big, the British beat scene revolved around 'skiffle' kings like Lonnie Donegan, The Vipers and Chas McDevitt. Skiffle was an early twentieth century improvised folk music that drew on American jazz and blues, using instruments like washboards, tea-chest bass, kazoos and cigar-box fiddles. Originally called "Spasm Bands", by the 1930s a form of skiffle was established in Louisville and Memphis and by the 1950s, influential British television pop show *6.5 Special* was featuring teenagers dancing to skiffle bands in its studios. After Lonnie Donegan's international success with Leadbelly's, "Rock Island Line", Adam Faith famously declared, "Skiffle hit Britain with all the fury of Asian flu. Everyone

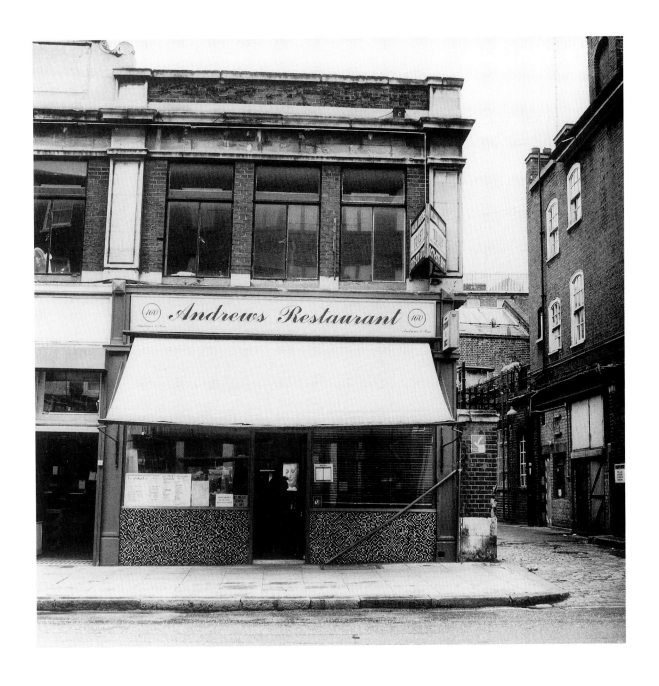

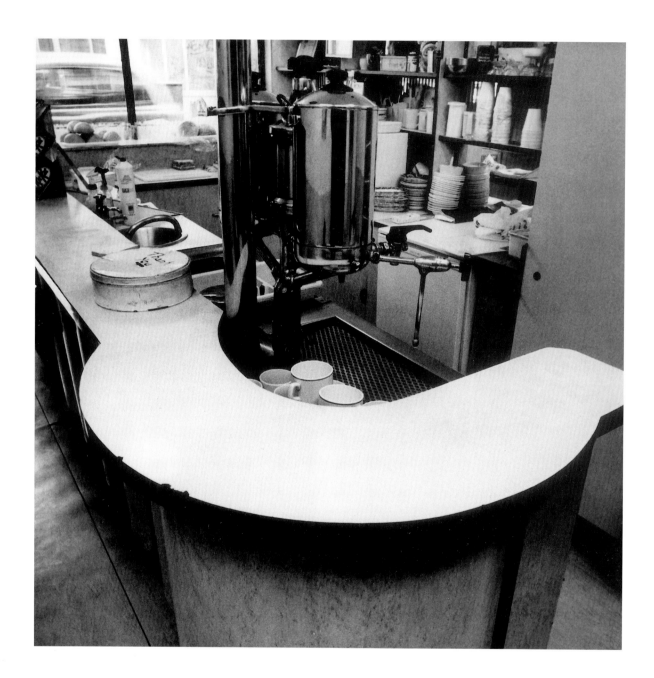

went down with it." In turn, Jack Good, the inventor of *6.5 Special*, broadcast Faith live from a coffee bar in 1958 and launched him as a major star. Faith's trademark moody 'sunken cheek, hungry look' would be honed on other TV spots after his handlers forbade him to smile on camera:

> Coffee bars fell into two distinct categories: beatnik – all black polo necks and existentialism; and teeny-bop – beehive haircuts and bobby socks... there'd be a ground floor cafe, with linoleum floors and Formica tables... (but) it was downstairs, at night, under the street, that the real action took place... the record industry, fuelled by the skiffle craze, began to explode. But everyone expected it to be a nine-day wonder. The old-timer agents would sit around in their old-timer agent restaurants, shaking their heads, muttering "It'll all be over in a week or two".... "[6]

The 21s, owned by professional wrestler Paul Lincoln, was a melting pot for many of these nine-day wonders, infusing country, blues, jazz, skiffle, calypso and rock for a new generation. Its notoriety attracted visitors from all over the country. One regular, Joe Moretti, moved to London at the end of 1958 to play guitar for Vince Eager and Gene Vincent:

> In 1958 the 2i's was the fuse for the explosion that was to come in the world of UK rock 'n' roll... Adam Faith, Joe Brown, Hank Marvin... it was just a little cafe with an old battered piano in the basement in Old Compton street. But it had a soul and a buzz... when we finished at the 2i's at night, around 11.30pm, we'd go to a coffee bar further up in Soho called the Freight Train... on the corner of Berwick Street and Marlborough Street and we would drink coffee and talk till the place closed, around 2.30-3.00am....[7]

McDevitt started his Freight Train cafe after realising just how big espresso culture was going to be:

> I was working in Unilevers, and on a Friday night (this would have been in 1954-1955) we went to sixteen coffee bars in Hampstead alone. I had a coffee in each place, and I didn't sleep for a week. Then you began to hear music in these places. All kinds of music, from a Spanish guitar-player to what eventually became skiffle music. I thought it would be a good thing to get my own. We named the coffee bar The Freight Train after our hit record. I thought it was the logical thing to do, to cash in on the name. It became a meeting place... coming home from a job, kids found all the stars there, or the stars to-be, and the place really blossomed. The area was still sleazy, but that was part of the attraction for the youngsters, they were getting a bit of excitement after those really strict severe years of rationing... people were able to express themselves, it was a reaction to the years of deprivation.[8]

Black leather motorcycle hub

Despite this profusion of indigenous talent there were naysayers. New Musical Express initially denounced Cliff Richard's "violent, hip-swinging" and "crude exhibitionism" lamenting, "Tommy Steele became Britain's teenage idol without resorting to this form of indecent, short-sighted vulgarity". And many on the political Left in the 1950s condemned coffee bars outright as part of an American cultural erosion of traditional British art forms. Cultural theorist (and Workers' Educational Association stalwart) Richard Hoggart was particularly incensed, decrying young coffee bar patrons as: hedonistic passive barbarians: "the directionless and tamed helots of a machine minding class". More pointedly, Hoggart objected: "Many of the customers... are living to a large extent in a myth-world compounded of a few simple elements which they take to be those of American life... society gives them an almost limitless freedom of the sensations but makes few demands on them... ".[9] But it was precisely because of this new-found freedom that a line of influential folk and skiffle artists emerged from the cafes and milk bars and, following on from them, whole jazz, mod and rock 'n' roll micro-cultures.

As Soho transformed into "that hallucinated enclave where we waited consumed by angst, to cure today's hangover by making certain of tomorrow's", another cafe, The Ace, came to prominence trading on the fact that the rock n' roll records of the day were largely confined to being played at fairgrounds or on the huge Bal Ami juke boxes placed in all the most popular transport cafes.[10] The Ace had originally been built in 1938 in suburban North London, catering to hauliers, but became the all-night black leather motorcycle hub for a new breed of bikers, termed "Ton-up Boys", who arranged races on London's North Circular road. Thus the 'drop the coin right into the slot' legend of 'record racing' – putting on the juke box then racing to a given point and back before the record finished. The decline of the motorbike industry and an expanding motorway network saw the old Ace serve its last egg and chips in 1969 (It re-opened thanks to the Herculean efforts of supporters who acquired the building in 2000.) By then such places had passed quickly into the pulp pantheon: "He pulled on his big leather motorcycling jacket and went out to his bike.... They met at a... workingmen's café in the daytime, quite ordinary, but at night it was different. It acquired for them at least an excitement and glamour. It was the café for the boys on motorbikes. It was like a badge of admittance... ".[11]

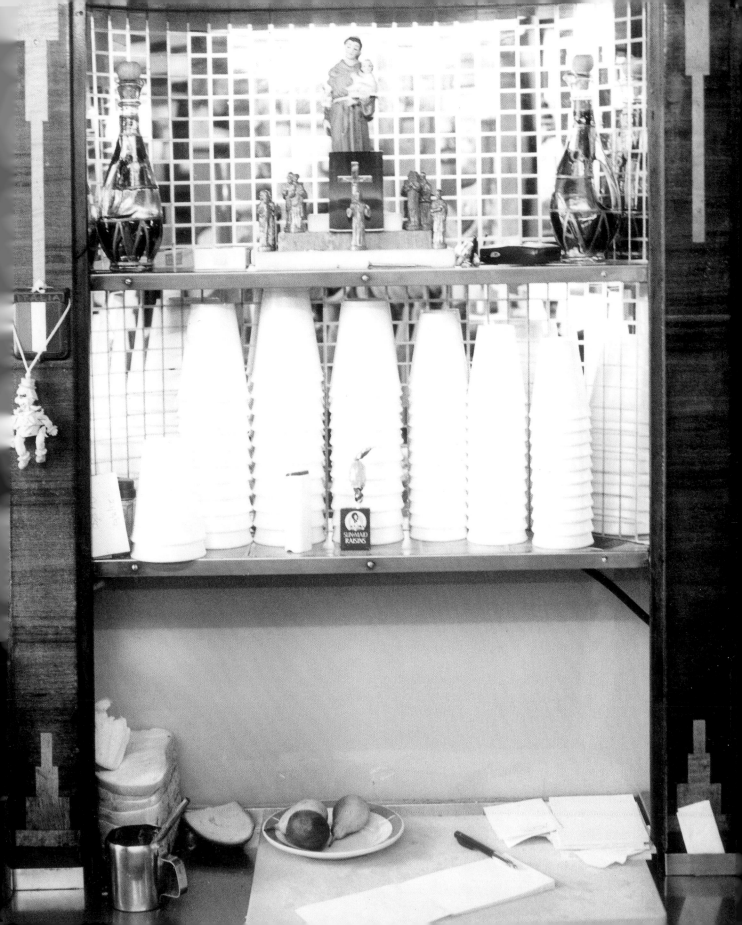

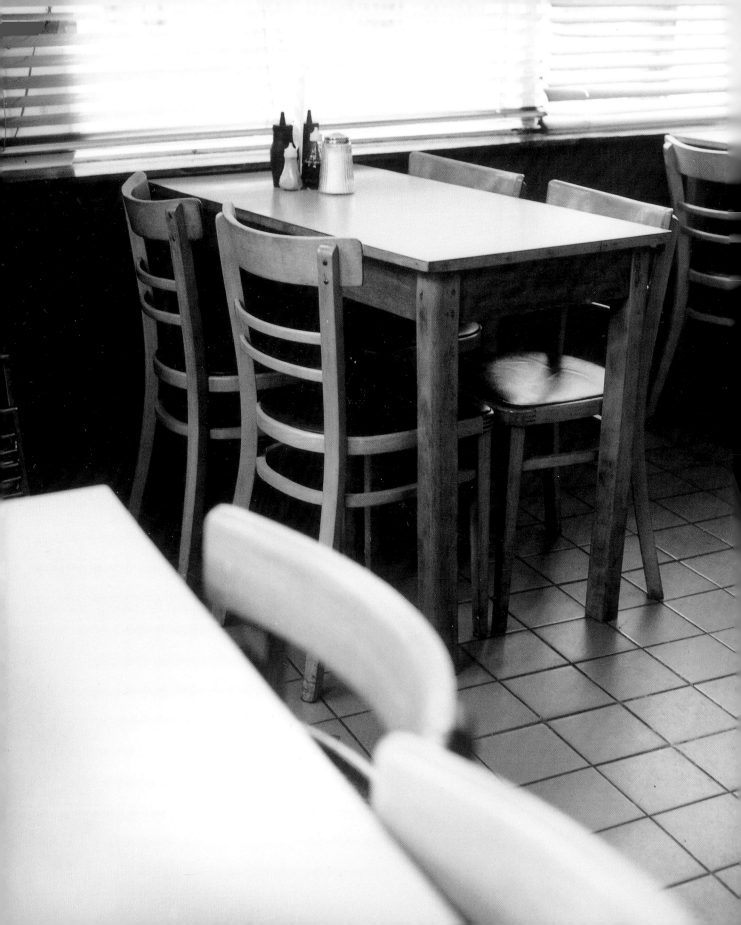

Moral panic

As the image of beat-crazed cafe-dwellers became increasingly familiar, coffee bar vignettes surfaced in many UK pop films of the era: movies like *Serious Charge*, *Some People*, *The Golden Disc* and *The Tommy Steele Story* (in which real-life 2i's doorman Tom Littlewood features as a judo instructor!). Possibly the best of the bunch was Don Sharp's *The Golden Disc*, 1958. A low budget slice-of-lifer, set among the bottom feeders of Tin Pan Alley, the story revolves around the Lucky Charm coffee bar and features heartthrob Terry Dene as yet another British Elvis-in-waiting.

Two other coffee bar movies in particular would capture the public imagination. Val Guest's *Expresso Bongo,* 1959, splendidly evoked the grasping music biz world of Tin Pan Alley and starred king rocker Cliff Richard revelling in a cafe-swamped Soho (later lovingly recreated in Julien Temple's *Absolute Beginners*). Edmond Greville's *Beat Girl,* 1960, also launched a teen idol, the svelte, feral Adam Faith in the story of an architect neglectful of his offspring's involvement with internecine delinquents. A particularly timely theme, reflecting the looming assault on traditional artistic and societal values the cafes would often be blamed for.

Increasingly, cafes became a focus for moral panic, with mods, rockers and others regularly demonised by a media reeling from the rise of the teenager. By 1958, a record 2,051 young people had been convicted of crimes of violence (in 1938 the figure stood at only 147) and scare stories of drug taking in Soho coffee bars were circulating. One jazz fan of the time remembered:

> We used to take Dexedrine or Benzedrine, feel really great and stay up all night… it was licensed anarchy…. About six in the morning you'd go out into the street find a

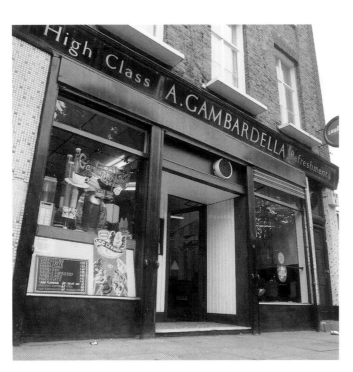

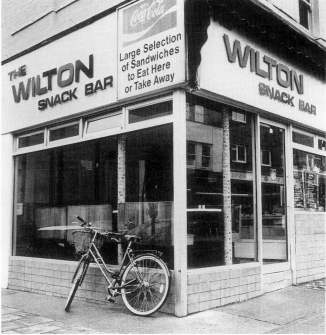

caff and have breakfast with all the prostitutes, who were just knocking off work. [12]

Former 'Hard' Mod John Waters recalls just how territorial the gang scene could be:

There were two distinct types of mod within the London area. The first was the familiar scooter boys, the generally accepted face of sixties Modernism. However, there was another type of mod. These gangs consisted of between fifty to a couple of hundred in strength at any one time. Each manor had its own caffs. We congregated in two or three local cafés and pubs… Friday and Saturday nights up West. Off to the Coffee An' in a cellar down the bottom of Wardour St. Early next morning meeting up at the all night café El Passant on the Strand (what a great juke box). The thing about the sixties was that everything was so new. The clothes, music, clubs and for the first time we had some money in our pockets to indulge. [13]

Ex-mod Kevin Rowland would take up this lineage when putting together the original Dexy's Midnight Runners line-up in 1978. The Apollonia cafe in central Birmingham became the band's operational base. Here, Rowland worked out his Young Soul Vision that would eventually end up as a series of splenetic ads in the music press, expounding his Lutheran distrust of the music business. Rowland recalls setting up early gigs from the caff payphone, and it figures briefly in the band's video for their hit single, "Gino". Rowland finally immortalised The Apollonia in the Northern Soul twister "The Teams That Meet in Caffs", a centrepiece of the band's puissant *Searching For The Young Soul Rebels* album of 1980. In direct homage, a decade down the line, the Manic Street Preachers would condemn themselves to rock 'n' roll with team forcing sessions sitting in the front window of their local cafe, Dorothy's in Blackwood, Wales.

Whores, narks and tortured intellectuals

Soho eateries had long been gangland enclaves. Lorenzo Marioni remembers that in 1956 when his cafe, The New Piccadilly, became a focal point for Hungarian dissidents fleeing the Soviet invasion, one of them showed off a rival's severed finger to his father Pietro Marioni. In the early 1960s, when bikers with flick-knives were banned from putting their feet up on the Formica tables, the gangs returned and smashed the cafe's windows with armfuls of rubble.[14] Slightly further east, shoot-outs in the cafes and pubs of Holborn, Clerkenwell and Gray's Inn Road (usually involving racecourse racket gangs) were becoming increasingly commonplace.

On the edges of this criminality, self-declared tout, thief and layabout Frank Norman lived out much of the 1950s in Soho's 86 cafe, "a sleazy haunt of pimps, whores, narks and tortured intellectuals".[15] Norman went on to write the musicals *Fings Ain't Wot They Used To Be* and *A Kayf Up West*, but a real-life cafe also figured large in the lives of some altogether more serious career criminals. The Pellicci (still going strong, still unchanged since its gangland heyday, still boasting an interior that looks like a Deco foyer from the Empire State Building) was a Kray twins favourite:

> a fine, step-down establishment; lace curtains in ice-cream parlour windows, shiny vanilla panels and the name spelled out in generously spaced Univers Medium lettering… mirrors and marquetry, inside… a key rendezvous – gossip, fashion updates, subsidised grub – for the firm in its earliest days. Tony Lambrianou remembers it with affection… one of the places that the (Krays) used to hold their afternoon meets.[16]

Owner Nevio Pellicci swears Reg and Ronnie used to tick off punters for swearing within earshot of female customers. However, 1950s top-cop Robert Fabian (aka Fabian of the Yard) dismissed the cockney caprice and "my-manor" homilies out of hand:

> The average person walking about or riding in a bus sees only… the respectable London. But the other London, the seamy, corrupt, side of the world's greatest port and city is there all the time, lurking down ill-lit streets or in the back quarters of a smoke filled café.[17]

Aside from this frenzy of prurience, the mass media would overlook the cross-pollinating effect of the cafes and their role in incubating the disparate aesthetic (and sexual) activities of their habitués – musicians, artists, photographers, writers. Much as the coffee houses of the seventeenth century had done earlier.

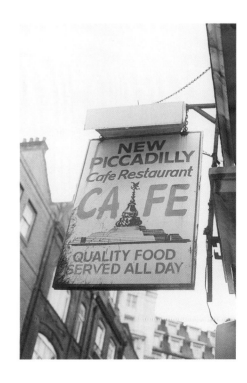

Bohemian no-go area

Links between art and music assumed particular significance after the War. The American craze for traditional 1920s jazz had taken hold in London by the late 1940s, coinciding with a flood of middle-class entrants into art schools. Jazz became the music of choice for London art students and their coteries (early jazz pioneer Humphrey Lyttleton studied at Camberwell School of Arts and Crafts in the 1940s and his tutor John Minton regularly attended his gigs.) For jazz aficionado and art connoisseur George Melly "The fifties were a time of austerity of punitive conventions, of a grey uniformity… Soho was perhaps the only area in London where the rules didn't apply. It was a bohemian no-go area." [18]

The cafes were very much part of this birth of British cool. Richard Wollheim, reviewing Colin MacInnes' novel *Absolute Beginners* in 1959, insisted the 'hip' coffee bar kids of the 1950s represented an aristocracy of cool whose dominion he specifically located in "films from France and Poland and Japan; and in the cafes and bars of every American or Americanized city in the world." [19] As well as hip teens, the cafes (and pubs and drinking clubs well documented elsewhere by Daniel Farson) attracted many of London's leading intellectuals and artists, including Francis Bacon, John Minton, Lucien Freud and Frank Auerbach. Cafe Torino alone, at the corner of Dean Street and Old Compton Street, housed numerous groups of architects, designers and journalists:

> It was pleasantly old-fashioned with tall, arched windows… It had wrought-iron tables with marble tops, cups of proper coffee… you could talk for hours over a small cup of coffee….They were so anxious to keep their customers happy they kept their prices low and were rash enough to allow credit…. The goodwill was reciprocated and the tables were usually crowded. There were dark Italians huddled in earnest discussions, suddenly bursting into furious argument… and several pale young artists and poets searching half-heartedly for jobs…. [20]

Most infamous among them was Colin Wilson who, legendarily, formulated his new-existentialist Outsider shtick at the height of the espresso bar craze. Actually dubbed "The Philosopher of the Coffee Bars" and "The Messiah of the Milk Bars", Wilson owed his livelihood, not to mention his reputation, to the new rash of cafes:

> I'd sleep on Hampstead Heath… and cycle down the hill to a little café where I could get tea and bread and dripping for about sixpence, and then go on to the British Museum… [I] was told that a new coffee house was opening in the Haymarket, and that they wanted a washer-up… suddenly fate had ceased to harrow me… to be around students hoping to become the great actor or actress was tremendously stimulating, and I felt perfectly at home among them, since I was determined to become a great writer. [21]

In 1956, Wilson's first book *The Outsider* became a publishing phenomenon – and Wilson an intellectual cause celebre – influencing much 1960s Aquarian New Age thinking and feeding into decades of subsequent occult revivalism. [22]

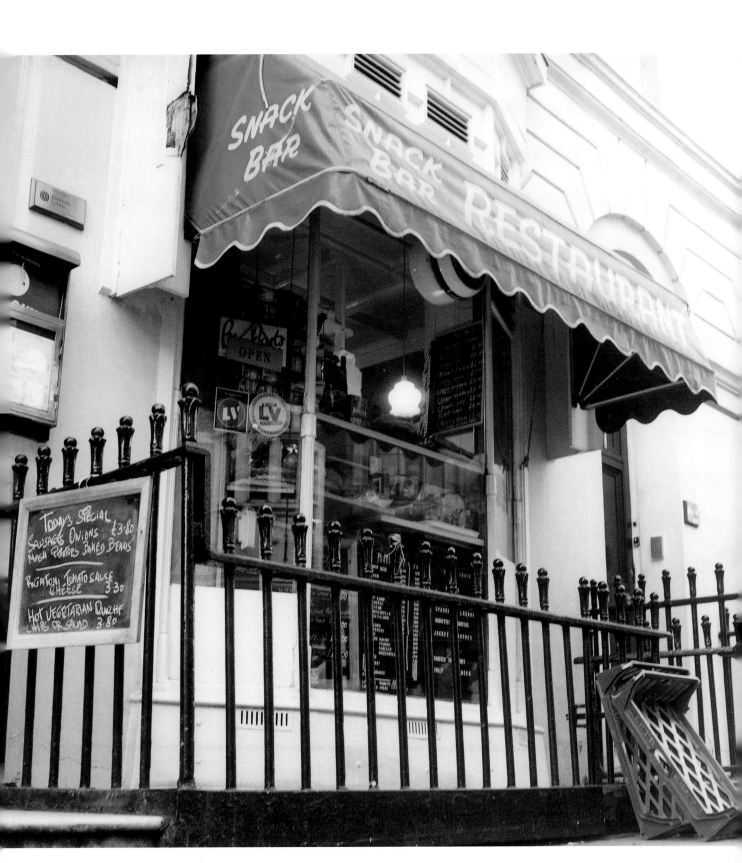

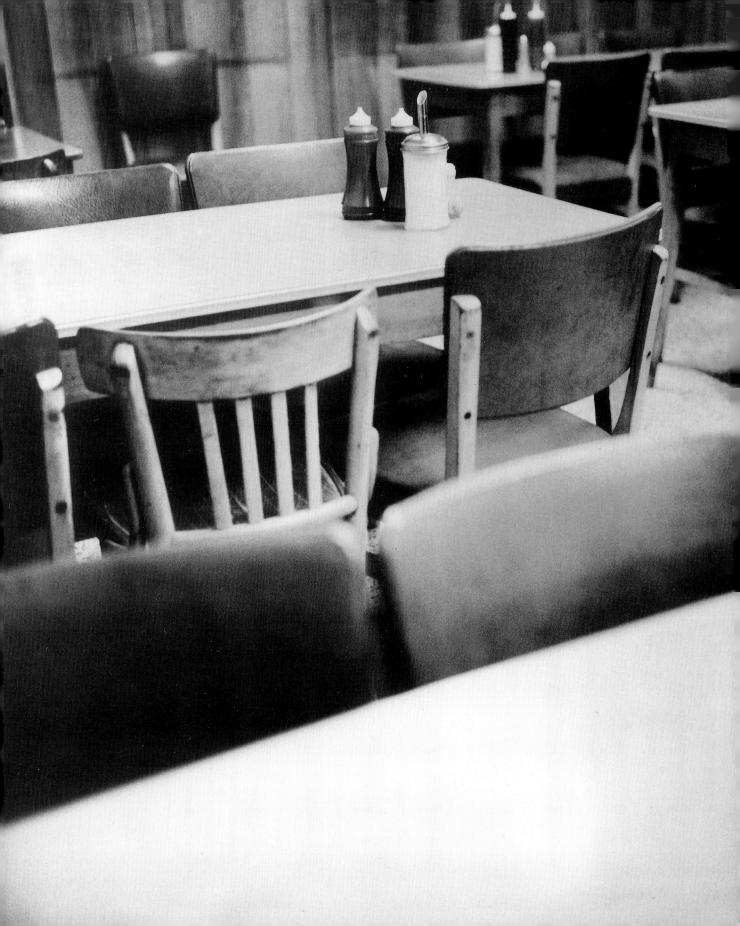

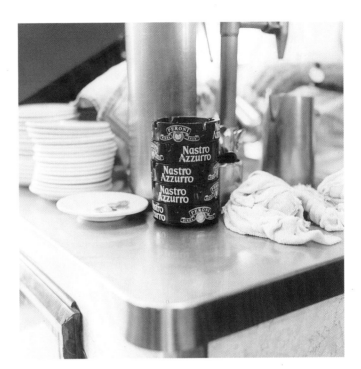

Giant paved double bed

Other outsiders also emerged as coffee bars began to feature in the sexual mores of the day. Stephen Ward, unwitting architect of 1963's Profumo sex scandal which led to the resignation of Prime Minister Macmillan, was an inveterate coffee bar patron, constantly setting up dates and drug connections in a clutch of favoured Central London haunts. In her autobiography, Ward associate Mandy Rice Davies recalls: "[Ward's] home territory was the triangle made up of his flat in Wimpole Mews, his consulting rooms in Harley Street and his local coffee bar in Marylebone Lane. Occasionally he used another coffee bar favoured by artists who could sketch the nude model provided by the management while they drank their coffee."[23] And Christine Keeler acknowledged the importance of Ward's stomping grounds in her own life: "Eugene [Ivanov] was a Moscow spy who arrived in London on 27 March 1960 to work for Stephen. That long-ago day in the smoke-filled Kenco coffee shop when I first witnessed them altogether, all I wanted was some company."[24]

Also much exercised by matters of company, Dr Patrick Trevor-Roper was one of three gay men who undertook to explain to a Home Office committee what it was like to be homosexual in Britain in 1955. Partly as a result of his testimony, it was recommended in 1957 that male homosexuality be decriminalised. The findings also revealed that, despite blackmail and public hostility, many gay men quietly thrived during the time, to the extent that Quentin Crisp described 1950s London as being "one giant paved double bed." In his autobiography, *The Naked Civil Servant*, Crisp disclosed that being introduced to cafe subculture by a life-model friend helped him connect with a queer milieu previously invisible to him:

When the class was over he suggested that we should visit one or two of the cafés which he frequented in Charlotte Street. If it had not been for this casual invitation a whole world might for ever have remained closed to me… no one who had not a pathfinder's badge could have reached them… I could devote two or three nights a week to sitting in one or other of the cafés… my homosexuality was of no consequence…. The staff was friendly and unhurried to the verge of immobility. So was the clientele: bookies and burglars, actresses and artisans, poets and prostitutes; and there was an entirely new caste brought into being by the war – deserters…. [25]

Later in the 1960s, Gilbert and George would amplify Crisp's self-as-art stance. After meeting at St Martin's College of Art in 1967, they claimed not to be able to separate their art from their lives and became 'living sculptures'. Sending out 300 postcards showing themselves gazing out of a window in 1969 they labelled the work: "a sculpture of overwhelming purity, life, and peace, a rare and new art-piece." Another early work, *Singing Sculptures*, saw the couple dressed in matching suits, singing and staggering around to old Flanagan and Allen music hall songs. The pair spent much of the 1970s and 1980s lauding the delightfully grimy Fournier Street Market Cafe near their Spitalfields home. A Spitalfields Huguenot house where a doctor once lived, Clyde Armstrong took it over in 1947. Gilbert and George, at one point, helped run the business and served customers as trade from the surrounding markets crumbled. "It was like Rules", claimed Gilbert, "only much better and cheaper". (Sections of the Philip Haas' 1981 documentary *The World of Gilbert & George* show the duo becoming increasingly fractious

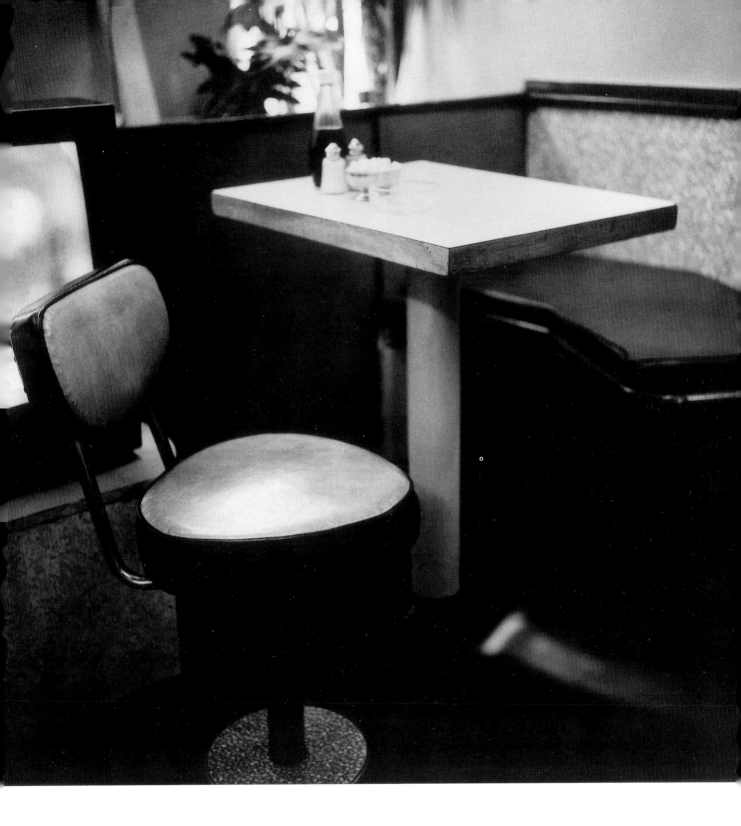

in one particular caff session.) They also became regulars at Rosa's Cafe round the corner in Hanbury Street, where Bud Flanagan once lived above the shop. A small display of music hall ephemera – and Gilbert and George photos – still lines one wall.

The duo maintained a long relationship with writer and art critic Daniel Farson, whose celebrated photo-memoir *Soho In The Fifties* did so much to fix the image of Post War artistic London.[26] Today, the bohemia of Farson's pleasure is vanishing. The once cafe-filled confines of Soho are emptying of the old-style eateries that originally made its name. But, as of today, a few Italianate stalwarts persist: that pulsing temple of lemon Formica, The New Piccadilly; the chalet-chic Bar Bruno; the red-boothed Pollo; the espresso-brown Centrale, the curtain-twitching Presto; the Sorrentine Amalfi and the dive-like Cappuccetto. All remain as popular with layabouts, deserters and seekers after gilded gutter-life as ever.

These Soho restaurants are the last pointers to a period that saw Britain's slow climb out of its pre-War insularity. A time when a London 'Left Bank' intellectual culture once prospered; when the mass upsurge in milk bars, coffee bars and cafes was part and parcel of the gradual adoption of a more international perspective that was reflected across the art, music, literature and sexual politics of the time. Just as London – the city itself – became the subject of much British art in the 1950s, it's worth remembering that the cafes of the time also warrant remembrance "as palimpsest, as the site for cycles of renewal".[27] The prescient urban dream of Gerald Wilde should no longer pass unnoticed on the bustling, crowded streets of London.

Britannia Moribundia

A valediction in Formica

I went up streets of dark purple and vomit green, all set at angles like ham sandwiches… and there were the peasant masses… shuffling along in their front-parlour-curtain dresses and cut-price tweeds and plastic mackintoshes, all flat feet and fair shares… and I thought, my God, my Lord, how horrible this country is, how dreary, how lifeless, how blind and busy over trifles!
Colin MacInnes, *Absolute Beginners*, 1959

For the really lonely individual in the city, life becomes a string of disconnected occasions designed to illuminate and isolate his aloneness. Eating by himself in a restaurant he feels conspicuous; he catches the eyes of other lone diners… an epigraph from Celine: "He is a fellow without any collective significance, barely an individual."
Jonathan Raban, *Soft City*, 1974

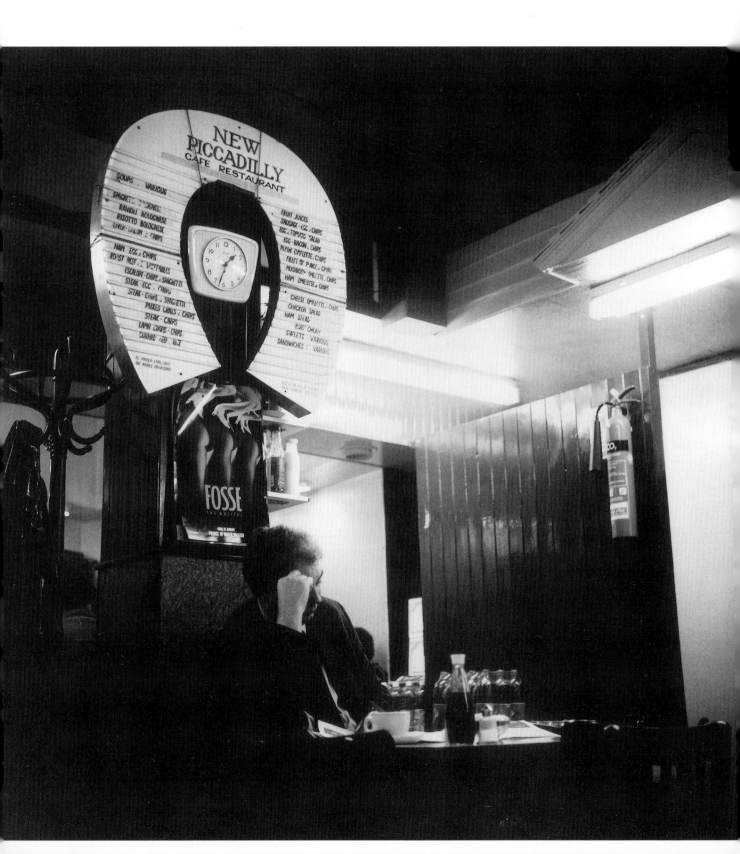

The Eternal festival

The Situationists – the late 1950s avant-garde that emerged in the wake of the *Lettrist International* and *Situationiste Internationale* magazine – had envisaged the renewal of the urban landscape through a revolution of the imagination. This siege of pleasure was to take the form of an 'eternal festival'; a celebration of creativity achieved through the transformation of everyday life. To this end, it would employ a series of strategies like *derivé* (a flow of acts and encounters) and *detournement* (the re-routing of events and images) to confront the petrifaction of modern life into a spectacle of commodity consumption.[1]

This imagineering of the city itself as a supreme opportunity for creative self-expression certainly appears to be borne out by London's cultural florescence throughout the 1950s and early 60s. But the nation's economic boom didn't last and the dream of eternal festival in Britain soon expired.

In the 1970s, severe bust lead to a halving of the UK's manufacturing employment base and large companies began leaving the capital en masse, flush with government grants encouraging them to relocate. Increasingly, British industry (for so long dependent on the spoils of Empire) fell behind the leaner economies of the USA, Germany, Japan and Eastern Europe.

Unemployment, virtually unknown in Britain in the 1950s, began a long spiral upwards, the subsequent recession accompanied by high inflation and a collapse in living standards. By the summer of 1976, unemployment shot over the one and a half million mark – the worst figure since 1940 – signalling "a sudden decay of trade and commerce in a city devoted to them".[2] This crumpling of a *zeitgeist* that had buoyed Britain throughout the Post War years saw cafes fade from view by the late 1960s.

As proprietors found more profit in selling food, so the coffee bars gradually all turned into general cafes or cheap restaurants. The accompanying longterm rise of pub culture in Britain also damaged the cafes' customer base – a reiteration of the decline the original coffee houses had suffered at the hands of the early nineteenth century taverns and chop houses.

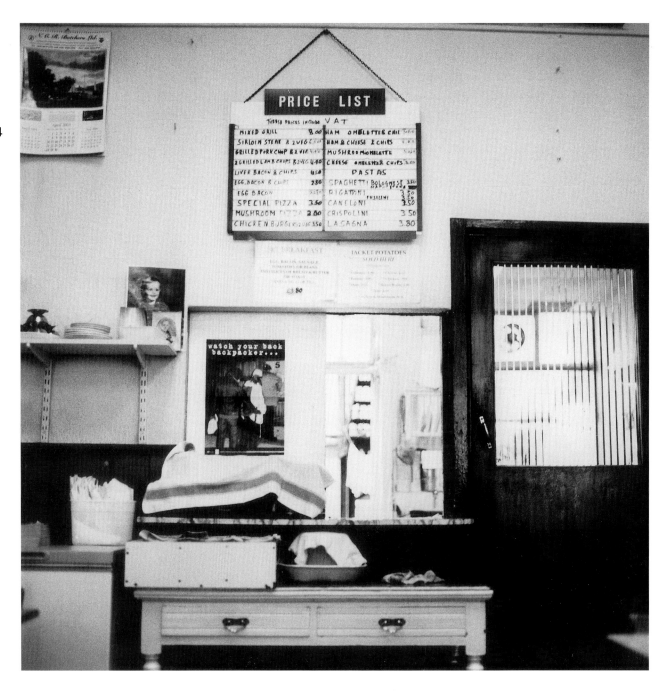

Playback

Only a couple of die-hard cafe chains managed to last out the 1960s and hang on into the 1970s: the Lyons Wimpy Bars and the Golden Eggs (set up by Philip and Reggie Kaye in the early 1960s). The Wimpys avoided gimmickry, maintaining their simple duo-tone minimal interiors (as seen in the late 1960s movies *Bedazzled* and *The Sorcerers*) but the Golden Egg chain (glimpsed in the George Melly scripted *Smashing Time*) was altogether more outlandish, employing: "The most controversial use of colour in British restaurants… where riotous colour schemes and brilliant opaline lights have brought a jazzy mood to eating in low-price popular restaurants."[3]

In an attempt to differentiate itself from the tatty cracked Vitrolite and scuffed Formica of its rivals, the Golden Eggs made abundant use of handmade ceramics and modern materials like coloured melamines and fibreglass. Brightly coloured sculptures by young ceramics firms like Newland and Hine became a mainstay of the company's designs. Lyons & Co countered with their mid-1960s Sizzling Sausage and Chips with Everything niche-chains aimed squarely at the youth market and by the mid-1970s the Golden Eggs had vanished, their singular Italian, Spanish and Hollywood theming a last colourful gasp before most cafes reverted to the plain, stripped-down Formica models left today.

Even the mother of all Soho coffee bars, the legendary Moka, went under. Opened in a great fanfare by movie star Gina Lollabrigida in 1953, 20 years later, cult American writer William S Burroughs purported to have closed it after some perceived discourtesy and a spat over a "poisonous cheesecake". From August 1972, Burroughs subjected the Moka to weeks of para-psychic bombardment, insisting: "I have frequently observed that this simple operation ('playback') – making recordings and taking pictures of some location you wish to discommode or destroy, then playing recordings back, taking more pictures – will result in accidents, fires , removals…. "[4]

Eventually, business did indeed fall off and The Moka was taken over by the Queen's Snack Bar on October 30 1972. (30 years on, Wild Bill's hex induction programme seems as potent as ever: after a decade of this author photographing and archiving old London cafes, the majority of them have now shut up shop and gone for good.)

Incoherent windswept spaces

Despite their once epochal freshness, by the 1980s cafes were well and truly off the menu. A revitalised pub culture, swarming burger conglomerates and insidious sandwich operations pushed all aside, leaving in their wake only the "hunched sedated souls lingering in cafes and souped-up milk bars" so hauntingly limned in David Seabrook's Kent coast travelogue *All The Devils Are Here*. Alfredo's regular, author and poet Iain Sinclair embraces their erasure:

> I was born in Wales and there's a whole culture of classic Italian cafes there. But I like 'bastard' cafes – mongrelised ones, with bits and pieces strategically placed and altered. I like that idea of one culture imposing its culture on top of another in bits and pieces. The kind of thing I'm looking for is these caffs that change ownership all the time. As you move out from the centre and the immigrant groups come in you get a big turnover of places: Albanian cafes, Vietnamese cafes… I guess the original Soho cafes took off with people buying into that whole era of French existentialism. It was the last time you had that leisured, dole culture of people hanging round talking, the start of pop and all that. But there was a moment of division where it all devolved to pubs culturally. You'd get writers like Michael Moorcock and J G Ballard meeting in these select pubs and discussing imaginative writing and Sci Fi. But now the whole culture has speeded up so that people just queue to get takeaways. And it's the death of cafes. Who's going to spend days hanging out at cafes? It's gone.[5]

Now, almost all the old time classic cafes have disappeared, been re-fitted or left derelict. Family owners are nearing retirement age and their children are unwilling to take over the

businesses; property leases are coming to an end, and the pace of shut-down has speeded. This aura of lostness remains an abiding element of the classic cafe today. The wistful dowager quality that many of them preserve may well be a spectral hangover of the devastation they sustained almost immediately after the Festival of Britain – the event that had launched them throughout the country. After the General Election of October 1951, a new Conservative Government, eager to prove its mettle, turned on the distinctly un-eternal Festival site. Convinced that it had been a monstrous act of profligacy (Churchill called it "three-dimensional socialist propaganda") at a time when the pound was actually being devalued, the Tories stripped the 27 acres of the site back to ground level. It remained derelict for a decade.

After a brief burst of light and colour and the hope of becoming part of an international scene it was straight back to hard times. Terence Conran, who'd spent six weeks sleeping onsite designing furniture, sculpture and plastic lettering, lost his job and went to run a pauper's soup kitchen off Trafalgar Square. (His landmark Habitat store wouldn't open until 1964.) Much later, in the 1970s, a massive car park wiped out all memory of Festival year. All that remained a legacy of "incoherent windswept spaces… unresolved walkways and unpleasant underpasses… all overshadowed by the mediocrity of the Shell Tower." [6] A single symbolic snuffing-out at birth.

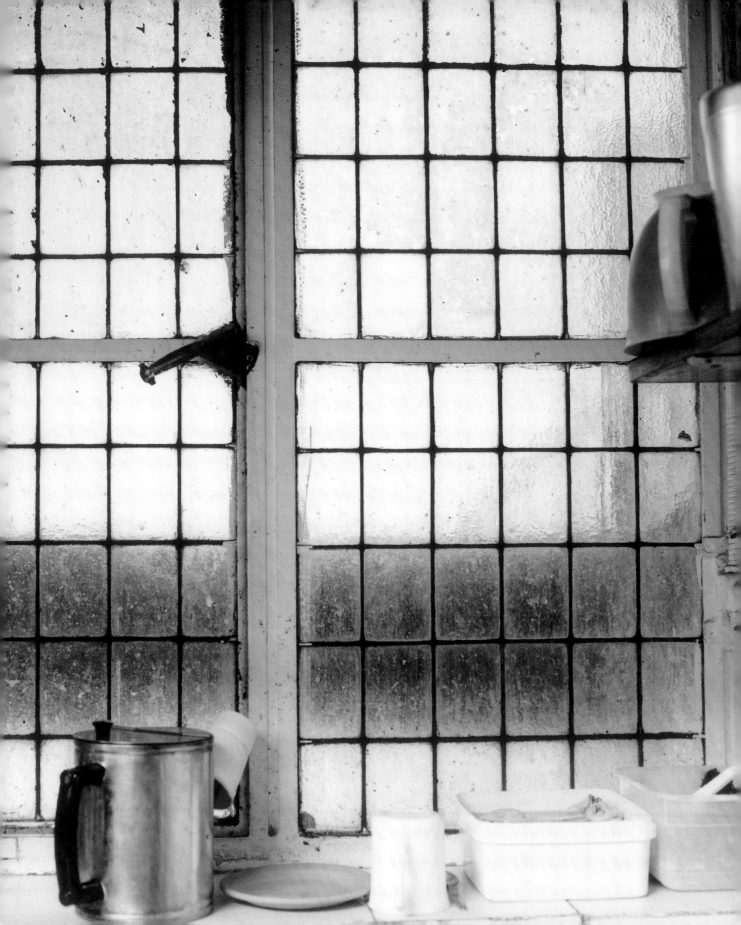

Oubliettes of exquisite boredom

In 1999, the Royal Institute of British Architects unprecedentedly gave its coveted Gold Medal not to a single person or firm but to the whole of Barcelona. Two years earlier, as part of a national rebranding exercise code-named 'Cool Britannia', one of New Labour's first projects on taking office had been a fact-finding mission investigating how the city was so well managed. Little appears to have come of the recce, but within two years the UK had embarked on the building of the disastrous Millennium Dome by wasteland on the Thames (an echo of the construction of Barcelona's hugely successful Olympic City of 1992, itself built on reconstructed waterfronts).

For all this looking to our neighbours, the sheer functioning success, civic acumen, and high living standards of much of Western Europe seem forever beyond England. In many ways, the country remains relentlessly third-rate (in Philip Larkin's pained phrase, the "First slum of Europe"); afflicted by an ongoing social psoriasis of hospital crises, train crashes, shutdowns, strikes and crime waves. Yet this is where England most truly excels: in all the characterful shabbiness of its drizzled parks, soiled launderettes, frayed tailors, abject chemists, sparse barbers, bare foyers, dun pubs, weary Legion halls… and cowed solitary cafes.

From an era when Britain Could Have Made It, these silently wasting emblems of Britannia Moribundia – that chronic malaise of managed-decline and shattered public services that clings to the country like a pall – are now confined to reproaching the double mocha latte merchants subsuming them. This is the real re-branding of Britain: the cloning of global chains on every high street:

we are losing an essential element of British life, to wit, drabnesss… there was [once] a spectrum of drabness… a local pub, which would be resplendently empty, silent as the grave, offering day old sandwiches and a barmaid who last laughed at Arthur Askey in 1953…. It's beginning to seem as if there isn't a pub extant which hasn't been done over… (they) used to be oubliettes of exquisite boredom….[7]

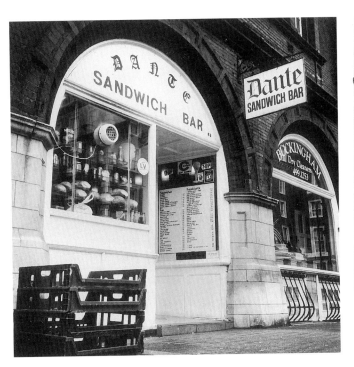
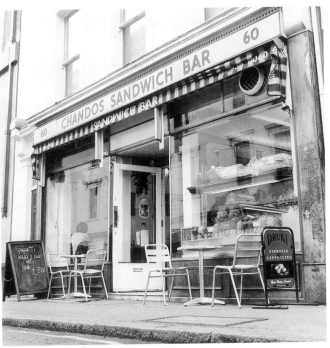

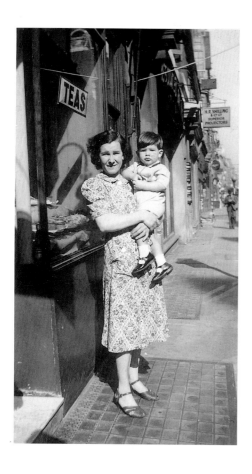

This wonderful family

One key place particularly harshly 'done over' by the re-branders was the celebrated Valoti cafe on Shaftesbury Avenue. Forced to close on November 9 1996, only the previous month 1,500 people – including heavy-weight thespians and long-time customers Albert Finney, Tom Conti and Madonna-muse Rupert Everett – signed a petition to halt its redevelopment. For nearly 50 years the Formica and banquette interior, with its ceiling full of space-age lighting, had been a celebrated actors bolt hole. In her youth, Audrey Hepburn (then an impoverished chorus girl needing credit) had been a regular alongside stars like Sir John Gielgud, Sir Ralph Richardson, Ron Moody, Sid James and Tommy Steele.

Mirka Summers, who worked at Valoti's for over 11 years, was famed for ordering Dustin Hoffman to take his place at the back of a queue. Rupert Everett feared he would "die without my twice daily helping of Valoti's baked beans", and owner Rick Valoti keened: "It's like a community centre here…. Having to leave this wonderful family here is breaking my heart…." Author, critic and self-styled 'Neoist' fountainhead Stewart Home measured out most of his conceptual plagiarist career at the Valoti:

> I used to treat Valotti's like an office. The waitresses couldn't bear to see me licking stamps, so they'd bring over a saucer of water for me to dip the stamps in. The waitresses never changed and they were fantastic. As soon as I sat down there'd be a large tea in front of me. It came in a tall glass that was inserted into a chrome holder with a handle. I loved them: they were like everything you wanted your mum to be but without the aggro of them actually being your mum. They were absolutely the best

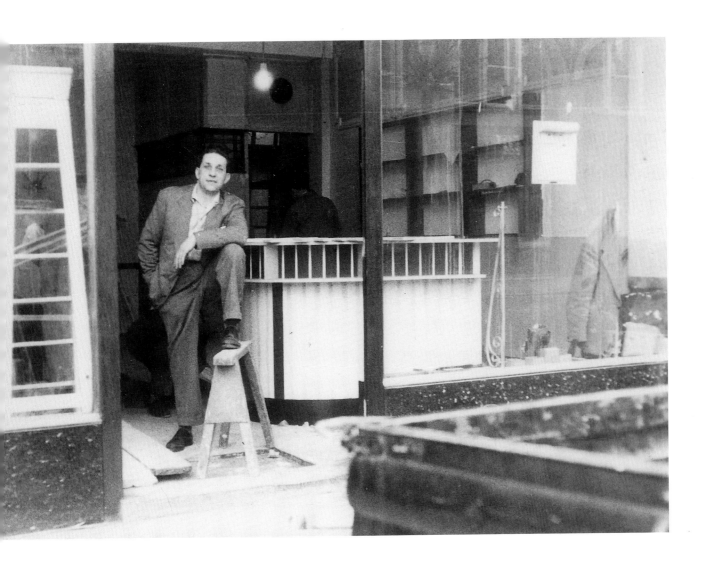

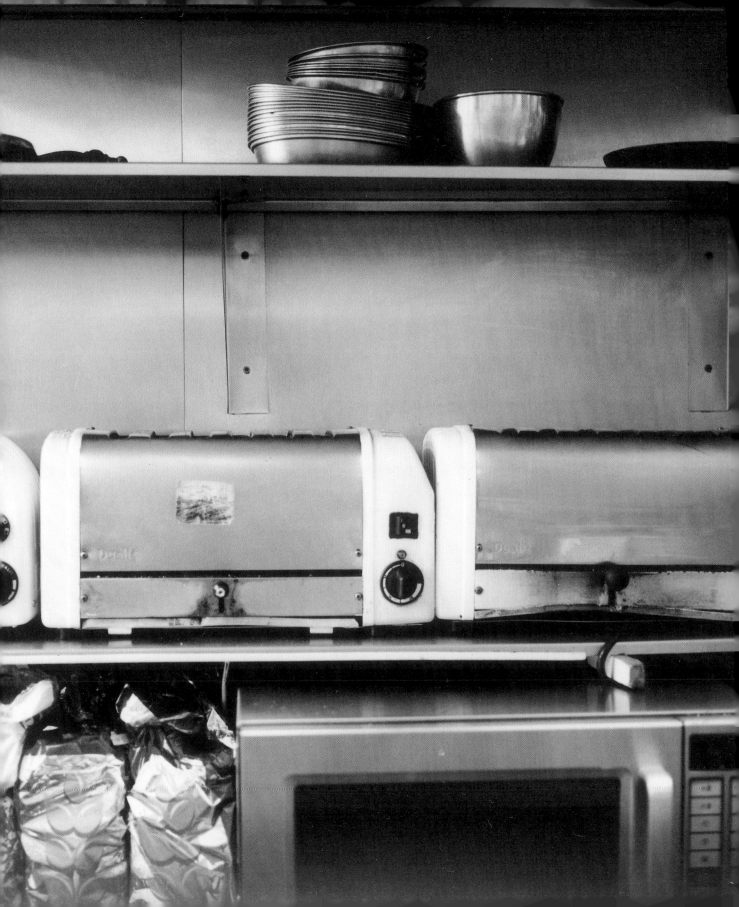

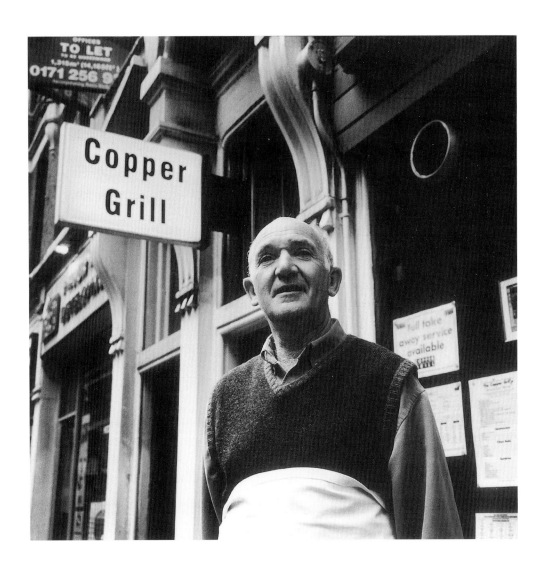

thing about Valoti's. The best waitresses in any cafe I've ever been too, no one could touch them.[8]

Despite the plaudits, Simon Quayle, a spokesman for Shaftesbury plc (owners of the cafe's lease) insisted: "We want to create a bigger place. We don't want a greasy spoon."[9]

Valoti's story reflects the plight of thousands of similar places that closed in the 1990s (1994 was the worst year of the entire century for employment in London) as cafes run by first-generation Italian families all started to disappear:

> Valotis was set up in 1947 in Shaftesbury Avenue and my father, Vic, opened another place, The Sorrento, right next to it; one of the first places to bring over an espresso machine. My mum used to run the cafe on her own when dad was in the army. She used to rule customers with a rod of iron, they all liked her: Audrey Hepburn, John Guilgud and Ralph Richardson…. It was very homely, family run. Never modernised much. A lick of paint here and there; chairs went, banquettes came. Everything was done by hand. Chips were fresh-cut. We even made the pastries and cakes ourselves. When Albert Finney became a star in the original London stage-run of *Billy Liar* my mum used to look after him, he was only a kid! "Call me Alberto, mum" he used to say. He was almost part of the family! The 1950s was the pinnacle of the lunch hour, so we were really busy. These days people eat when they can, the whole ethos has changed. When the big firms with canteens started, lunch trade died down and the cafes wound down too. Then in the 1970s the whole sandwich thing took off. The 1980s were really tough; massive increases in rent. Small places couldn't cope with that. We'd relied a lot on builders coming in but in the 1980s the building trade was non-existent. A lot of cafes suffered. I do miss it; not the work, the bonhomie. It was always a tough business. I always said I don't want my kids to have to do this. But we were family. We stuck through it.[10]

Mirka Summers still keeps the original Valoti door keys: "I just can't bear to throw them out."

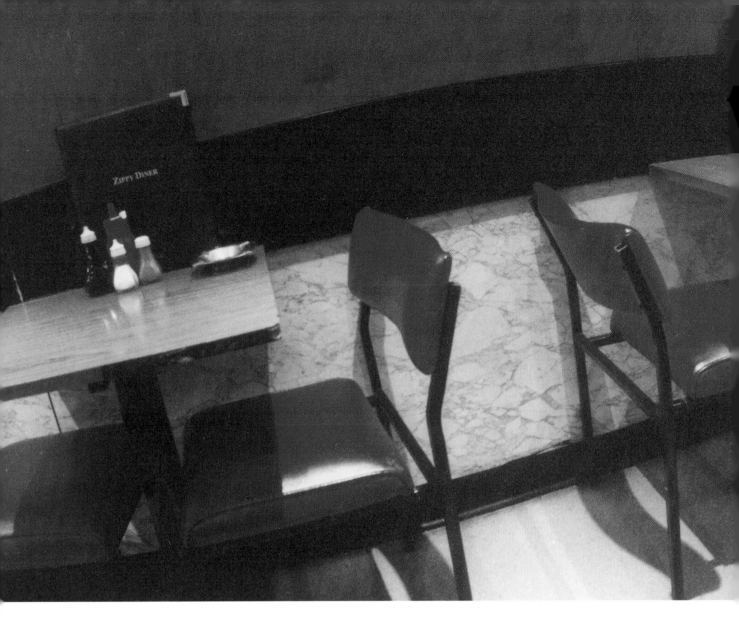

Rank tide

As one generation of Italian cafes closed down, others took their place. Just as the Moka was suffering Wild Bill Burroughs' psy-bombardments, a young Alberto Pagano opened his first trattoria, The Cappuccetto, on Moor Street W1. Pagano, who proudly insists he introduced cocoa powder on the top of cappuccinos to London, had first come to London from Rome in 1962. His brother-in-law already had 15 restaurants in London and the Cappuccetto had belonged to his mother in law. In 1972 he was charged with re-launching the room:

It used to be a Formica cafe. I took over the place with my wife and fitted the basement out all by myself. I didn't like the brickwork that was there, so I decided to panel it. It was meant to be like a cabin on a ship… it was a fashionable thing at the time. We used to have a lot of celebrities. The cabin was used by Tom Jones and Engelbert Humperdinck

nearly every night in its heyday! The Pretty Things used to eat here. To do something with a business, you have to put your heart into it, to give your personality to the business. Three generations of family have come here. Some people got married in the Cappuccetto and now their kids come. My customers tell me "don't change a thing... it's got history, it's warm." These days, places last three months then the money is pulled, there's no time to develop.[11]

What has developed, however, is the rank tide of American coffee outlets. Pleasingly, feeling against them reached such a peak that it briefly became a key plank in Malcolm McClaren's London Mayoral campaign of 2000. Unfortunately, McClaren (who had himself groomed 1980s Burundi pop quartet Bow Wow Wow at Soho's Centrale cafe) withdrew his candidacy at the last minute.

A restoration

Today, you have to look harder than ever to find decent, intact classic cafes. The daddy of them all, the New Piccadilly in Denman Street W1 – a cathedral among caffs – has retained its superb aspect on the hinterlands of Soho since 1951. "I've been here fifty years," says proprietor Lorenzo Marioni, "and apart from when I was in the army, I've been here on this street every day of my life…. This place used to make me a living. Now it's more like half a living. I'm the like last one on the ship. It's sinking, and there's only a little bit of it left above the surface of the water."[12]

Cafes like the New Piccadilly, that survived the culls of the 1980s and 1990s, should be designated national treasures. Central to the success of these venerable old haunts – including New Piccadilly Soho contemporaries like Centrale, Pollo, Lorelei, Euro Snack Bar, Sergio's, Bar Italia, Presto, 101, Bar Bruno and the Cappuccetto – is a certain nostalgic quality but also their unconscious embracing of 'third place' philosophy. Originated by community-values theorist Ray Oldenburg, the term posits a neutral area, away from the distractions of home, office, crowds and bustle, where people can meet as equals. Private yet social, discrete yet visible, the third place is a restorative oasis of peace and repose in an increasingly power-crazed, craze-powered metropolis. A place where "conversation may flourish, individuals may acquire… social polish… and society may reap the benefits of such collective reasoning".[13] Starbucks CEO, Howard Shultz – a third place adept of longstanding – maintains his business is as much about retailing sociablity as providing 'excellence' in the "rich-brewed Italian-style espresso beverage" market. The pay-off: as of today, Starbucks' market value stands at around $11 billion.

A full half-century after the appearance of the first classic cafes, the restorative element of 'third place' thinking points back to the very etymology of the word "restaurant": the "restorative" French soup that by the late nineteenth century had lent its name to all forms of eating houses. With this circularity in mind, it's possible that a return to the proper form and function of the classic cafe might occur. Certainly, as in the seventeenth century, the coffee house remains at the forefront of debate over reform. The Starbucks empire, in particular, has become a focus for anti-globalisation activists. In the words of Situationist operative Raoul Vaneigem, it represents "a caricature of creativity from a conveyor belt", driving out independent operators from local markets and glutting high streets with prefabricated outlets.

Design-wise, post-Starbucks modernist cafes like Eat and Cafe Brerra are more attractively turned out. But, better yet, the S & M (Sausage and Mash) restaurant chain's loving restoration of Alfredo's cafe in Islington is a real indigenous attempt to face-off the American chains. Alfredo's was founded and run by the DeRitus family who came to Britain at the turn of the century. After 80 years in the business, Vincent DeRitus looked forward to his son taking over, "but he wasn't cut out for the catering game". Although parts of *Quadrophenia* were filmed there, first-circle London ganglander Frank Fraser was practically part of the furniture and actor Steven Berkoff was a regular throughout his hungry years, Alfredo's closed for several years. It eventually re-opened under the S & M banner – Formica tables, Thonet chairs, Deco chrome trim and Vitrolite panels fully intact. And the company promises to revive more classic caffs in the future.

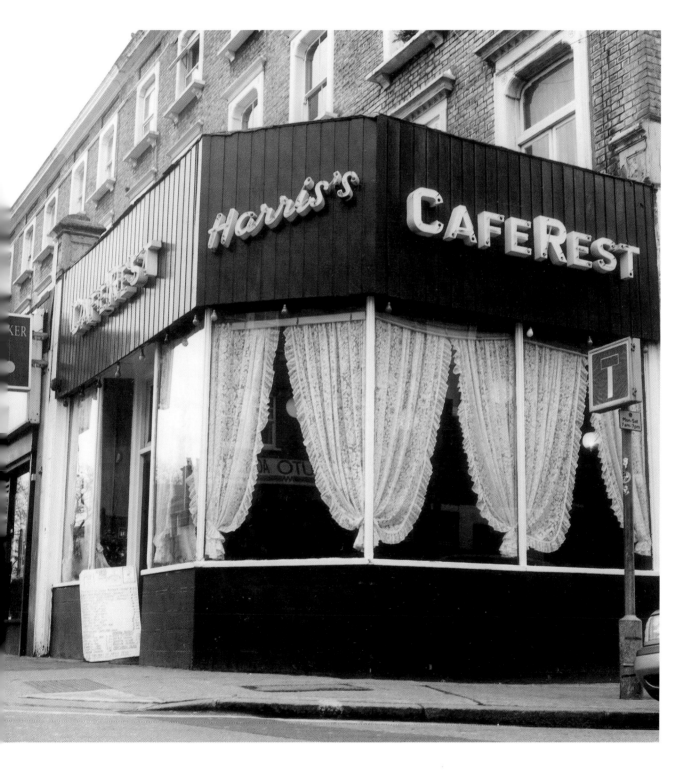

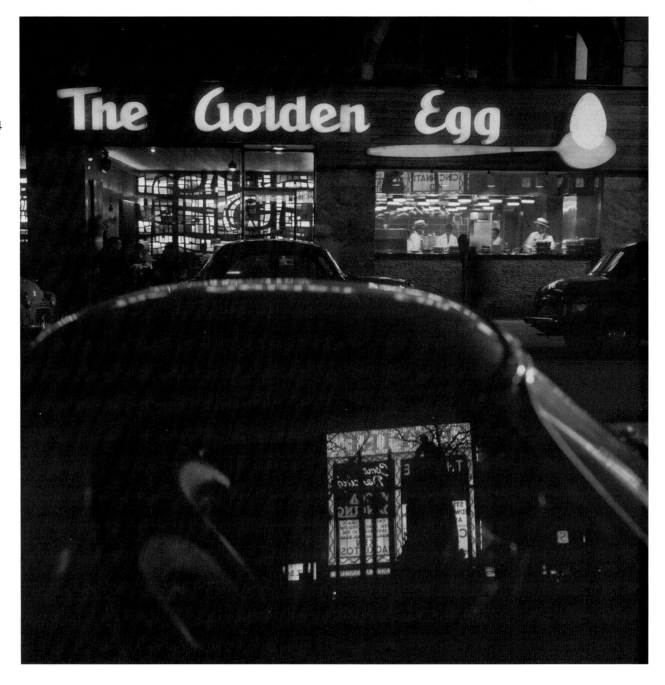

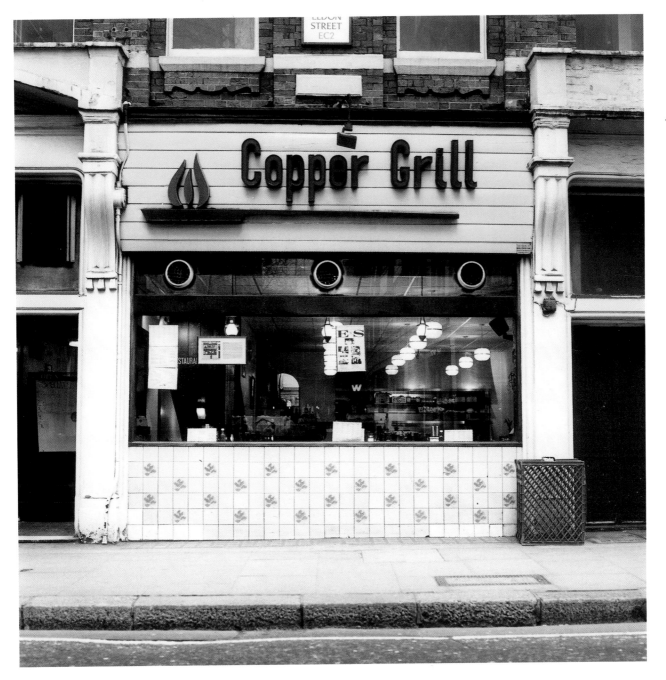

"The world's no. 1 comfort food"

DINGS | BREAKFASTS | TAKE AWAY | SNACKS

Coincidentally, the opening of the Alfred restaurant (no relation) on New Oxford Street in the mid-1990s prefigured the S & M reconstruction by several years. Utilising a vernacular cafe-style in wall-to-wall custard-coloured Formica, designer Quentin Reynolds drew on the caff haunts of his youth. He then went on to fit out Stanleys bar/restaurant on Little Portland Street: all Frank Lloyd Wright relief walls and plush crimson banquettes. A massive pile-up of Brit motorway cafe and LA lounge:

Stanleys was a bit shock horror to most people. Jonathan Meades said it was very Woolworths. I liked that. People are embarrassed about the 1950s period but I like it – that Heals building look, the brave new world. I wanted that British feel. I used to eat at Alfredo's. I knew the family for eighteen years. And I got a lot of the look for Alfred from there, and The Metropolitan on Edgware Road. But I'm not into pastiche. I just take the key elements and move them on. I want to do stuff that will be around for ten years or more. You've got to set your own agenda.[14]

But Kevin Finch – head of S & M restaurants and former chief executive of Damian Hirst's designer eatery, Pharmacy in Notting Hill – actively wants to return to the source. On the back of his Alfredo's relaunch, cafes are now a consuming passion:

With the new caffs I'm doing, the building, the fabric is as vital as the food. Proper tables, authentic light fittings… that's so important to me. Right down to getting the proper plastic "Open" or "Closed" signs in the windows. There are very few opportunities left in the restaurant business. We've had the culinary revolution. Now there's a reaction against higher prices and celebrity chefs. All these designer coffee shops have done is drive up prices and ruin the sector. That whole 'third place' Starbucks thing has moved on. Now's a good time to be at the cheap end of the market, it's a good time to do something British. We want that real atmosphere; we want to be associated with British food, the local community. I want to replicate what Alfredo's was, what it meant. It's got to be done with integrity and it's got to be done with heart.[15]

The classic cafe – restored in full.

In search of classic cafes

The signs of dissipation, that we used to know, are no longer present in the child hoodlum of today. He does not touch alcohol, preferring milk bars and cups of tea in cafes and coffee stands.
Robert Fabian, *London After Dark*, 1958

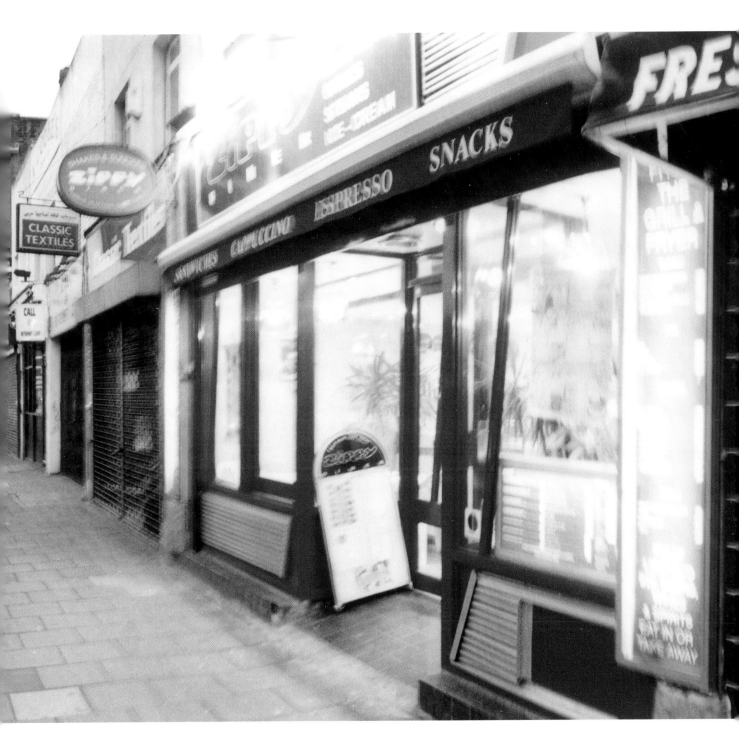

The Cellar Club was a coffee bar down fourteen steps and narrow stairs from the pavement. A dark, damp and disused cellar before the dawn of the Espresso age, it had rapidly been converted by two existential artists....They had ridden high on the wave of Espresso enthusiasm....The Cellar Club was a vortex of noise, frenetic movement, and cigarette smoke.

W Howard Baker, _The Cellar Boys_, 1963

Synoptic urban drift

Britain's Post War gloom and insularity were a recurring theme of much of the work presented at the Festival of Britain and the topic preoccupied artists and critics throughout the 1950s. After years of actual, and metaphorical, blackout, many paintings of the time blaze with intense colour palettes that play with motifs of interpenetrating light and dark. Festival exhibits frequently used "decorative colour as a means of stimulating the perception of light…" – a process that has been linked to "the spatial and temporal 'porosity' observed by Walter Benjamin in the city of Naples."[1] This invocation of the great flâneur is itself illuminating; Benjamin's accounts of early twentieth century Paris ("Full of beautiful aphorisms and leaps of imagination, a scholarship of evocation rather than definition") manifest the same sense of primed latency that marked the cafe scene of the 1950s.[2]

Though the term "psychogeography" originally harks back to Thomas De Quincey's dreamy, druggy treks of the nineteenth century, Benjamin's excursions around the Paris streets of the 1920s – fusing Jewish messianism, Kabbalism, Marxism and visionary Surrealism – redefine psychogeography, making it "more extreme, a matter of taking very conceptual decisions about the walking you would do and how you would access the city like that."[3]

After *Internationale Situationiste #1* 1957, the term evolves again, indicating the study of the effects of geographical settings on mood and behaviour. Today, the expression is possibly most readily associated with Iain Sinclair's synoptic urban drifts; the divining of the unconscious cultural contours of places… with a twist: "By the time I was using it, it was more like 'psychotic geographer'… more of a raging bull journey against the energies of the city… of creating a walk that would allow you to enter into a fiction."[4]

...IPS	300	
...GE CHIPS	300	
...GE BACO...	300	
...ON BEANS CHIPS		
...ON BEANS CHIPS	350	
...TOMATO CHIPS	400	
...GE BEANS		
...EF BEANS CHIPS	5.00	
...E BEANS CHIPS	300	
...L BEANS CHIPS	350	
...ER BE..NS CHIPS	350	
	350	
	350	

...CHIPS	350	
	350	

EXTRA PORTIONS

SIDE SALAD	200
TOMATO	
SAUSAGE	100
FRIED EGG	
BEANS	
MASH	
CHIPS	
2 TOAST	90

SALADS

HAM	350
SOTCH EGG	250
EGG	250
CORN D BEEF	350
CHICKEN	350
PORK PIE	250
CHEESE	300
ROAST BEEF	400
PRA N	400

(TO... TOA...)

...ES	
...EAK PIE BEANS	300
...EANS SAUSAGE	350
...BEANS TOMATO	350
...E BEANS TOM'S	400
...PASTY BEANS	350
...USAGE BEANS	350
...EANS T MATO	400

SWEETS

WILL
I EVER
SEE
YOU...

...LL WITH BUN	
...URGER CHIPS	200
...URGER CHIPS	220

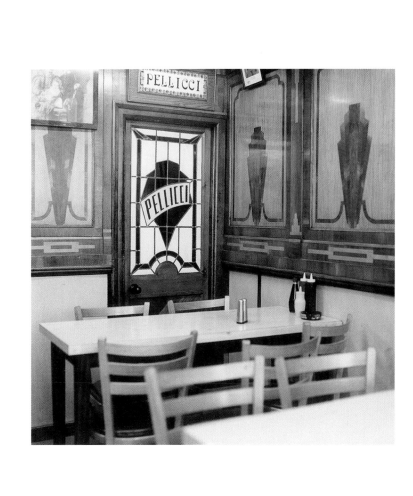

Greatest social revolution

As so many cafes today remain effectively benighted often the only way to bring them to light is via random walking exercises in the Sinclair or Benjamin mould: taking wrong turnings, looking down and around corners, blundering behind main streets. A broad sweep through the EC1 postcode, for instance, uncovers many leftover classic cafes. This presence is concentrated around and about the Dickensian tenement back streets of Mount Pleasant and Clerkenwell where the influx of original Italian immigrant families first forged a unique UK cafe style. The visual focus here is the mix of traders, brokers and their banshee PRs. Andrew's on Gray's Inn Road acts as an unofficial clearing house for entrepreneurs from the nearby multi-occupation office block of Mount Pleasant's Panther House; a warren of lean-to offices in a former optics factory, over-run with waxing and waning DJ collectives, wanna-be label barons, graphics moguls, artiste wranglers and innumerable low-end maestros.

Other surrounding cafes (City Snacks, The Golden Fish, Farina's, Luigi's, Muratori, Scotti's...) are similarly charged; still exuding all the original promise of a Britain looking out beyond itself, craving the more open, social lifestyles of Europe from a time when:

"The vogue for coffee bars... provided a whiff of exotic cosmopolitanism and gave eclecticism free rein... (when) the increasing availability of Italian espresso machines from 1953 occasioned what *Architectural Design* hailed as "the greatest social revolution since the laundrette".[5]

With most classic cafes fading fast, here is a personal selection of some of the best left standing in London – and further abroad – as of September 2003. Updates and photo-specials can be found on the companion website to this book www.classiccafes.co.uk (click the tea cup logo on the homepage to access a full London cafe tour...).

Gazetteer

North (central) London

Bloomsbury Restaurant, Brunswick Centre WC1
Set in a vast brutalist housing estate amongst a cluster of windswept concourses, boarded up shops, walk-in centres… and art cinemas, the Bloomsbury's fake brick wallpaper is repellent but the green booth seating is cheerfully redolent of some long lost motorway caff circa 1968.

Chandos Sandwich Bar, Chandos Place WC2
A fine red sign and Wimpy-style interior with solid booths and a great range of single chrome and green leatherette stools ranged along the back eating bar.

Regent Cafe, Whitcomb Street WC2
Hidden off the main tourist drag of Trafalgar Square, this half-decent little plain cafe has some pensive and withdrawn brown booths at the back. Nice hanging sign outside too.

Andrew's, Gray's Inn Road WC1
Slightly off the Little Italy drag, Andrew's is a brilliant local "plain" cafe: fine part-mosaic exterior; solid dun-coloured window frames; generous awnings; worn Formica tables; Thonet chairs; nice hatstands and an intriguing serving hatch.

City Snacks, Theobalds Road WC1
The huge outside sign signals a fine local. The small interior is notable for its wall-to-wall Formica.

Fryer's Delight, Theobald's Road WC1
Original old-style chippy with several sit-down Formica (and coloured leatherette) booths. Chips here are still made with beef dripping. A local landmark.

Alfie's, Mount Pleasant WC1
This hole-in-the-wall caff boasts a tiny counter bar running like a ledge of Formica round the walls, a Belisha beacon of a sign in orange Copperplate and a magnificent clock shaped like a cappuccino cup.

Sidoli's Buttery, Alfred Place WC1
Good seating and a pleasing ambience well away from the crushing boredom of the Tottenham Court Road furniture shops. The Sidoli family used to run chains of cafes throughout Britain.

Bar Central, Bernard Street WC1
Almost next to Russell Square tube, this caff is joined on to a pleasant old trattoria. The nice suspended moderne ceiling is reminiscent of Morelli's in Broadstairs. Half a dozen rangy leatherette booths make up the seating along the walls.

Tea Rooms, Museum Street WC1
Peter Ackroyd's vital *London: The Biography* reproduces a mournful 1914 painting by William Ratcliffe entitled *The Coffee House* with the caption: "despite its colourful interior… the cafe conveys a characteristic melancholy and anonymity". The Tea Rooms miraculously retains all of this flavour.

Zita, Shaftesbury Avenue WC2
Just round from the Tea Rooms, the Zita preserves a few highlights left over from the Festival of Britain Contemporary look: a nice 1950s exterior sign, glorious orange Formica seats and a suspended ceiling. The waitresses have orange aprons with the cafe logo on it.

101 Snack Bar, Charing Cross Road WC2
This little pull-in, almost opposite the Phoenix Theatre, has been a Soho staple for decades. The intensely coloured yellow and black laminate interior stands out like a beacon. The faded and broken outside sign is a classic.

Centrale, Moor Street W1
Tiny but with a good big window frontage and battered old brown vinyl seats. Functional and lovely, this is where Malcolm McClaren used to dragoon his 1980s band, Burundi pirateers, Bow Wow Wow. Unchanged for 50 years.

Amalfi, Old Compton Street W1
Pleasantly renovated restaurant with a large basement. The adjoining coffee bar is ruined but the main room has kept its great murals, lamps, Sorrentine tile-work and a beautiful blue ceiling sculpture.

Cappuccetto, Moor Street W1
Small patisserie with part-panelled interior serving own-brand cappuccinos and cakes. The owner, Alberto, claims to have introduced pesto to Britain in 1962 and the powdering of cappuccinos with cocoa.

Trattoria Aldo, Greek Street W1
Lost trattoria with rows of cute booths strung round with cod-Italiana.

Valtaro, Kingly Street W1
Unremarkable interior but the brown leatherette bench seats (and a convenient Soho location) mean it's worth a punt. The wall menu and paintings on the back wall add much needed atmosphere. Service is spectacularly grudging.

Presto, Old Compton Street W1
Cruelly overlooked for decades, the orange and blue booth interior (with its plastic oak beams and opaline lights) makes for a great Italian chalet-style experience. One corner is a shrine to Derek Jarman – once the Presto's most devoted customer.

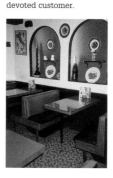

Pollo, Old Compton Street W1
The lovely red and black seats, beanpole rails and hanging signs recreate something of the look and atmosphere of the original Soho coffee bars.

Maison Bertaux, Greek Street W1
Small patisserie cum cafe with a rickety upstairs room that looks like an old dairy annex: wood seats and tables and a delightful selection of cakes and pastries.

Bar Italia, Frith Street W1
Founded in the late 1940s, the neon entrance sign and hanging clock front an interior with stools running down a long counter space laminated in two-tone Formica. Open 23 hours a day, the atmosphere is somewhat impaired by the large projection TV and droves of Soho media flunkeys.

Lorelei, Bateman Street W1
Slapbang in the centre of Soho, the Italian flag exterior and the lovely old sign are all absolutely untouched. The interior resembles a miniature village hall circa 1958: linoleum floor, square Formica tables, shabby posters, tiny serving area, creaky wooden chairs. Hot tip: the hidden entrance to the side of the restaurant is reputedly the club that local strippers retire to when their own gaffs have closed.

Bruno Snack Bar, Wardour Street W1
A little slice of ye authentic Soho of olde which, along with the Lorelei, has eluded the developers. Chalet-style pew booths in cheery green leatherette sit under massive wall menus offering dozens of Italian sandwich combinations. One of the few London cafes to stay open late into the evening.

Marylebone Cafe, Thayer Street W1
Plain-style caff on the verges of Oxford Street. Good exterior mosaic tile patterning and a big bold nameplate. Decent booth interior.

Paul Rothe, Marylebone Lane W1
Untouched deli and old-fashioned provisions shop dating from the early twentieth century with unique fold-up white leatherette seating area. Renowned for its liptauer sandwiches.

John's Sandwich Bar, Mortimer Street W1
A cluster of frayed brown booth seats, unusual patterned counter, ratty hessian wall coverings and interesting false ceiling units. Plus, for caff anoraks, the very same elegant patterned cup 'n' saucer sets used by the mighty Alpino in Islington.

Maria's, Grafton Way W1
A sumptuous orange and yellow Vitrolite exterior with Deco metal trimming. Despite the small interior, there are two good gingham covered tables with excellent minimalist 1960s leatherette 'n' metal chairs. A chalet-style beamed ceiling and trusty Helvetica awning completes the package.

Sandwich Bar, Brooks Mews W1
A hidden gem, utterly overlooked in a lost mews surrounded by galleries and serviced apartments (and one of the only surviving London cafes originally listed in Jonathan Routh's *The Good Cuppa Guide* of 1966). Amazing sign, good door handles, brilliant green leatherette seats, worn Formica tables. Functional and friendly. A model of British utility.

The Chalet, Maddox Street W1
This compact little place (with two hidden rear sections) is kitted out in 1960s Swiss-style very much like the Lucky Spot (in North Audley Street) and Scoffs (on Kensington High Street). This look was once all the rage, as Alpine-exotica briefly irrupted throughout Europe. Lots of polished brown wood, curved panels, fancy ironwork lighting and pew-bench seating. Perfect for Bond Street impulse-trysts of all kinds.

The Lucky Spot, North Audley Street W1
An oddly grand stone exterior fronts this crypto-Swiss interior featuring carved high-backed pews and lots of dark panelling. The owner reckons the design is Elizabethan pastiche.

Stanley's, Little Portland Street W1
The LA-lounge-cum-motorway-caff design was overseen by Quentin Reynolds. Frank Lloyd Wright relief walls in grey, dazzling scarlet banquettes… and a big municipal clock over the stairwell.

The New Piccadilly, Denman Street W1
A cathedral amongst caffs run by the irrepressible Lorenzo and his crack team of uniformed waiters. This is the last of the big hitters left in Soho and one of the largest original cafes left in Britain: pink Formica coffee machine, big plastic horseshoe shaped menu, wall-to-wall lemon Formica surfaces and lots and lots of brilliant booth seating. Even the New Piccadilly menu is a collectors-item design classic. Truly, a place of reverence.

Euro Snack Bar, Swallow Street W1
Tucked off the tourist trail, subsisting on a seemingly need-to-know basis among a brace of lapdancing clubs, this smart little snack bar sports a superb orange and green frontage with 1960s typography. Inside: small, comfortable booths; low ceilings and odd little mini-counters holding the drab green salt 'n' pepper sets.

The Express, Shepherd Street W1
The only authentic part-classic cafe left in Mayfair. Great frontage with a small, Formica table interior. A nice touch: the "model for hire" red-light perched in the window of the flat above; a throwback to the friendly old Mayfair of yore! Heritage Britain at its best.

Golden Hind, Marylebone Lane W1
Open for nearly 45 years and owned by the Schiavetta family, this Art Deco chippie with classic cafe chairs and tables – and staggered opening hours – has become monstrously popular.

RendezVous, Maddox Street W1
Espresso Bongo-like sign outside and a domestic living room interior featuring a bay-fronted window, covered tables, excellent wooden chairs, hanging lamps, and lashings of warm Formica on the walls.

Fish Bar & Kebab House, Whitfield Street W1
The main front-section is a standard fish bar, but tucked round the side is a bolt-on mini-restaurant that looks pretty well untouched since 1953. Features include: square, solid, metal and drab-green leatherette chairs; ranks of tables; polished vinyl-wood walls; scallop shell ceilings; period clocks; random wall plates….

S & M Restaurant (formerly *Alfredo's*) Essex Road N1
Owned by the DeRitis family for some 80 years, the Deco styling dates from 1947 and the lovely chrome exterior doorways, tiling and Vitrolite interior are listed. (The upper apartments are protected as an eighteenth century terrace.) Lashings of blue Formica and polished surfaces throughout. Lovingly restored in 2002.

Alpino, Chapel Market N1
Only the stylish serif typeface of the sign above the door indicates anything special from the outside. Inside, however, this is a wonderland of fine top-of-the-range period tables and luxury booth seating. The Alpino's plum-patterned cup and saucer sets are ceramic perfection.

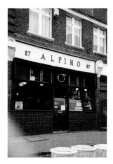

Sorrento Snack Bar, Woburn Walk WC1
Hidden in a lovely enclave of late Georgian bay-fronted shops near Euston, this place features good booth-style wooden seats and murky-green wall tiling. A neat row of leatherette and steel upright stools runs along a breakfast bar style counter. (Surrounded by great little specialist second-hand bookshops.)

The New Goodfare, Parkway NW1
Super old-style Italian restaurant/cafe. Not a looker from the outside but good tables and chairs within… and a huge back wall mural. Open seven days a week. Worth noting the fine scallop door handle on the main entrance too.

Continental Cafe, Highgate Road NW5
This dark, dank, dusty old caff is unchanged in decades – a feast of raw chipped Formica and buckled laminate sitting disconsolately in the base of a mysterious bright red building almost opposite The Forum club.

San Siro, Highgate West Hill N6
Good, old and rundown with great tables and chairs and a suspended ceiling detail. In terminal decline for decades but still up and at it in the ambience stakes.

Coffee Cup, Hampstead High Street NW3
Venerable institution which somehow retains the feel of an original seventeenth century coffee house: red-and-white stripped wooden canopy over the front; gothic logo over the entrance; dark, cosy panelling; tasselled ironwork chalet lamps on the walls; crumbling vine-patterned

cornices; a mediaeval-looking carved door; mosaic steps; low pews, banquettes and red velvet stools everywhere. A fine companion piece to The Troubadour in Earl's Court.

John's, Chalk Farm Road NW1
Great plum and cream interior with fluted panelling on the lower walls and fine chairs. Brusque service a speciality.

Highbury Cafe, Holloway Road N7
A good selection of solid wooden tables and chairs, featuring worn tartan patterning, plus a back section with six booths and powder blue Formica panels. (Also worth a visit nearby, The Trevi Italian restaurant by The Garage music venue – a mini-lounge with booth seating throughout.)

Hope Workers Cafe, Highbury Corner N5
For the brilliant array of polished wood chairs and tables alone this is worth a punt. Pity about the wretched metal doors and window surrounds though.

Panda Restaurant, Holloway Road N7
With a lovely old sign above the door and a fusty interior left just as nature intended, this is net-curtained, faded English gentility at its finest.

Rheidol Rooms, St Peters Street N1
Good plain cafe filled with fine yellow Formica furnishings throughout.

The Italian Restaurant, Rochester Row SW1
A truly great local in a brilliant little enclave dating from 1936. The impressive beige curvilinear counter is the centrepiece. Classic monochrome Formica covers all the walls and there's an authentic parlour-like section through a lattice work. Smashing hand-painted sign outside too. A delight.

New Grosvenor Cafe, Horseferry Road SW1
A few doors up from the now ruined Fiesta cafe, this has a brilliant exterior sign in Gill typeface with some surviving red leatherette seating.

Tony's Cafe, Chapter Street SW1
Neat local in Victoria off Vauxhall Bridge Road. Good booths and interior lighting. Simple but effective.

Wilton, Wilton Road SW1
Splendid 'plain' cafe in the heart of Victoria: top sign, powder blue marbleised flooring, neat rosewood and black leatherette booths. Very cramped.

Regency Cafe, Page Street SW1
Imposing black tile Deco exterior with lovely Gill typeface logo built into the base of a 1930s block of mansion flats. Walls and ceilings are good but all the original tables and seating have been removed. Often used for film shoots.

East London

E Pellicci, Bethnal Green Road E2
Owner Nevio was born above the shop and Pellicci's has now been serving up top nosh for over 100 years. The jaw-dropping marquetry interior – like something out of the Empire State Building – was crafted by Achille Capocci in 1946. The imposing exterior Univers-face steel logo on custard-coloured Vitrolite panels makes for maximum authenticity. Local heavies the Krays were firm fixtures during the 1960s. This is simply one of the greatest – and friendliest – eateries in the world.

Copper Grill, Eldon Street EC2
This timewarp caff is set in an unlikely road behind Liverpool Street. The large amount of wood booth seating is inspirational. Other key features include: rosewood tables; Lapidus beanpole rails; good window lights; great yellow outside sign (Golden Egg-style) and, better yet, a large downstairs basement with caff-murals adorning the back alcoves.

Piccolo, Eldon Street EC2
Next door to the Copper Grill, this narrow cafe has an unusual basement with classic chalet-style decor throughout and great purple-patterned Formica table-tops. Both upstairs and downstairs sections retain the original Swiss light fittings.

Dino's, Commercial Street E1
Good old Italian survivor from the days when this area was rife with Dino family cafes. Rangy seating and a neat dumb waiter. Demand a serving of Dino's excellent 'specialist chips' – which for some reason you have to know to specifically ask for.

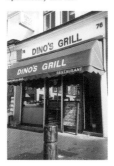

Vernasca, Wentworth Street E1
Hard to find behind the bag stalls of Petticoat Lane, inside, the dark sensurround rosewood Formica gleams under the lamps. Serried ranks of green booths and neat little plum-coloured cup and saucer sets....

Rosa's, Hanbury Street E1
Bud Flanagan once lived above the shop but this is now a pleasant left-alone relic selling awesomely cheap food and featuring a vaudeville shrine in one corner and signed Gilbert and George ephemera in the other. (It's also now their local after the closure of the Market Cafe near their home on Fournier Street.)

City Corner, Midddlesex Street EC1
Good looking cafe with compact sea-green leatherette booths, a lovely back-wall mosaic and nice menus in the window. Terrible prices however and consistently grim service.

Farina's, Leather Lane EC1
Farina's has a fine large dark interior with marbleised, chrome legged tables and dozens of worn, green leatherette chairs. A classic of its kind in the heart of Little Italy.

Luigi's, Roseberry Avenue EC1
Once used for a Pulp LP shoot, this little gem has a classic Univers sign, a couple of fine booths and some stool seats. A hideaway basement (down a tiny stairwell behind the counter) is decked out in two-tone fake-wood Formica. Always rammed with postmen from the local Mount Pleasant sorting office.

Golden Fish, Farringdon Road EC1
Eleonora Ruocco's cosy familial Italian cafe, opposite Mount Pleasant post office, is also half of a fish and chip shop. The dainty interior, with its ranks of 1950s rosewood booths with metal arms (very like those in the Copper Grill), is one of the loveliest in London. The lone antique hatstand by the door always brings a lump to the throat.

Muratori, Farringdon Road EC1
Set up by Parma Italians in the 1960s, this all-brown cafe retains superb panels throughout, top-notch Formica wood veneer tables and some high-backed booths for good measure. Family-run, and always overrun with gangs of howling cabbies, manageress Giuliana Muratori reckons there's one vital ingredient for a successful caff, "Noise!".

Quality Chop House, Farringdon Road EC1
Not a caff, but a perfect example of a chop house established in the late 1800s as a "progressive working class caterer". Retains many original fittings including pews and etched windows inscribed with the legend "London's noted cup of tea".

Scotti's Snack Bar, Clerkenwell Green EC1
An absolute gem surrounded by churches, fine industrial architecture and the myriad attractions of Little Italy. Great panel ceiling; fabulous grey op-art Formica walls; grade-A chairs; classic counters and 1950s shelving throughout; a mysterious stairway; attentive staff; fine lights; good clocks; kitsch parlour paintings; textured 1940s wallpaper; confection displays... all of human life is here.

Popular Cafe, Lever Street EC1
Doubles as a basic Thai restaurant. Univers typeface over the old double-doorway; classic oval Pepsi sign outside; dark orange Formica tables; ratty red leatherette seating and fake wood wall panelling. Nice display of giant fork and spoon wall hangings too.

Barbican Grill, Whitecross Street EC1
Good dowdy sign and green booth-style seating in an excellent little enclave near Bunhill Fields cemetery.

Central Cafe, West Poultry Avenue EC1
Set inside one of the great meat market avenues, hidden under the awnings, this place is a symphony of beautiful yellowing tables and a wall-to-wall powder blue Formica. Chipped, grubby and perfect.

Beppes, West Smithfield EC1
Nice booth seats, brilliant signage and a beaten copper counter. The tables are slightly altered but the locals relish this family-run place with its sense of Clerkenwell history and legendarily frosty service. Old man Beppe's journal is framed on the wall (with a picture of him as a young lad) but the power in the house is Mama with her signature house dish, steak and kidney pie.

Butts, John Street EC1
Unremarkable exterior but a fine deep-brown furnished interior with chocolate coloured Formica tables, proper Thonet chairs and a mosaic floor built of large bright shards of tile.

Castle, Paul Street EC2
Built into the base of a derelict three storey building, this cafe features stool seating looking out onto the street, old-school shelving and a warm and friendly Italian family behind the counter.

Ferrari's, Lea Bridge Road E17
A chequerboard floor, endless brown booths and plenty of chrome stool bar seating at the counter.

L Rodi, Blackhorse Lane E17
Splendid old caff that's been with the same family since 1925. The frontage is somewhat altered (thought the excellent "L. Rodi Light Refreshment" sign is untouched) but the interior is phenomenal. The front room is a fantasy of marble-mint Formica set under sparkling Vitrolite; chrome edged tables are packed tight opposite an original counter which has a huge 1930s extractor pipe hovering over the tea boiler and a giant old English Electric fridge at the back; the upper walls are lined with authentic 1950s tobacco posters. The back room is a veritable caff museum: lined with emerald and off-white tiles; Victorian marble tables; a working grandfather clock that still chimes the hours; black lacquer bentwood coathangers; framed menus from the past and beaten silver signs embossed with the words "Teas" and "Suppers". There used to be three other Rodi branches in Islington and Westminster and – as the display of black and white snaps of Rodi's through the ages shows – the place has barely changed in a century. Overwhelming. Emotional. Essential.

Sea Breeze, High Street E17
Well worth travelling for (near-ish the tube end of this packed local market street): behind the cut-glass front door there's a remarkable interior with large black and brown booths, astounding light-fittings and masses of Mondrian-coloured Formica panels throughout. A must-see.

L Randolfi's, Roman Road E3
A sandwich-only caff with marble Victorian tables, magnificently worn Thonet chairs, Vitrolite panel ceilings and a wooden-shack rear-section with simple painted lemon walls and a dozen 1950s counter stools. Some original neon strip lighting remains over the counter and ice creams are still served from the front hatch on the street.

Regis Snack Bar, Leadenhall Place EC3
The fine little 1950s frontage of this cafe sits in the shadow of the Lloyd's Building at the side of Leadenhall Market. Inside, it's counter stools all round, fake beams on the ceiling and relentless bonhomie from the three serving guys.

Star Cafe, Whitechapel Road E1
Acres of proper 1970s leatherette booth seating and a general air of large-scale Wimpy styling remain in this old cafe – situated opposite the hospital where the remains of Elephant Man are kept.

Pubali, Commercial Road E14
Part normal fry cafe, part basic Indian restaurant, this is one of the few London caffs to be protected by English Heritage – the frontage can't be altered since it's technically part of the listed building next door. The characterful gothic undertakers a few doors down used to keep their overspill coffins in the basement here.

Roman Fish Bar, Roman Road E2
Good looking chippy with powder blue Formica counter and odd orange high-back pew booths. Nice fish motif on the signage.

Don's, Lower Clapton Road E5
Almost as turbid as the Clapton Ponds it stands next to, with its creaky double-fronted exterior and unremitting drab decor, this caff seems to be perpetually on its last legs. Orders are written in felt-tip pen on an ancient piece of plastic on the counter which is then wiped clean. Don's chirpy whistling (and the accompanying polka music) is a unique selling point... along with the big fat caff cat.

South London

Cafe On The Green, Camberwell Green SE5
Small and scuzzy with fair seats and endlessly bickering staff.

Gambardella, Vanbrugh Park SE3
Run by the same family right from its opening day over a half-century ago, this is possibly the most hidden cafe gem in all of London – lost in the Blackheath Standard area at the top of Greenwich Park. The building dates from the 1930s, but the unique moulded plywood revolving chairs were installed during the 1960s. Other fine features: the amazing flesh-coloured Vitrolite and chrome front section; the red and black Formica back room; the silver Deco clock, the tile-floor parlour, the 100 year old fridge; the nifty old wall heaters.... A masterpiece.

Mama's, Waterloo Road SE1
This utility-build worthy has interesting high-backed grey booth seats, solid tables, good counter-space and corking wall coverings. Often rammed with extravagantly flatulent building crews.

Marie's, Lower Marsh Street SE1
Small but popular local with a superb ratty, two-tone Formica interior and plenty of red booth seating.

Perdoni's, Kennington Road SE1
The dread selection of wall-pictures is a turn-off, but the plentiful coffee-brown booth seating is a compensation.

Phoenix, Coldharbour Lane SW9
Great, packed little local with plain laminate walls, proper tables and chairs and a small corridor-like back section. An institution holding its own in one of London's most wretched drug thoroughfares.

West London

Metropolitan, Edgware Road W2
Just down from where the Regent Milk Bar used to be, this longstanding local features lots of green and cream Vitrolite and an original plastic deco counter with stylish moderne lettering. Joe Strummer and Paul Simenon were regulars in the late 1970s and the old place briefly appears to no great effect in the execrable Clash vehicle *Rude Boy*.

Chelsea Kitchen, King's Road SW3
Long established coffee bar-ish place dating back to the 1960s with nice period booths and banquettes upstairs and a roomy downstairs basement full of alcoves. (The Picasso cafe down the road retains its original sign – though little else – from an era when it too was a key King's Road hangout with Martin Amis and Anita Pallenberg among the regulars.)

Harris' Cafe Rest, Goldhawk Road W12
Loizos Prodromou came to London from Cyprus in 1951 to take over Harris' and the same Greek Cypriots have been running the place ever since. The fluted wall panelling, voluminous net curtains, anaemic pot plants, hat stands, dun 'n' plumb coloured panels, place mats, and motherly waitresses make this a real home from home.

Zippy Grill, Goldhawk Road W12
Almost opposite Harris', Zippy's neat red leatherette booths and American diner-style fixed counter stools have been welcoming market folk for decades. The interior is the nearest thing London has left to the old original Wimpy. Look out especially for the illuminated plastic menus, above-the-counter lights, and single fixed tables running up the back with free standing leatherette chairs.

P George, Fulham Road SW6
Near Pulton Place, this still surviving caff was featured in Ken Loach's film *Poor Cow*. Facing an old ABC Cinema in 1967, it's where Carol White gets into a hopeless love tangle with Terence Stamp. (Scott Walker also filmed a BritVic advert sitting in the window here.)

The Troubadour, Old Brompton Road SW5
An important, authentic and unusual cafe environment from a period when Earl's Court was rampant with coffee houses. Founded by Michael and Sheila van Bloemen in 1954, the walls and ceilings are hung round with exotica. (*Private Eye* was first produced and distributed here. Paul Simon, Charlie Watts, Sammy Davis Jnr, Jimi Hendrix and Bob Dylan all performed here.)

Daquise, Thurloe Street SW7
Lovely old Polish tea room cum refectory overseen by legions of harassed looking waitresses. Like The Troubadour, it has a strong flavour of original 1950s coffee bar.

Pembroke Cafe, Warwick Road W8
An unpromising exterior but a fine booth-based set-up inside. Always packed with builders.

Frank's, Addison Bridge Place W8
Uniquely situated above a railway line, this is a superb old American diner-style place with crumbling interior, single stool seating and a picturesque Deco counter area. It's actually built out of an old abandoned signal box. Along with the Snack Bar in Brooks Mews, this is one of the only surviving London cafes to be listed in Jonathan Routh's *The Good Cuppa Guide* of 1966.

River Cafe, Putney Bridge Approach SW6
This place has it all: superb Vitrolite ceiling, magnificent blue-tile work, garlanded friezes, murals, excellent wood seats, full-on Formica tables, large busy counter, eccentric locals and a splendid frontage with Gill-face sign. (Also a handy base for a river visit to the church that featured in *The Omen*.) A show-stopper and no mistake.

Metro, Goldhawk Road W12
Built precariously into the tube station, the Metro was comprehensively destroyed internally in July 2002 after remaining characterfully empty for decades. However, the old rotting frontage with a "Lunches" sign in the window remains. To move with the times, owner Michael inexplicably installed a dozen Edwardian drawing room tables and draped the entire place in Eritrean nick-nacks. The cafe is now rammed every day.

Other British classic cafes

Despite the capital having the highest remaining concentration of classic cafes, good examples can still be found beyond London – often around older, less modernised seaside resorts or towns… .

Morelli's Cappuccino, Victoria Parade, Broadstairs
One of only a handful of 1950s UK coffee bars left in existence. With its swathes of original pink vinyl seating, a small working fountain and an amazing curvilinear suspended ceiling, the general out-of-timeness makes the place feel like a sort of Portmeirion in pink Formica.

Rossi's Coffee Lounge, Western Esplanade, Westcliff on Sea
Sitting at the base of the vaguely Moderne Cliffs Pavilion, this shrine to light refreshment is always packed with pensioners and children who revel in its blatant other-worldliness. The frontage (which should be listed immediately) has good sea views.

Connaught Corner House, Marine Parade, Worthing
Worthing seems to have been pretty well forgotten since Harold Pinter briefly lived there in 1963 (and wrote the scripts for the films *The Pumpkin Eaters* and *The Homecoming*). But the lovely Connaught, with its large curved windows overlooking the pier, retains a Pinter-esque flavour – a languid enclave of plump, olive banquettes, slow churning ceiling fans, pot plants and marbleised Formica.

Harbour Bar, Sandside, Scarborough
Famed for serving some of the best ice cream in the country, Giulian Alonzi's Harbour Bar is almost unaltered since opening in 1945. With decor described by *The Times* as, "a sunburst of yellow and white, a banana split recreated in Formica" the walls are lined with mirrors and slogans "Get your vitamins the easy way", "Eat ice cream every day"." The Alonzi's settled in Scarborough in 1896 and the old milk bar is thriving. Says Giulian: "We're busy all winter here…. In the summer, people come to enjoy themselves…. In winter, they come to enjoy the place." A Valhalla of Vitrolite!

Brucciani's, Marine Road, Morecambe
Built on the eve of War in 1939, the local paper feared that Brucciani's might not be good for the sedate Victorian image of Morecambe and could be positively harmful to young people. Originally a milk bar, Brucciani's typifies the simple, geometric 'high street Deco' popular at the time. The brown wood and chrome exterior has black lacquer base panels to the street, porthole lamps

160

above the doors, ziggurat pattern doors, classic deco handles and original menus. The interior preserves extensive wall panelling, a slightly reworked counter, red Formica tables, red upholstered chairs, wall-to-wall etched glass (Venetian canal scenes), mirrors, Deco clocks and penny-in-the-slot cubicles in the cloakrooms. That most Art Deco of confections, the Knickerbocker Glory is still served throughout the summer season.

Hart's, Marine Road, Morecambe
Keeping up the Lyons' Corner House tradition of silver teapots, maple floors, crystal chandeliers and waiting staff in traditional black and white uniforms, Hart's actually appears as a location in Tony Richardson's film of *The Entertainer* but seems more like something out of Tony Hancock's *The Punch and Judy Man* (filmed in Bognor in 1962). Hancock co-star John Le Mesurier remembered the location as "a disaster area. The trippers had stayed away in swarms... Hancock stood on the seafront at Bognor as lightning hissed and crackled overhead.... Turning his face skyward he shouted, "go on make it worse"." Hart's has outlasted them all.

Abergeldie Cafe, Shude Hill, Manchester
Once serving the Smithfield wholesale market next door – now long gone – the Abergeldie retains a long counter with a steel hotplate for cooking; battered and bubbling pans on the hobs behind; Formica booths, proper tables and the original window frames. The Heath-Robinson style tea system behind the counter brings it all into focus. (In September 2003, film crews turned the Abergeldie and surrounding streets into a mock-up of New York's SoHo district for a remake of *Alfie* starring Jude Law.)

University Cafe, Byers Road, Glasgow
This family-run classic – all rosewood wall panels, Formica side tables and mirrored booths – has been providing cafe staples since it opened in 1918. Matriarch Rina Verrecchia has been looking after generations of regulars since 1952 and her three sons (and some grandsons) work here too. Devotees revel in the Edwardian-tearoom-meets-1950s-ice cream-parlour feel.

The Koffi Pot, Welling High Street, Welling
Dates from the 1930s and still has its original decor and unusual collection of coffee pots – all sizes, colours, shapes – displayed on the shelves. Originally owned by an Italian family called the Ferraris, in 2001, director Mike Leigh shot a couple of scenes here for his film *All or Nothing*.

Gavin's Coffee Lounge, High Street, Haverhill
Be transported back into the 1950s with Gavin's special mix of timewarp red leatherette banquettes, pink Formica tables and bouquets of plastic flowers everywhere.

Kardomah Coffee House, Portland Street, Swansea
A longstanding local institution with some period detailing which, in an earlier incarnation in Castle Street, used to be a haunt of a young Dylan Thomas. The present location dates from 1957 (the original Kardomah was destroyed in the Blitz of 1941) but it was the nerve centre for a group of Welsh artists and writers through the 1930s including Daniel Jones, Thomas Warner, Mervyn Levy, Wynford Vaughan-Thomas, Charles Fisher and Vernon Watkins.

Divalls, Terminus Road, Brighton
A dingy, parlour-style cafe next to the town train station, this remains the *sine qua non* of lost, languishing resort cafes: a battered orange logo above the door, outside windows lined with hand-written menus, flesh-coloured Formica canteen tables, cankered fake-wood laminate on every wall.... The spectral presence of Graham Greene and Patrick Hamilton hangs heavy in the air. The sheer bitter seediness of the joint seeps into everything around it; the atmosphere of dank, crumbling low-life is thrillingly potent.

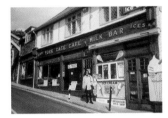

Further abroad

Original classic cafes can often be found scattered around the backstreets of Portugal, Italy, Spain and France. These local, old-timer cafe-bars often preserve a better flavour of 1950s London than London itself.

Cayuco, Passeig de Born, Barcelona, Spain
Little more than a Formica corridor off Passeig de Born, this has just the right period decor; a jumble of smudged rosewood tables and tall bar stools.

Bar Xatet, Carrer Street Francesc, Sitges, Spain
Dating from the 1920s, this cafe is filled with miniature black lacquered chairs and zinc-top marble tables. The walls are laden with locals' sketches and photo-memorabilia; the ceiling groaning with fleshy, hanging hams....

Pensio Can Julian, Avgda, Artur Carbonell, Sitges, Spain
Boasts a small part-Deco chrome doorway, while inside the bar and cafe look like an old 1950s Spanish home: caramel coloured chairs and tables, odd paintings, clocks and lights on the walls and American diner stools at the bar.

Al Quiros, Paseo del Altillo, Almuñécar, Granada, Spain
A true local coffee-lounge in the classic mould: plain, dark veneered interior; old style caramel leather swivel seats; smart Contemporary seating and a nifty covered section outside with orange-striped awnings and sun-guards.

The Solmar, Rua das Portas de Santo Antao, Lisbon, Portugal
Not so much a cafe as a vast Bond film movie set of a restaurant devoted to lobsters in all their glory and fitted out in full 1950s Contemporary mode. This main gastrodome does however have a smaller little café section attached.

Notes

Elusive whiff of the new abundance

1 Levy, Shawn, *Ready, Steady, Go!*, London: Fourth Estate, 2002.
2 MacDonald, Sally and Porter, Julia, *Putting on the Style*, London: Geffrye Museum, 1990.
3 Frayn, Michael in *The Age of Austerity 1945-51*, Michael Sissons and Philip French, eds., Harmondsworth: Penguin, 1964.
4 *Internet Movie Database*
5 Ackroyd, Peter, *London: The Biography*, London: Vintage 2001.
6 Sandall, Robert, "How London taught the world to swing", *The Sunday Times*, September 8 2002.

The academies of civility

This chapter is indebted to: Helen Stringer's *The Story Of The Restaurant* at www.themediadrome.com; Christina Hardyment's *Slice of Life*; Peter Ackroyd's *London: The Biography*; Stephen Inwood's *A History of London* and J Pelzer and L Pelzer's "Coffee Houses of Augustan London" in *History Today* October 1982.

1 Ellis, Ayton, *The Penny Universities: A History of the Coffee House*, London: Secker & Warburg, 1956.
2 Ellis, *Penny Universities*.
3 Ellis, Markman, "The Devil's Ordinary" in *Cabinet*, Issue 8, 2002.
4 Ellis, *Penny Universities*.
5 Stringer, Helen, *The Story Of The Restaurant*, www.themediadrome.com/content/articles/food_articles/
6 Routh, Jonathan, *The Good Cuppa Guide*, London: Wolfe Publishing, 1966.
7 Ransome, Arthur, *Bohemia in London*, Oxford: Oxford University Press, 1984
8 Adcock, St John, ed., *Wonderful London*, vol 1, London: Amalgamated Press, 1928.

All the young have gold

This chapter is indebted to: Colin Hughes's *Lime, Lemon & Sarsaparilla*; Lawrence M Knowles's "Gaggias, Monkey Parades and Frothy Coffee" from the *Coffee Journal* winter 1997-98 and Gábor Tóth's *Wellington Café Culture 1920-2000* at www.nzhistory.net.nz.

1 Stamp, Terence, *Coming Attractions*, London: Grafton Books, 1989.
2 Hoggart, Richard, *The Uses of Literacy*, London: Chatto & Windus, 1957.
3 "Milk Bar, Gray's Inn Road", *The Architects' Journal*, February 18 1937, p. 317.
4 "A London Milk Bar", *The Builder*, April 30 1948, pp. 518-519.
5 Reilly, Paul and Low, Helen, "London Coffee Bars", *Architecture and Building*, March 1955, pp. 83-95.
6 Fletcher, Geoffrey, *The London Nobody Knows*, London: Penguin, 1962.
7 Pagano, Alberto, interview with author November 2002.
8 Hardyment, Christina, *Slice of Life*, London: Penguin/BBC, 1997.
9 Hughes, Colin, *Lime, Lemon and Sarsaparilla*, Bridgend: Seren, 1992.
10 White, Jerry, *London in the Twentieth Century*, London: Viking, 2001.
11 Sweet, Matthew, "Keep The Change", *Independent on Sunday*, June 15 2003.
12 Crisp, Quentin, *How To Become A Virgin*, London: Fontana, 1981.
13 Bramah, Edward and Jean, *Coffee Makers, 300 years of art and design*, London: Quiller Press, 1989, p. 144.
14 Macinnes, Colin, "Pop Songs and Teenagers", in *England, Half English*, London: Hogarth Press, 1958.
15 Conran, Terrence, "Dining Out", *Cafe Society*, Gavin Weightman/LWT Productions, 1996.
16 Reilly, Paul, *Architecture and Building*, March 1955.
17 Duttmann, *Martina, Morris Lapidus: The Architect of the American Dream*, Berlin: Birkhauser Verlag, 1992.
18 Reilly, Paul and Low, Helen, "London Coffee Bars", *Architecture and Building*, March 1955.
19 Elwall, Robert, *"Building a Better Future"*, London: Wiley-Academy, 2000.
20 Humphries, Steve and Taylor, John, *The Making of Modern London 1945-1985*, London: Sidgwick & Jackson, 1986.
21 Ackroyd, Peter, *London The Biography*, London: Vintage, 2001.
22 Hardyment, Christina, *Slice of Life*, London: Penguin/BBC, 1997.

Inside the classic cafe

This chapter is indebted to Matthew Partington's work in the Design History Research Centre Archives at the Faculty of Arts and Architecture at the University of Brighton www.brighton.ac.uk/designingbritain

1 Esher, Lionel, *The Architect and Building News*, vol 197, January 6 1950; Rennie, Paul, "Fat Faces All Around" in *The Festival Of Britain*, E Harwood and A Powers, eds., London: Twentieth Century Society, 2001.
2 Baynes, Kate, "Eating Out Can Be Fun", *Design*, February 1966, p. 29.
3 Boyer, Marie-France, *The French Cafe*, London: Thames & Hudson, 1995.
4 Jacobson, Howard, "Our duty to be beautiful and value the mind", *The Independent*, November 23 2002.
5 Reilly, Paul and Low, Helen, "London Coffee Bars", *Architecture and Building*, March 1955, pp. 83-95.
6 "Cafe Konditorei", *The Builder*, February 22 1957, p. 351.
7 "Espresso Bar", *The Builder*, November 16 1956, p. 841.
8 Reilly, Paul and Low, Helen, "London Coffee Bars", *Architecture and Building*, March 1955, pp. 83-95.
9 Gardiner, Stephen, "Coffee Bars", *Architectural Review*, vol 118, no 705, September 1955, pp. 165-173.
10 Hess, Alan, *Googie*, San Francisco: Chronicle Books, 1995.
11 Hopkins, Harry, *The New Look*, London: Secker and Warburg, 1964.
12 Elwall, Robert, *Building a Better Future*, London: Wiley-Academy, 2000.
13 "Let's Speak Teen" in *The Beginners' Guide to Absolute Beginners The Musical*, Vicky Hayward, ed., Corgi, 1986.
14 Gardiner, Stephen, "Coffee Bars", *Architectural Review*, vol 118, no 705, September 1955, pp. 165-173.
15 Reilly, Paul and Low, Helen, "London Coffee Bars", *Architecture and Building*, March 1955, pp. 83-95.
16 Laski, Marghanita, "Espresso", *Architectural Review*, vol 118, no 705, September 1955, pp. 165-167.
17 Hoggart, Richard, *The Uses of Literacy*, London: Chatto & Windus, 1957.
18 Pevsner, Nikolaus, London 1: *The Cities Of London And Westminster*, London: Penguin, 1957.
19 Temple, Julien, "A City of the Imagination" in *The Beginners' Guide to Absolute Beginners The Musical*, Vicky Hayward, ed., Corgi, 1986.
20 Hopkins, Harry, *The New Look*, London: Secker & Warburg, 1964.

The teams that meet in caffs

This chapter is indebted to Mike Brocken's
Musical Traditions The legacy of Skiffle
http://web.ukonline.co.uk/mustrad/articles/
brocken4.htm.

1 Harrison, Martin, *Transitions: The London Art Scene in the Fifties*, London: Merrell/Barbican Art, 2002.
2 Harrison, *Transitions*.
3 Booker, Christopher, *The Neophiliacs*, London: Fontana, 1970.
4 Scala, Mim, *Diary of a Teddy Boy*, Dublin: Sitric Books, 2000.
5 Samwell, Ian, *Expresso and Bongos*, http://www.saber.net/~orb/ch1b.htm
6 Faith, Adam, *Acts of Faith*, London: Bantam Press, 1996.
7 Moretti, Joe, http://www.ifrance.com/vince-taylor/1aenglishv/2i's.htm
8 McDevitt, Chas, "Dining Out", *Cafe Society*, Gavin Weightman/LWT Prodns., 1996.
9 Hoggart, Richard, *The Uses of Literacy*, London: Chatto & Windus, 1957.
10 Melly, George, *London Guides*, Roger Hudson, London: Haggerston Press, 1995.
11 Freeman, Gillian, *The Leather Boys*, London: New English Library, 1961.
12 Summers, Judith, *Soho*, London: Bloomsbury, 1991.
13 Waters, John, *Hard Mods*, www.modculture.com.
14 Sweet, Matthew, "Keep the Change", *Independent on Sunday*, June 15 2003.
15 Norman, Frank, *Stand on Me*, London: Pan, 1959.
16 Sinclair, Iain, *Lights Out for the Territory*, London: Granta, 1997.
17 Fabian, Robert, *London After Dark*, London: Pan, 1958.
18 Melly, George, introduction to *Soho in the Fifties*, Daniel Farson, London: Michael Joseph, 1987.
19 Wollheim, Richard, "Babylon, Babylone", *Encounter*, no 104, May 1962, pp. 25.
20 Farson, Daniel, *Soho In The Fifties*, London: Michael Joseph, 1987.
21 Wilson, Colin, *Beyond the Outsider*, www.raintaxi.com/online/1997winter/wilson.shtml
22 Lachman, Gary Valentine, *Turn off your Mind*, London: Sidgwick & Jackson, 2001.
23 Davies, Mandy Rice, *Mandy*, London: Sphere, 1987.
24 Keeler, Christine, *The Truth At Last*, London: Pan, 2002.
25 Crisp, Quentin, *The Naked Civil Servant*, London: Fontana, 1977.
26 Farson, Daniel, *Gilbert & George A Portrait*, London: HarperCollins, 1999.
27 Harrison, *Transitions*.

Britannia Moribundia

1 Marshall, Peter, *Demanding The Impossible: A History Of Anarchism*, London: Fontana, 1992.
2 Ackroyd, Peter, *London The Biography*, London: Vintage, 2001.
3 Newell, Malcolm G, *Mood and Atmosphere in Restaurants*, London: Barrie & Rockliff, 1965.
4 Burroughs, William S, "Playback: from Eden to Watergate" in *The Job: Topical Writings and Interviews*, Daniel Odier, London: John Calder, 1984.
5 Sinclair, Iain, interview with the author March 2000.
6 Stamp, Gavin, "The South Bank Site" in *The Festival Of Britain*, London: Twentieth Century Society, 2001.
7 Penman, Ian, "A Post Margins world", *The Face*, April 1988.
8 Home, Stewart, correspondence with author July 2002.
9 "Stars fight to save West End's famous cafe", *Evening Standard*, September 17 1996.
10 Valoti, Rick, interview with author November 2002.
11 Pagano, Alberto, interview with author November 2002.
12 Sweet, Matthew, "Keep the Change", *Independent on Sunday*, June 15 2003.
13 Ellis, Markman, "The Devil's Ordinary" in *Cabinet*, Issue 8, 2002.
14 Reynolds, Quentin, interview with author April 2000.
15 Finch, Kevin, interview with author October 2002.

In search of classic cafes

1 Powers, Alan, "The Expression of Levity" in *The Festival Of Britain*, E Harwood and A Powers, eds., London: Twentieth Century Society, 2001; Harrison, Martin, *Transitions: The London Art Scene in the Fifties*, London: Merrell/Barbican Art, 2002.
2 Solnit, Rebecca, *Wanderlust: A History of Walking*, London: Verso, 2000.
3 Sinclair, Iain, interview with the author March 2000.
4 Sinclair, Iain, *Fortean Times*, June 2001.
5 Elwall, Robert, *Building a Better Future*, London: Wiley-Academy, 2000.

Illustrations

Unless otherwise stated, all photographs courtesy of Phil Nicholls.

Details

Constructing the Classic Cafe

However sniffily dismissed in their day, cafes retaining any of their original Mid-Century detailing – however sparse – now seem like exotic national treasures. A proper classic cafe needs to have been left well alone for the last 50 or so years to facilitate that signature feeling of crushed romance and brief escape which such items supply. The rules are:

Formica is the cafe covering of choice: panelling is always good, but anything from a distressed woodchip to a worn fake wood lino can be effective.

The sight of a fine cafe sign at 20 paces is a pulse racer and no mistake: bold, old fonts are best, preferably slightly dilapidated; but a stalwart Helvetica or Univers job often suffices. Misplaced apostrophes are forgivable; words like Benjy's; Starbucks, Costas, Coffee Republic et al are not.

Chairs should be free-standing variants of Michael Thonet's Vienna Café chair No. 14. They should positively clatter. American diner-style fixed counter stools, leatherette banquette seating or sectioned booths of suitably utilitarian design are all perfectly acceptable. Pre-moulded, bolt-down coloured plastic seating is a blasphemy and an abomination.

Tables must be square, or oblong. Formica table tops should feature abstract patterning – or fake wood designs – worn from years of loving mug-nudging.

A counter arrangement of glass/Formica with a smart display of light refreshments is the one true way – accept no other. (A straining silver tea boiler must always be on the go for good measure.)

The ideal crockery set will have been in use for generations: something with a plain 1950s pattern or simple line is good; Pyrex cup 'n' saucer sets are, of course, top of the wish list.

Prime examples of period lighting can always be spotted by their resemblance to the UFOs in *The War of the Worlds*.

The legendary red Drury's "Good Tea" sign hanging in a cafe window is an especially good omen....

Tables and chairs
New Piccadilly W1; Andrew's WC1; Golden Fish EC1; Lucky Spot W1; Chandos WC2; Zippy Grill W12; Alpino N1; Mama's SE1; Presto W1; Marie's SE1; L Randolfi E3; Zita WC2; Bar Bruno W1; Sandwich Bar W1; Chalet W1; Valtaro W1; Paul Rothe W1; Rheidol Rooms N1; Alpino N1; Sorrento Snack Bar WC1; Farina's EC1; Muratori EC1; River Cafe SW6; Bar Italia W1; Euro Snack Bar W1; Central Cafe EC1; Ferrari's E17; Piccolo EC2; Gambardella SE3; Chelsea Kitchen SW3; L Rodi E17.

Booths and banquettes
Presto W1; Pollo W1; Centrale W1; Marylebone Cafe W1; City Corner EC1; Luigi's EC1; Zippy Grill W12; New Piccadilly W1; Stanley's W1; Tea Rooms WC1; Zita WC2; Perdonni's SE1; Alpino N1; Piccolo EC2; Chelsea Kitchen SW3, Bloomsbury Restaurant WC1; Sea Breeze E17.

Walls
New Piccadilly W1; Pellicci's E2; Coffee Cup NW1; Scotti's EC1; Italian Restaurant SW1; 101 WC2; John's NW1; Gambardella SE3; Troubadour SW5; Harris' Cafe Rest W12; City Snacks WC1; Muratori EC1, Marie's SE1; Gambardella SE3; Chelsea Kitchen SW3; Chalet W1; Lucky Spot W1; Bar Italia W1; Luigis EC1; L Rodi E17; Sea Breeze E17.

Signs
New Piccadilly W1; RendezVous W1; Copper Grill EC2; Piccolo EC2; Barbican Grill EC1; Panda N7; The Pollo W1; Snack Bar WC2; Tea Rooms WC1; Zita WC2; Euro Snack Bar W1; 101 WC2; Lorelei W1; Chalet W1; Italian Restaurant SW1; Wilton SW1; Centrale W1; Sidoli's Buttery WC1; Lorelei W1; Euro Snack Bar W1; Marylebone Cafe W1; Regent Cafe WC2; Express W1; Rheidol Rooms N1; Continental NW5; Coffee Cup NW1; Regency SW1; Frank's W8; Pellicci E2; Barbican Grill EC1; Beppe's EC1; Amalfi W1; Bar Italia W1; New Grosvenor SW1; Farina's EC1; Luigi's EC1; Central Cafe EC1; Gambardella SE3; Bar Italia W1; Regis Snack Bar EC3; L Rodi E17; Rossi Westcliff on Sea.

Counters
Italian Restaurant SW1; Copper Grill EC2; New Piccadilly W1; Zippy Grill W12; Gambardella SE3; L Rodi E17.

Crockery
Alpino N1; John's Sandwich Bar W1; New Good Fare NW1; The New Piccadilly W1; Pembroke W8; Vernasca E1; Gambardella SE3; L Rodi E17.

Lighting
Chalet W1; Sea Breeze E17; Alpino N1; Copper Grill EC2; Lucky Spot W1; New Piccadilly W1; L Rodi E17.

Doors and doorways
New Piccadilly W1; Tea Rooms WC1; Sandwich Bar W1; Bar Bruno W1; S & M Cafe (formerly Alfred's) N1; RendezVous W1; Chalet W1; Lucky Spot W1; San Siro N6; Italian Restaurant SW1; Pellicci E2; Gambardella SE3.

Murals
Copper Grill EC2; City Corner EC1; New Goodfare NW1; River Cafe SW6.

Formica
New Piccadilly W1; City Snacks EC1; Italian Restaurant SW1; Scotti's EC1; Piccolo EC2; Rheidol Rooms N1; 101 WC2; Fryer's Delight WC1; Andrew's WC1; Luigi's EC1; Sea Breeze E17; Marie's SE1; Gambardella SE3; L Rodi E17; Frank's W8.

Handles
Beppes EC1; Golden Fish EC1; Snack Bar W1; New Good Fare NW1; Gambardella SE3.

Tea boilers/Coffee machines
Snack Bar W1; Scotti's EC1; Andrew's WC1; Regis Snack Bar EC3; New Piccadilly W1.

Vitrolite
S & M Cafe (formerly Alfredo's) N1; Metropolitan W2; River Cafe SW6; L. Randolfi E3; Gambardella SE3; Maria's W1; L Rodi E17.

Ceilings
Bar Central WC1; Amalfi W1; San Siro N6; Troubadour SW5; Zita W1; RendezVous W1; Gambardella SE3; L Randolfi E3; River Cafe SW6; L Rodi E17; Morelli's Broadstairs.

Window signs
RendezVous W1; Scotti's EC1; Tea Rooms WC1; L Rodi E17.

Serving hatches
RendezVous W1; Andrew's WC1; Pellicci's E2.

Menus
New Piccadilly W1; Alpino N1; Golden Fish EC1.

Uniforms
Zita WC2; New Piccadilly W1.

Dumb waiters
Dino's E1.

Coatstands
Harris' Cafe Rest W12; Andrew's WC1; Golden Fish EC1; L Rodi E17.

Paper bags
Zita WC2.

Deco
Brucciani's Morecambe; Pellicci E2; S & M Cafe (formerly Alfredo's) N1; Frank's W8.

Awnings
Andrew's WC1; Coffee Cup NW1; RendezVous W1.

Mystery staircases
Golden Fish EC1; River Cafe SW6; Scotti's EC1; Luigi's EC1.

Clocks
Gambardella SE3; Alfie's WC1.

Memorabilia
L Rodi E17.

Huge carved forks and spoons
Popular Cafe EC1.

Resources

Selected Bibliography

Aaron, Cheryl A, *Cafe*, London: Printers Inc Press, 1985.

Ackroyd, Peter, *London: The Biography*, London: Vintage, 2001.

Allan, John, *Berthold Lubetkin And The Tradition Of Progress*, London: RIBA Publications, 1992.

Bird, Peter, *The First Food Empire: A History of J Lyons & Co*, Phillimore & Co, 2000.

Booker, Christopher, *The Neophiliacs*, London: Fontana, 1970.

Bramah, Edward and Jean, *Coffee Makers, 300 Years Of Art And Design*, London: Quiller Press, 1989.

Bramah, Edward, *Tea & Coffee: A Modern View Of Three Hundred Years Of Tradition*, London: Hutchinson and Co, 1972.

Briggs, Asa, *A Social History of England*, London: Penguin, 1983.

Burton, David, and Sheehan, Grant, *Character Cafes of New Zealand*, Wellington: Phantom House, 1994.

Colam, E F, *Practical Milk Bar Operation*, London: Food Trade Press, 1961.

Colpi, Terri, *The Italian Factor*, Edinburgh: Mainstream, 1991.

Crisp, Quentin, *The Naked Civil Servant*, London: Fontana, 1977.

Curtis, William R, *Modern Architecture Since 1900*, London: Phaidon, 1996.

Ehrman, Edwina, *London Eats Out*, London: Philip Watson, 1999.

Ellis, Aytoun, *The Penny Universities: A History of the Coffee House*, London: Secker & Warburg, 1956.

Elwall, Robert, *Building a Better Future*, London: Wiley-Academy, 2000.

Fabian, Robert, *London After Dark*, London: Panther, 1958.

Farson, Daniel, *Soho In The Fifties*, London: Michael Joseph, 1987.

Fletcher, Geoffrey, *The London Nobody Knows*, London: Penguin, 1965.

France Boyer, Marie, *The French Cafe*, London: Thames & Hudson, 1995.

Gardiner, James, *Who's a Pretty Boy Then?*, London: Serpent's Tail, 1996.

Goodwin, Cliff, *When The Wind Changed*, London: Century, 1999.

Hardyment, Christina, *Slice of Life*, London: Penguin/BBC, 1997.

Harrison, Martin, *Transitions: The London Art Scene in the Fifties*, London: Merrell/Barbican Art, 2002.

Harrod, Tanya, *The Crafts in Britain in the 20th Century*, Yale: Yale University Press, 1999.

Harwood E and Powers A, eds., *Festival of Britain*, London: Twentieth Century Society, 2001.

Hayward, Vicky, ed., *The Beginners' Guide to Absolute Beginners The Musical*, London: Corgi 1986.

Hess Alan, *Googie*, San Francisco: Chronicle, 1993.

Higgins, Patrick, *Heterosexual Dictatorship*, London: Fourth Estate, 1996.

Hoggart, Richard, *The Uses of Literacy*, London: Chatto & Windus, 1957.

Hopkins, Harry, *The New Look*, London: Secker & Warburg, 1964.

Hughes, Colin, *Lime, Lemon & Sarsaparilla*, Bridgend: Seren, 1992.

Inwood, Stephen, *A History of London*, London: Macmillan, 2000.

Jackson, Lesley, *Contemporary*, London: Phaidon, 1994.

Katz, Sylvia, *Plastics Designs & Materials*, London: MacMillan, 1978.

Kersh, Gerald, *Night and the City*, London: Brainiac Books, 1993.

Lewin, Susan Grant, *Formica and Design*, New York: Rizzoli, 1991.

Lillywhite, Bryant, *London coffee houses: a reference book of coffee houses of the seventeenth, eighteenth, and nineteenth centuries*, London: George Allen & Unwin, 1963.

MacDonald S and Porter J, *Putting On The Style*, London: Geffrye Museum, 1990.

MacInnes, Colin, *England Half English*, London: Chatto & Windus, 1993.

MacInnes, Colin, *Absolute Beginners*, London: Allison & Busby, 1980.

Marks, Joan N, *Cafe & Milk Bar Catering*, London: Hoywood & Co., 1952.

Marshall, Peter, *Demanding The Impossible: A History Of Anarchism*, London: Fontana, 1992.

Moncrieff, George Scott, *Cafe Bar*, London: Wishart & Co, 1932.

Nairn, Ian, *Nairn's London*, London: Penguin, 1966.

Newell, Malcolm G, *Mood and Atmosphere in Restaurants*, London: Barrie & Rockliff, 1965.

Norman, Frank, *Soho Night & Day*, London: Corgi, 1966.

Pinter, Harold, *The Black and White*, London: Faber, 1969.

Porter, Roy, *London: A Social History*, London: Hamish Hamilton, 1994.

Raban, Jonathan, *Soft City*, London: Fontana, 1974.

Richards, J, *Introduction to Modern Architecture*, London: Pelican, 1959.

Routh, Jonathan, *The Good Cuppa Guide*, London: Wolfe Publishing, 1966.

Scala, Mim, *Diary of a Teddy Boy*, Dublin: Sitric Books, 2000.

Sinclair, Iain, *Lights Out For The Territory*, London: Granta, 1998.

Sissons, Michael and French, Philip, eds., *The Age of Austerity 1945-51*, Harmondsworth: Penguin, 1964.

Smithells, Roger, ed., *News of The World Better Homes Book*, London: News of The World, 1953.

Solnit, Rebecca, *Wanderlust: A History of Walking*, London: Viking, 2000.

Summers, Judith, *Soho*, London: Bloomsbury, 1991.

Thomas, Gwyn, *The Dark Philosophers*, New York: Little Brown, 1947.

Turner, Christopher, *London Step by Step*, London: Pan, 1985.

Turner, E, *A Catering Business of your Own*, Barrie and Rockliff, 1967.

Wade, Peter, *Echoes of Art Deco: Art Deco in Morecambe*, Peter Wade, 1999.

Weston, Richard, *Modernism*, London: Phaidon, 2001.

White, Jerry, *London in the Twentieth Century*, London: Viking, 2001.

Wilson, Colin, *Adrift In Soho*, London: Pan, 1961.

Selected articles

Rennie, John, "An artistic haven", *EastEnd Life*, July 9-15 2001.

Robinson, Alice, "Caffs are no longer naff", *Daily Telegraph*, October 22 1998.

Keating, Sheila, "Caff Society", *Times Magazine*, February 1 2003.

McGlown, Martin, "Invasion of the coffee shops", *Evening Standard*, November 29 2001.

Buncombe, Andrew and Price, Daisy, "Coffee shop wars spill on to the high street", *The Independent*, August 15 2000.

Kossoff, Julian, "Final curtain for Valotis", *Time Out*, October 2-9 1996.

Jury, Louise and Streeter, Michael, "Finney and Conti line up to save the greasy spoon", *The Independent*, September 19 1996.

Stacey, Caroline, "Grease Proof", *Time Out*, June 9-16 1993.

Curtis, Nick, "Hold the croissant", *Evening Standard*, April 28 2000.

Martin, Andrew, "Save Our Sausages", *Evening Standard*, November 3 2000.

Holliday, Richard, "Stars fight to save West End's famous cafe", *Evening Standard*, September 17 1996.

Mudd, Tony, "The ten-best greasy spoon cafes", *The Independent Review*, January 14 2003.

Knowles, Lawrence, "Gaggias, Monkey Parades and Frothy Coffee", *Coffee Journal*, winter 1997-98.

Rattray, Fiona, "Breakfast at Kevin's", *Independent Magazine*, March 8 2003, pp. 42-43.

"Cafe Society", *ES magazine*, November 1990.

"A fetish for Formica", *Guardian Space Magazine*, March 23 2000.

Selected architectural journals

Reilly, Paul and Low, Helen, "Le Mistral coffee bar", *Architecture and Building*, March 1955, p. 86.

Reilly, Paul and Low, Helen, "Moka-Ris coffee bar", *Architecture and Building*, March 1955, pp. 86-92.

Reilly, Paul and Low, Helen, "Negresco coffee bar", *Architecture and Building*, March 1955, pp. 88-93.

Reilly, Paul and Low, Helen, "Le Reve coffee bar", *Architecture and Building*, March 1955, pp. 80-86.

Reilly, Paul and Low, Helen, "The Coffee House", *Architecture and Building*, March 1955, pp. 85-93.

Reilly, Paul and Low, Helen, "Kon-Tiki coffee bar", *Architecture and Building*, March 1956, pp. 98-99.

"Wayang coffee bar", *The Builder*, November 16 1956, p. 841.

"Cafe Konditorei", *The Builder*, February 22 1957, pp. 351-352.

"A London milk bar (Moo Cow)", *The Builder*, April 30 1948, pp. 518-519.

"Colombo Tea Bar", *Architectural Review*, June 1957, p. 457.

"Wayang coffee bar", *Architectural Review*, July 1963, pp. 43-46.

Baynes, Ken and Kate, "Eating out can be fun", *Design*, February 1966, p. 29.

"Thought for food", *Design*, June 1956, pp. 20-23.

"Coffee bar at Rhyl, North Wales", *The Architect and Building News*, April 19 1958, pp. 471-473.

"Milk Bar, Gray's Inn Road (Black & White Milk Bar)", *The Architects' Journal*, February 18 1937, pp. 317-318.

Selected websites

Arts and Architecture at the Design History Research Centre
www.designingbritain.org
Magnificent historical project managed by the Faculty of Arts and Architecture at the University of Brighton with extensive visual material from their expanding Design History Research Centre (DHRC) Archives and associated collections.

Asserta
www.asserta.com/jsp/living/design_gurus.jsp
Includes a brief discussion of Conran's early 1950s coffee bars.

Bramah Museum of Tea and Coffee
www.bramahmuseum.co.uk
The world's first museum devoted entirely to the history of tea and coffee.

Commonplace
www.journale.com/commonplace/index.html
"… I think these sometimes modest, sometimes sterile, sometimes pretentious rooms are important… I am searching for ways to use the light, color and form to crystallise their beauty, poignancy, irony, wealth and humanity."

Colin Wilson Page
www-personal.umich.edu/~jbmorgan/cwilson.html
Author of cult cafe novel *Adrift In Soho*... and much else.

Diner City
www.dinercity.com
In the early 1980s, there were plenty of stainless steel and porcelain enamel diners to be found in New Jersey. Many have since been demolished....

Diner Museum
www.dinermuseum.org
When Walter Scott began to offer prepared food from a converted horse-drawn freight wagon in Providence, Rhode Island in 1872, he unknowingly inspired the birth of what would become one of America's most recognised icons.

Festival of Britain Society
www.packer34.freeserve.co.uk/
"In 1951 an austere Britain tried to shake off the post-Second World War blues by mounting a nation wide festival to show who the British people were."

From Here To Modernity
www.open2.net/modernity
"Last century, many architects believed that advances in technology could be harnessed to produce a better quality of life for all. For better or worse, these Modernists have changed the British landscape forever. This is how they did it...."

Hart's Restaurant
www.harts-restaurant.co.uk/
As seen in *The Entertainer*, for over sixty years this family-run seaside establishment has been a "rendezvous with a reputation for English fare good enough to please every palate at prices reasonable enough to suit every pocket".

History of the Tea Shop
www.londoneatsout.co.uk/1900/1900_page3.html

Iain Sinclair
www.complete-review.com/authors/sinclairi.htm#links
The "De Quincey of contemporary English letters".

Ian Samwell
www.saber.net/~orb/ch1b.htm
Online memoires of Cliff Richard by the writer of the hit "Move It" – considered by many to be the first UK rock record to have mattered.

Interpreting Ceramics
www.uwic.ac.uk/ICRC/journal001/picasso/picasso.htm
In search of the Picassoettes, cafe decorators extraordinaire.

Joe Moretti
www.ifrance.com/vince-taylor/1aenglishv/2i's.htm
Site by musician Joe Moretti about the 2i's coffee bar in Old Compton Street.

The Legacy of Skiffle
http://web.ukonline.co.uk/mustrad/articles/brocken4.htm
Do-it-yourself music culture as the focal point of the coffee bar.

Los Angeles Conservancy
www.laconservancy.org
Works to preserve existing architectural resources by developing preservation strategies and by raising public awareness of the value of those resources through tours, lectures, publications and major programs....

Milk Bar Revolution
www.ihrinfo.ac.uk/ihr/reviews/hilton.html
By 1995 around twenty per cent of all drinks bought in Britain were soft drinks – a "cold drinks revolution".

Mod Culture
www.modculture.com
Fulsome archives and research relating to all things Mod.

Museum of Domestic Design & Architecture (MoDA)
http://www.moda.mdx.ac.uk/
One of the world's most comprehensive collections of nineteenth and twentieth century decorative arts for the home.

Psychogeography.org.uk
www.psychogeography.org.uk
A superb resource pertaining to all things psychogeographic.

Pubs
www.pubs.com
Award-winning site upholding the proper London pub experience.

SCA-Roadside
www.sca-roadside.org
The oldest national organisation devoted to the buildings, artefacts, structures, signs, and symbols of the twentieth century commercial built environment.

Snapcity
http://snapcity.com/past
An extensive series of portraits of lost American bars and cafes – and much else.

Terence Nunn
www.tnunn.ndo.co.uk
"In the mid-1960s I began wandering the deserted Sunday streets of London, photographing the offbeat, slightly surreal aspects of a still-postwar city: bomb-sites, junkyards, doomed theatres, greasy-spoon cafes and failed empty shops."

Troubadour Cafe
www.troubadour.co.uk
An important authentic cafe from a period when Earls Court was rampant with coffee houses. Founded by Michael and Sheila van Bloemen in 1954.

Twentieth Century Society
www.c20society.demon.co.uk
"The Society's prime objectives are education, conservation and extending our knowledge about those buildings or artefacts – whether important or humble, rare or commonplace – that characterise the Twentieth Century in Britain".

General architecture resources
www.architecture.com
www.riba-library.com

Selected filmography

All or Nothing, Mike Leigh, 2002
Rancid estates, slum supermarkets, desperate spouses, wrecked lives, bitter tears, emotional sclerosis... and a couple of shots of Welling's exceedingly pleasant 1930s Koffi Pot cafe.

B Monkey, Michael Radford, 1998
Romantic actioner about an unlikely affair between a soft-hearted English teacher and a master cat burglar, played with crazy-sexy aplomb by Asia Argento. Worth watching only for Argento's sustained Beatrice Dalle impersonation – clothed and unclothed – and interiors shot in the grand old Regent Milk Bar, Edgware Road.

Bedazzled, Stanley Donen, 1967
Faustian update with Dudley Moore as a miserable and shy short order cook in a Wimpy – alluded to in the film as a defacing blight on the face of Britain. (The place where the Devil and Stanley nip in for ice-cream was Frobisher & Gleason in a cul-de-sac off Abbey Road NW8.)

Billy Liar, John Schlesinger, 1963
A parable of an era – British youth renouncing post war cultural repression etc. etc. – shot entirely on location in Bradford. Features a clutch of gut-wrenching cafe scenes: Billy in a coffee bar with a girlfriend, Billy waiting at the station cafe to leave for London.... Astounding cinematography from Denys N Coop and wonderful incidental music by Richard Rodney Bennett.

Brief Encounter, David Lean, 1945
Weep and weep again! Especially for the scene where the stiff-lipped duo meet for afternoon tea in the ocean liner luxury of a Kardomah cafe.

Cosh Boy, Lewis Gilbert, 1952
Delectable teen glamour puss Joan Collins plays an abused girlfriend in this, the first ever British X certificated movie (widely banned on release because of the ongoing Derek Bentley "Let him have it" trial). No cafes, but the ambient murk of bombed-out post war London is well realised. The lovable cockney accents proved too much for American audiences; but a source of much-treasured delight for the rest of us.

The Criminal, Joseph Losey, 1960
Cracking hard boiled British heist movie about an underworld kingpin (played with meaty relish by Stanley Baker) sprung from prison to mastermind a racetrack scam. Features scenes in the upstairs of the 2i's coffee bar looking out onto Old Compton Street. The cafe is decked out in Cliff Richard posters, skiffle hoardings and coffee containers. Originally advertised as "The Toughest Film Ever Made in Britain!"

The Golden Disc, Don Sharp, 1958
It's all happening at the Lucky Charm coffee bar! Includes skiffle, rock n' roll, cool jazz, ballads… and even a trumpet solo. Notable numbers include: "Dynamo" by Tommy Connor and Terry Kennedy (an Afro-Caribbean skiffle group); "The In-between Age" (by Ray Mack/Philip Green) and a Nick Cave-ish murder ballad "Johnny O" by Nancy Whiskey.

Hell Drivers, Cy Endfield, 1957
A bunch of moody truckers at a cheapjack freight firm are pushed to recklessly break speed limits on English country roads. Features Sean Connery, Sid James, Patrick McGoohan, William Hartnell, Herbert Lom, Gordon Jackson, David McCallum *and* Alfie Bass! (Sid James and Sean Connery play table football together.) Truly, the daddy of the he-man-haulage genre – all too often dismissed as: "*This Sporting Life* with lorries".

if… , Lindsay Anderson, 1968
English public school rebels turn on the archaic customs and authoritarian rule of their elders. Features weird scenes in a transport cafe, The Packhurst, as Malcom McDowell undertakes a primitavistic mating rite round a juke box. A microcosm for the whole of English society, natch.

The Intelligence Men, Robert Asher, 1965
Espionage spoof featuring a humble coffee shop manager (played by Eric Morecambe) forced into the secret world of spies in Swinging London.

The Leather Boys, Sidney J Furie, 1965
Earthy kitchen sink drama set against the burly motorcycle clubs of 1960s England. Combines "the sexual frankness and harsh realism of the British New Wave with the homoeroticism of Kenneth Anger's *Scorpio Rising*".

The London Nobody Knows, Norman Cohen, 1967
"The gritty historic fabric that was London in the sixties… facets of London life long since forgotten."

Miracle in Soho, Emeric Pressburger, 1957
Labourer and lothario, Michael Morgan takes a job in Soho only to realise there is something special about local barmaid Julie Gozzi who's preparing, with her Italian family, to emigrate to Canada. Pressburger's story – originally called *The Miracle of St Anthony's Lane* – was written in 1934 and optioned to film at least four times. Several good restaurant scenes.

Mix Me A Person, Leslie Norman, 1962
Features some muted John Barry themes and several wanna-be Soho milk bar scenes. *The Monthly Film Bulletin* declared the film had been: "done up contemporary – which roughly means that the nightclub of a few years ago has been replaced by guitars and espresso". Odd to think that at the time it would commonly have been accepted that if God didn't destroy trad-jazz he owed Sodom and Gomorrah an apology!

Mojo, Jez Butterworth, 1998
Mamet-lite meets Pinter-decaf in the British criminal hinterlands of 1950s Soho. Features brief interior shots of Alfredo's caff, as was, on Islington Green just before it closed for several years in the late 1990s.

Never Let Go, John Guillermin, 1960
Tough British crime thriller that ends with a slugfest between a disgruntled toiletries salesman and an evil garage-owner character (played by Peter Sellers.) Effective London locations – including some cafe exposition – and a jazz score by one John Barry.

Poor Cow, Ken Loach, 1967
Sordid South London slice-of-lifer as Carol White gets into a hopeless love tangle with Terence Stamp in a caff, the still extant P George Snack Bar on the Fulham Road.

The Punch and Judy Man, Jeremy Summers, 1962
Snobbery and decay in Bognor Regis with Tony Hancock as seaside Punch and Judy Man, Wally Pinner. Darkly depressing and breezily comic, the extended – almost silent – scene set in an ice cream bar lashed with torrential rain has passed into legend.

Queen of Hearts, Jon Amiel, 1989
Rather Disney-fied history of an Italian family setting up a cafe in the East End. Many Little Italy location scenes focusing on the Italian experience in London.

The Rebel, Robert Day, 1960
Some hokey coffee bar scenes are included for local colour as Tony Hancock moves to Paris to be acclaimed by cod intellectuals. (The film premiered at the Beirut Film Festival!)

Sapphire, Basil Dearden, 1959
Racial intolerance surfaces as a pregnant girl, assumed to be white, is murdered. Good honest coppering, however, unearths her 'mixed' racial origins. Public prejudice and police bigotry are duly cautioned. (Made shortly after race riots broke out in London and Nottingham.)

Secrets and Lies, Mike Leigh, 1996
An adopted middle-class black woman tracks down her biological mother – who turns out to be white and working class. The two leads meet up at a fine cafe packed with banquettes and these core scenes trace the effects of their reunion. (The film won the 1996 Palme D'Or at Cannes.)

Serious Charge, Terence Young, 1958
A searing mix of youth, delinquency, rock 'n' roll, coffee bars… and Cliff Richard.

She Knows Y'Know, Montgomery Tully, 1961
A searing mix of youth, pregnancy, pop, coffee bars… and Hylda Baker. In this "lively British sex farce", a coquettish daughter falls pregnant as her mother tries to protect the family's honour. *The Monthly Film Bulletin* dismissed it as having "a pop singer and a coffee bar thrown in to prove that the film's makers are bang up to date". What a swizz!

The Sorcerers, Michael Reeves, 1967
Wonderfully creaky, down-at-heel shocker featuring Boris Karloff on the periphery of Swinging London administering psychotronic retribution to groovy twentysomethings. Alongside many blissfully moribund locations, the film features an extended sequence in a great period Wimpy bar.

The System, Michael Winner, 1967
Oliver Reed plays Tinker, the leader of a gang of youths who work the summer season at a UK seaside resort and leave a "trail of dishevelled females" in their path. Some fish bar action.

Also good for period atmosphere…

Beat Girl, Edmond T Greville, 1960; *Dance With A Stranger*, Mike Newell, 1984; *The Entertainer*, Tony Richardson, 1960; *Frightened City*, John Lemont, 1961; *Hell Is A City*, Val Guest, 1959; *A Kind of Loving*, John Schlesinger, 1962; *The Krays*, Peter Medak, 1990; *Look Back In Anger*, Tony Richardson, 1959; *Scandal*, Michael Caton-Jones, 1988; *Some People*, Clive Donner, 1962; *Spider*, David Cronenberg, 2001; *The Tommy Steele Story*, Gerard Bryant, 1957; *Victim*, Basil Dearden, 1961.

Selected architects

Antoine Acket with E E Barlow (ARIBA)
The Coffee House, Haymarket
The Coffee House, Fleet Street

John Bainbridge
Bamboo, Old Brompton Road

John Burket ARIBA & Gordon Sheere (ARIBA)
Le Mistral, Pelham Street

G R Cole (FRSA)
Arabica, Brompton Road

Terence Conran
The Orrery, King's Road

Geoffrey A Crockett (FRIBA)
Pinnochio, Frith Street
Sarabia, Onslow Crescent
La Ronde, Baker Street
Moka-Ris, Dean Street
Negresco, Brook Street

Douglas Fisher
El Cubano, Brompton Road
Mocamba, Brompton Road

Adam Gelister
Cabana, Princes Street

D G Henderson
Bamboo, Fulham Road

Helen Low and Humphrey Spender
Gondola, Wigmore Street
Walter Marmorek with Lionel Weaver (Shopfitters: Hardinge & Sons)
Cafe Konditorei, Brompton Road

Lucas Mellinger ARIBA (Shopfitters: Oliver Toms
Catering Equipment)
The Wayang, Earl's Court

Michael Watts
La Reve, Kings Road

Jack Williams
Las Vegas, Old Brompton Road

C P Zee
Rice Bowl, Pelham Street

Selected documentaries

01 For London
Mentorn Films, Thames TV/ITV, 1992
Paula Yates interviews a spiky Rupert Everett in
his beloved Valoti cafe.

"Cafe Society", *Dining Out*
Gavin Weightman/LWT Productions, 1996
Documentary series about the history of
British restaurants.

Excess Baggage
BBC Radio 4, August 24 2002
Travel show with a special interview section
devoted to London's classic cafes.

Substance
Somethin' Else Productions, July 1 2003
BBC Radio 4 documentary series. Wayne
Hemmingway fronted this Formica special.

The Transport Cafe
Peer Productions, July 26 2003
Short BBC Radio 4 history of the transport cafe
presented by comedian Tony Liddington.

The Reunion
BBC Radio 4, August 29 2003
Short history of the Festival of Britain, bringing
together some of the original designers and
architects who worked on the site.

Selected photo-archives

*Museum of Domestic Design & Architecture
(MoDA)*
Middlesex University
Cat Hill
Barnet
Herts
EN4 8HT

RIBA Library Photographs Collection
RIBA
66 Portland Place
London
W1B 1AD

Design History Research Centre
68 Grand Parade
Brighton
BN2 2JY

Museum of London
London Wall
EC2Y 5HN

National Library of Wales
Mo Wilson Archive
Aberystwyth
SY23 3BU
Wales

Bramah Museum of tea and coffee
40 Southwark Street
London
SE1 1UN

Selected suppliers

Dentons
2/4 Clapham High Street
London
SW4 7UT
www.dentonscatering.com

Bentwood Furniture Company
Units 41-42
Blue Chalet industrial Estate
London Road
Kent
TN15 6BQ
www.bentwoodfurniture.co.uk

Timeline

1453 Coffee introduced to Constantinople by Ottoman Turks. The world's first coffee shop, Kiva Han, opens there in 1475.

1600 Pope Clement VIII urged to consider coffee part of the infidel threat. Instead, he baptises it to make it an acceptable Christian beverage.

1650 The "first coffee house in Christendom" established in Oxford.

1668 Edward Lloyd's coffee house opens in London. Eventually it becomes Lloyd's of London, the best-known insurance company in the world.

1670 London teems with new coffee houses.

1675 Tea available in food shops throughout Holland.

1688 Over 800 empty newly built Soho houses fill with Huguenots.

1790 British coffee houses disappear as taverns take over.

1802 The term "Cafe" is coined from the French "café" and the Italian "caffe" ("coffee" or "coffee house") to describe a basic restaurant serving coffee.

1822 Prototype of first espresso machine created in France.

1839 "Cafeteria" coined from Mexican Spanish English.

1859 Michael Thonet's Vienna Café chair No. 14 produced as a "chair for mass consumption".

1868 John Wesley Hyatt produces the first commercial plastic.

1870 Tea Shops and Tea Rooms proliferate.

1886 Word "restaurant" first used to denote an "eating house".

1894 First Lyons Tea Shop established in Piccadilly.

1900 250 Lyons Tea Shops established through Britain.

1909 Lyons Corner Houses launched.

1913 Formica invented in Cincinnati. After World War Two, Formica laminates become common in offices, airports, hospitals, schools, restaurants and retail outlets.

1915 Pyrex first developed for railroad signal lanterns – a resilient glass resistant to thermal and physical shock. A kitchen staple for more than 80 years.

1920 Waldo Semon invents polyvinyl chloride – PVC. Vinyl raincoats, and shower curtains hit stores in 1931 making vinyl products a staple of the interior design industry. Prohibition goes into effect in United States. Coffee sales boom. Vitrolite invented – sleek glass tile which becomes a key part of Art Deco movement.

1925 The Vienna Café chair No. 14 included in Le Corbusier's innovative housing exhibit L'Esprit Nouveau at the Paris Exposition Internationale. By 1930, more than 50 million had been produced.

1927 First espresso machine installed in the USA, the "La Pavoni" machine at Regio's in New York. Styled by Italian master designer/architect Gio Ponti.

1933 The first ever sandwich bar, Sandy's, opens in London's Oxendon Street.

1935 First milk bar set up in Fleet Street by an Australian, Hugh D McIntosh. Within a year there are 420 throughout Britain.

1938 Cremonesi develops a piston pump to force hot water through coffee.

1942 Widespread hoarding leads to coffee rationing in Britain.

1946 Gaggia manufactures commercial piston machine. Term "Cappuccino" coined from the colour of the robes of the Capuchin monks.

1947 *House Beautiful* devotes a colour spread to Earl S Tupper's polyethylene tumblers and bowls. Second annual National Plastics Exposition is held in New York with over 90,000 visitors.

1948 Achille Gaggia invents the espresso coffee maker in Milan.

1950 Wheaton Plastics produces the first injection blowmolded containers.

1951 Festival of Britain launches Contemporary look.

1952 Festival of Britain site demolished.

1952 Importation of Gaggia espresso machines to Britain in 1952 First Post War coffee house opens in London's Northumberland Street in July.

1953 Espresso bars spring up throughout Soho. The first is the Moka at 29 Frith Street.

1953 First Wimpy ("the square meal in the round bun") served at Wimbledon.

1954 War-time rationing ends. Polypropylene invented – first large-scale production of high-density polyethylene plastic begins.

1956 Invention of melamine, poly vinyl compound paper saturated into particleboard. Raymond Loewy designs upscale melamine dinnerware for Lucent Co Publication of Colin Wilson's *The Outsider*.

1957 Catherine Uttley lists 200 coffee bars in *Where To Eat In London*. Partisan Coffee bar opens. House of Tomorrow opens at Disneyland, its walls, roof, floors, rugs and furniture all made of plastic so strong that the wrecking crew has trouble demolishing it years later.

1958 First experimental plastic Coke bottle produced.

1959 *Absolute Beginners* published. Unemployment reaches a high of 500,000. First CND Aldermaston march.

1960 Number of coffee bars doubles from 1,000 to 2,000 in Britain – 500 in Greater London alone. *Good Housekeeping* magazine features plastic furniture.

1963 Profumo scandal.

1964 The pop boom, pirate radio and the emergence of the Beatles.

1965 Coffee bars die out, gradually turn into general cafes and restaurants. Golden Egg chain, a mixture of coffee bar and mid-price restaurant, starts up.

1969 460 Wimpy cafes open in the UK – with eight in Oxford Street alone.

1970s Wimpy and Golden Egg chains start to run down.

1972 Moka coffee bar shuts in Frith Street after para-psychic bombardment by American writer William S Burroughs.

1996 Cafe Valoti on Shaftesbury Avenue shuts after a petition to halt its redevelopment fails.

2002 Alfredo's restored (as S & M cafe) after being left derelict for four years.

London Top 10 cafes

1 *The New Piccadilly, Denman Street W1*
A cathedral amongst caffs run by the irrepressible Lorenzo and his crack team of uniformed waiters. A pulsing temple of lemon Formica. Even the New Piccadilly menu is a collectors-item design classic. Truly, a place of reverence.

1 *E Pellicci, Bethnal Green Road E2*
The jaw-dropping marquetry interior – like something out of the Empire State Building – was crafted by Achille Capocci in 1946. Simply one of the greatest (and friendliest) eateries in the world. See Pellicci's and die!

2 *Gambardella, Vanbrugh Park SE3*
The building dates from the 1930s, but the unique moulded plywood revolving chairs were installed during the 1960s. Amazing flesh-coloured Vitrolite and chrome front section with a red and black Formica back room. A masterpiece.

3 *L Rodi, Blackhorse Lane E17*
Splendid old caff that's been with the same family since 1925. The frontage is somewhat altered (thought the excellent "L Rodi Light Refreshment" sign is untouched) but the interior is phenomenal. A veritable caff museum.

4 *Copper Grill, Eldon Street EC2*
Rosewood tables; Lapidus beanpole rails; good window lights; great yellow outside sign (Golden Egg-style) and, better yet, a large downstairs basement with caff-murals adorning the back alcoves.

5 *Golden Fish, Farringdon Road EC1*
Eleonora Ruocco's cosy familial Italian cafe with its ranks of 1940s rosewood booths with metal arms is one of the loveliest in London.

6 *Sea Breeze, High Street E17*
Behind the cut-glass front door there's a remarkable interior with large black and brown booths, astounding light-fittings and masses of Mondrian-coloured Formica panels throughout. A must-see.

7 *Frank's, Addison Bridge Place W8*
Uniquely situated above a railway line, this is a superb old American diner-style place with crumbling interior, single stool seating and a picturesque Deco counter area.

8 *River Cafe, Putney Bridge Approach SW6*
This place has it all: superb Vitrolite ceiling, magnificent blue-tile work, garlanded friezes, murals, excellent wood seats, full-on Formica tables…. A show-stopper.

9 *RendezVous, Maddox Street W1*
Espresso Bongo-like sign outside and a domestic living room interior featuring a bay-fronted window, covered tables, excellent wooden chairs, hanging lamps, counters and lashings of warm Formica on the walls. Home from home.

10 *Tea Rooms, Museum Street WC1*
Magically washed-up parlour-style cafe decked out with wall-to-wall carmine mosaic Formica. A hint of nineteenth century worker's snack bar; a dash of twentieth century Lyons dining hall.

Acknowledgements

For suggestions, contributions, advice and unflagging support, abundant thanks are due to Stephen Ellcock without whom this book would never have appeared. I am also hugely obliged to Ken Hollings for input and editorial suggestions across the board; David Lawrence for feedback and resources; Phil Nicholls, the Hasselblad master, Peter Anderson for auxiliary photography; Pinkfish PR; Studio AS and all at Black Dog Publishing.

Dr Catherine Moriarty and Lesley Whitworth at the magnificent Design History Research Centre Archives at the Faculty of Arts and Architecture University of Brighton have helped enormously in tracking down Council of Industrial Design (COID) archive material. I am also particularly indebted to the efforts of the following archivists, photographers and enthusiasts: Jonathan Makepeace at the RIBA archives; Mo Wilson and the National Library of Wales, Aberystwyth; Sue Ashworth and Paul Thompson at Lancaster City Museums; David Rich at the Tower Hamlets Local History Archive; Emma Heslewood at the Harris Museum and Art Gallery, Preston; Kate Sclater at the Twentieth Century Society and Matthew Partington, Research Fellow, Applied Arts at the University of the West of England.

For favours, ephemera, tips, insights and inspiration many thanks also to: Mike Alway; Bentwood Furniture Company; Adair Brouer; Paul Caplan; Pete Compton; Richard Davenport-Hines; Edwina Ehrman; Kevin Finch; John Fulgoni; Ron Godwin; Mark Gould; Wayne Hemingway; Thom Hetherington; Stewart Home; Colin Hughes; Tamsin Hughes; Dave Johnson; Tom Lancaster; Andy Lyons; Kieran Mcaleer; Niall McGinley; Ian McKay; Ross MacFarlane; Edgar Matz; Jan Misiewicz; Claude Moreira; Alberto Pagano; Simon Price; Quentin Reynolds; Cathy Ross; David Rothon; Craig Saxon; Paul Schia; Iain Sinclair; Bob Stanley; Narguesse Stevens; Mirka Summers; Martin Tapsell; Louis Theroux; Joni Tyler; Peter Thomas Hill; Mark John Thompson; Rick Valoti; Peter Wade; Phil Whyte; Stephen Warbuton and Peter York.

Salutations to all at Andrew's, Brooks Mews Snack Bar, Cappucetto, The Copper Grill, Dante's, Euro Snack Bar, Gambardella, Harris' Cafe Rest, Metro, Morrelli's, New Piccadilly, Pellicci's, The Phoenix, Regis Snack Bar and Zippy Grill.

In Memorium: Allington SW1, Borough Cafe SE1, Brockwell Cafe SE24, Brunchies WC1, Brunest E3, Cross Street Cafe EC1, Chez Monique WC1, Dante W1, St George's SW4, Ginos W1, St John's Cafe EC1, Luigi's EC1, Market Cafe E1, Monaco WC1, New Windsor Grill EC1, Norrman's W2, Regent Snack Bar W2, Roma E10, Savoy E8, Serafino W1, Valoti W1, West One WC1 and The York Gate, Broadstairs.

With love to Ivor, Irene and Russell.

Colophon

Black Dog Publishing Limited

© 2003 Black Dog Publishing Limited

The author and photographers have asserted
their moral right to the work comprising
Classic Cafes.

Written by Adrian Maddox
Photographed by Phil Nicholls
Designed by Studio AS
Printed in the European Union

Black Dog Publishing Limited
5 Ravenscroft Street
London E2 7SH

Tel: +44 (0)20 7613 1922
Fax: +44 (0)20 7613 1944
Email: info@bdp.demon.co.uk

PO Box 20035
Greeley Square Station
New York NY 10001-0001

Tel: +212 684 2140
Fax: +212 684 3583
Email: pressny@bdp.demon.co.uk

www.bdpworld.com

British Library Cataloguing-in-Publication Data.

A catalogue record for this book is available from
the British Library.

ISBN 1 901033 83 X

Adrian Maddox was born in Staffordshire
but grew up in the 1970s in Northern Ireland.
After studying at University College London
he worked in the music business before
becoming a producer and editor. He has
worked for *NME*, *Melody Maker*, Rapido and
the BBC. He lives in Mile End in London, close
to his favourite cafe the mighty Pellicci in
Bethnal Green.

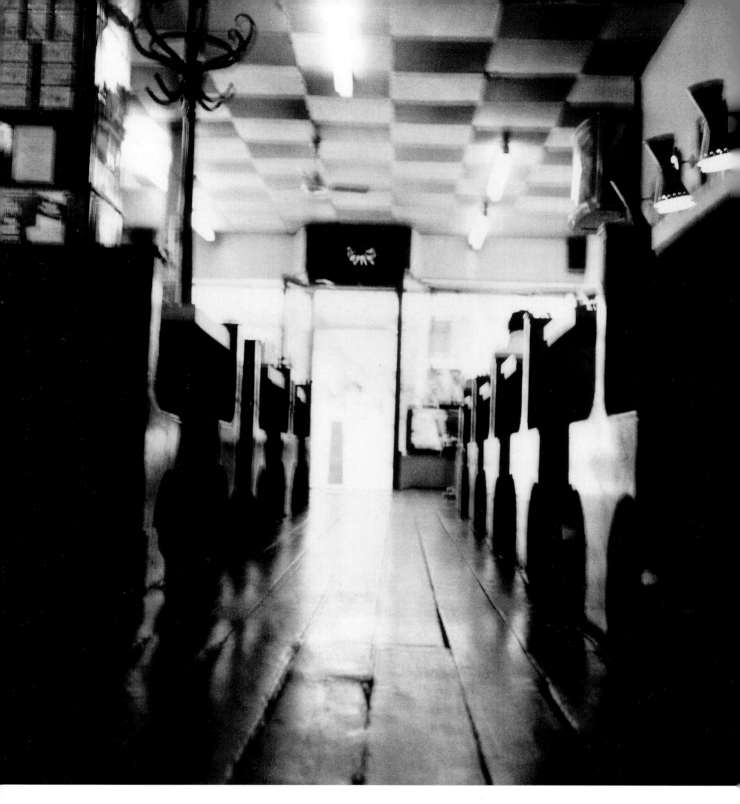

These cafes, these interiors, these faces give you identity. Life is for real. It is all here,
and that is enough. You have no ambition to be anywhere else. You know where you are.
Bernard Kops, introduction to *Cafe*, Cheryl A Aaron, 1985.